SHOOTING STARS

SHOOTING STARS

Photographs from the Portnoy Collection at the Hockey Hall of Fame

ANDREW PODNIEKS

Hockey Hall of Fame

FIREFLY BOOKS

A FIREFLY BOOK

Published in in the United States in 1998
by Firefly Books (U.S.) Inc.
P. O. Box 1338, Ellicott Station
Buffalo, New York, USA
14205

CATALOGING IN PUBLICATION DATA

Podnieks, Andrew
 Shooting stars: photographs from the Portnoy collection at the Hockey Hall of Fame
Includes index.
ISBN 0-55209-314-X

1. National Hockey League – Pictorial works. 2. Hockey – History – Pictorial works. 3. Portnoy, Lewis – Photograph collections.
I. Portnoy, Lewis. II. Hockey Hall of Fame. III. Title.
GV847.8.N3P63 1998 796.962'64'0222 C98-931002-7

Design by Tania Craan
Photographs courtesy of the London Life/Portnoy Collection at the Hockey Hall of Fame
Printed and bound in Canada

FRI 10 9 8 7 6 5 4 3 2 1

CONTENTS

--

INTRODUCTION

PHOTOGRAPHING HOCKEY games can be done in two ways: you can follow tradition and try to perfect the standard style of shooting, or you can take what has already been done, reject it out of hand, and come up with shots that are relevant for their innovation. The images may be radical and different, and breaking new ground is often the best way to put the past in the past and create an exciting and vibrant future.

Lewis Portnoy never copied anyone so much as he rejected everyone. His way, by definition, was consciously not what was anyone else's way. When this stubborn, confident approach was introduced to hockey, vivid photographs brought the NHL out of the black-and-white world of the Original Six and hit expansion fans smack in the face with players' tenacious efforts just inches away from the lens.

Portnoy was born in St. Louis on July 2, 1941, the first child of father R.J. and mother Blossom (he has a younger sister, Joycee). R.J. was a nationally ranked tennis and table tennis player who worried about a life as a racquet stringer when it came time to grow up. Happily, he went on to a career in life insurance, becoming the most successful agent in the United States for Crown Life of Toronto. Coincidentally, his early business partners included Sidney Solomon, future owner of the St. Louis Blues and employer of his son. As a result of his father's sporting trepidations and business acumen, Lew was dissuaded by R.J. early on to ignore his promising athletic abilities (in soccer and football). Although Lew also had a chance to go to Pennsylvania Academy of Fine Arts on scholarship (he had been a promising sculptor in high school), he was directed to Stanford for Business. Initially, this led to a career in securities ("get a hunch, bet a bunch"), an admirable enough line of work to be sure, but one not wholly satisfying for R.J.'s creative son.

One of Lewis Portnoy's high-school friends was Bob Kolbrener, a man equally interested in sports (he had been a talented high-school football player) and the arts, particularly photography. At Kolbrener's house were hundreds of issues of *Popular Photography* magazine, and he and Lew would sit for hours cropping published images with cardboard "L"s they had made to critique and understand composition. They examined the pictures for light sources to discover the world of lighting and taught themselves all the rudimentary rules of photography. Kolbrener took a trip out to Yosemite National Park in California and was transformed. He saw Ansel Adams' photographs in the gallery at Yosemite, signed up for workshops, and became a student under (and later, teacher with) Adams, the greatest landscape photographer of the twentieth century. Portnoy, who was too busy in securities and raising a family of three children to join Kolbrener out West, learned through his friend the techniques of fine printing, lighting, and composition.

A mutual friend's father had a darkroom in his basement, and there Portnoy and Kolbrener practiced the art of printing firsthand. The father, a manufacturer of photographic equipment and supplies (lens shades, filters, etc.), one day came across a jampol lens used for printing color paper. He sent the lens to his connections in the Far East and

asked if they could make it more cheaply. The manufacturers took the lens apart and put it together backward before returning it to St. Louis! It took Portnoy and Kolbrener months before they discovered why they couldn't make a decent print, but in the interim they learned a great deal about color darkroom photography. This was their tortured, meaningful apprenticeship.

As a season's ticket subscriber to Blues games, Portnoy took his camera to the Arena and shot from his seats which looked out just over the top of the Plexiglas. One night, he took some pictures of Noel Picard in a lively fight. He was elated by the black-and-white images that resulted, and took them to the Blues' public relations department the next day. Director Wayne Cooper was so impressed that he gave Lew a press pass and told him to walk around freely and shoot from more advantageous locations. Lew was just beginning to scratch his itch.

At the end of that season, Portnoy got his big break. After the Blues lost their playoff series to Montreal at the Forum in the spring of 1968, they returned to the Arena for a team picture, and then everyone and his family went to Florida for a vacation courtesy of owner Solomon. While down South, it was discovered that the team photograph had turned out poorly, and as Solomon wanted to use it for his Christmas cards, it had to be retaken. Portnoy was called at midnight one night by Cooper and asked if he could take a picture the next day at noon at the Arena and have a final print ready the day after that. Portnoy said yes and then called his friend Bob Lyner in the middle of the night to see if he had the necessary equipment (Lew certainly didn't!). The players flew home from the Florida vacation, boarded a bus to the Arena, got into playing gear, and had their picture taken on the concrete floor at center ice (the ice having been removed right after the earlier picture). Portnoy had saved the day.

Shortly thereafter, he was hired as the team's official photographer, leaving the securities business behind without a moment's hesitation. Around the same time, Kolbrener was working for the baseball Cardinals and began doing playing-card pictures, and together they formed Kolbrener-Portnoy as a business that was quickly expanding to dominate the St. Louis sports market. While the setup seemed perfect, the combination wasn't always so. Kolbruner became less interested in sports photography and more in landscape, and Portnoy tired quickly of baseball. During one spring training, he drove across Florida three times to try to photograph Johnny Bench of the Cincinnati Reds for a Topps gum card picture, only to be told each time by Bench that he wouldn't be shaving until after practice (by which time he'd be out of uniform).

Portnoy worked feverishly with the Blues at the old, magnificent Arena. It was, for him, the perfect venue. Unlike Maple Leaf Gardens or the Montreal Forum, the Arena was never sold out. Thus, he had plenty of room to walk around, try new angles, experiment. His contractual requirements to the team were simple: ten 8" x 10" pictures from each game for programs and inserts and the rest of the time he could do as he pleased. It was for this reason he traveled to other arenas infrequently in the coming years; he had no need to endure the pitfalls and inconveniences of another building when everything he needed was in his own backyard. The one quality about the Arena that he hated, ironically, was the empty seats, so much so that he would sometimes flip them down to expose the blue padding rather than shoot the chrome underside that he found made for an otherwise un-photogenic background.

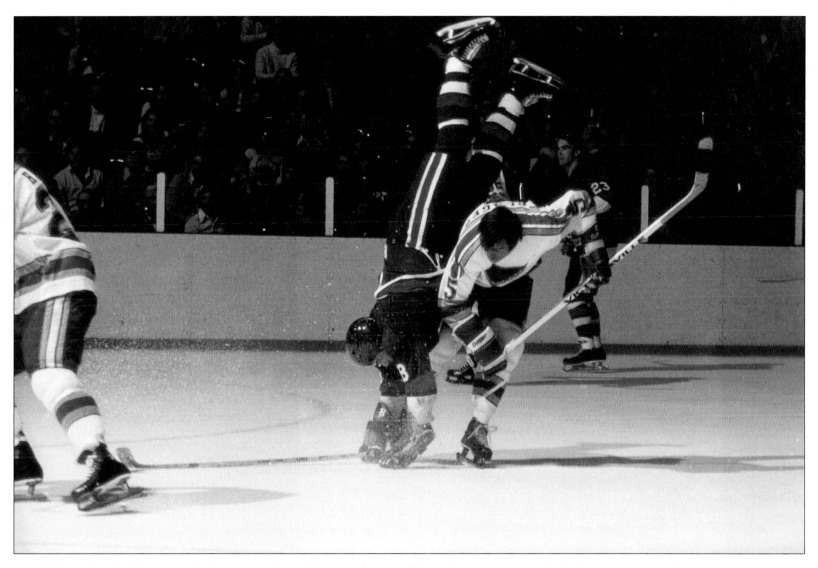

Without doubt, the seminal advance in color and action photography in the sixties was strobe lighting. In Montreal, David Biers had used strobes, and Joe Black and Michael Burns had used strobes at Maple Leaf Gardens for a decade or more. But Portnoy had never been interested in attaching the lights to the top of the Plexiglas as those other photographers had done because such a lighting system created large shadows on the ice. He wanted to put the strobes high above the ice so that the shadows were *under* the players (more or less removed, in other words) instead of being highly visible. (The light principle can be understood by looking at shadows on the sidewalk cast by the sun — the lower the sun, the longer the shadows.)

Portnoy's strobe setup represents a remarkable development in his photography. The set that he initially leased (and later bought) came from New York, only the fourth such set made. The first was used by Irving Penn, the second by Richard Avedon, and the third was installed at the finish line at the Yonkers racetrack in New York. Initially, Portnoy experimented with light locations. Sometimes they worked, oftentimes they didn't. He experimented for weeks on end to make the system effective and reliable, but in the end, he bought 600 feet of electrical cord and strung it 65 feet above the ice from corner to corner of the building, dangling the strobes over the ice from this cable which would then trip the lights. The two 40-amp lines required special electricity for either side, and these took the form of two 400-pound power packs and capacitors near the cable to ensure safe and powerful lights.

Portnoy positioned one strobe to hit the goalie's head and the other to hit the ice near the right faceoff dot, relying heavily on the ice as a source of light, a brilliant and original concept for hockey photography. Once the perfect system had been made foolproof, it took him another six months to get NHL approval of the strobes, and even then he had one final problem. Whenever Atlanta's Dan Bouchard was in goal when the Flames were in town, Portnoy couldn't strobe at that end, such was the goalie's annoyance with the unfamiliar photo system that bounced light off the ice near his crease.

One of the difficulties Portnoy had with the strobes led to one of his enduring innovations. Strobes provided such clarity and brilliance to the final image that even the slightest imperfections could be detected on the print — blemishes such as scratches or reflections on the Plexiglas behind which Portnoy stood. To solve the problem, he cut a small hole in the glass where he positioned his camera, bringing him even closer to the action and removing any faults to the image.

Portnoy's other great technique was to use zoom lenses for shooting. As he explained it, he wanted "to try to put on film something that's too quick for the eye to see." Capturing the moment in hockey was not new, but by using the zoom, he could crop his images very tightly and bring the camera in on the game. For the first time, players seemed to be skating into the lens, their intensity and emotions captured in a blink, and occurring in spontaneous syncopation with the release of the shutter. Action photographs were so clear and close, you could see the fibers on a player's jersey, the logo on the puck, the pigment of a player's skin, the threads of tape on a stick.

To enhance his techniques, Portnoy made sure he was thorough. He used two cameras simultaneously, one in his hand for "first person" shots — on-ice portraits and close-ups — and another, above and behind him, that was wired to the same lights and covered the entire area from the blue line in to the end red line. Thus, he could get two views of the exact same play. He also hired other photographers — primarily Bill Lamberg, Bob Bishop, and Steve Goldstein — to take black-and-white pictures from various other locations in the building, so that at the end of each night he had an impressive portfolio of that evening's game.

As a result of the new and exciting photography that Portnoy was bringing to the game, the NHL had a more marketable commodity. Through his technical skill, Portnoy was able to convey the very game itself as physical, emotional, and entertaining in a way that was fresh. The league had hired Ray Volpe as its vicepresident in charge of marketing, and he quickly used the Portnoy approach to effect by establishing *GOAL* magazine, a publication that would be sold

in most NHL buildings as a souvenir program. In the first few years that *GOAL* was distributed, Portnoy's pictures were on the cover an incredible 142 times during the early- to mid-seventies.

As Portnoy became better known, his talents became more in demand. His photographic business interests emerged in ever-expanding forms during these years, with hockey playing an ever-decreasing role. He worked for years with the Philip Morris company, doing everything from Benson and Hedges Grand Prix ski racing to the Virginia Slims women's tennis tournament. It was through this association that he first met the great landscape photographer Ernst Haas. Both were hired by Morris to cover the Marlborough Cup (horse racing), Haas for advertising, Portnoy for the public relations department. Portnoy had long admired Haas as well as John Zimmerman, Eliot Porter, and, of course, Ansel Adams. Haas's advice was always to ignore photography for inspiration and use painting to understand light and composition.

Portnoy was also doing a great deal of business with Spectrum, a photo lab owned by a company called Color Associates. So good was their relationship that Spectrum asked him to become a partner, and he named his division of the company Spectra Action. It was at Color Associates that he met Lois Constantz, soon to be his lifetime partner and associate, and in due course, Portnoy made Spectra Action his own independent company which thrives to this very day.

Outside hockey, Portnoy's longest and most fruitful association was with NBC television, for whom he worked for 12 years. He began in TV in 1972, doing photography for ABC "Monday Night Football" before being offered a contract by CBS. There he worked for the better part of five years, his last major event being the 1977 Masters at which he was the only photographer who was allowed access to the TV towers and from which he produced some of his finest images. His pictures were also an integral part of CBS's presentation for its bid to cover the 1980 Summer Olympics in Moscow, and his material eventually was used by the station in an Emmy Award-winning signature. However, there was a complex "out" clause that was invoked shortly after CBS was awarded rights, allowing the deal for the '80 Games to be transferred to NBC. Fortunately for Portnoy, a friend from his Philip Morris days — Bob Basché — was now working at NBC as director of talent and promotion, and he managed to bring Lew on board. While the United States was

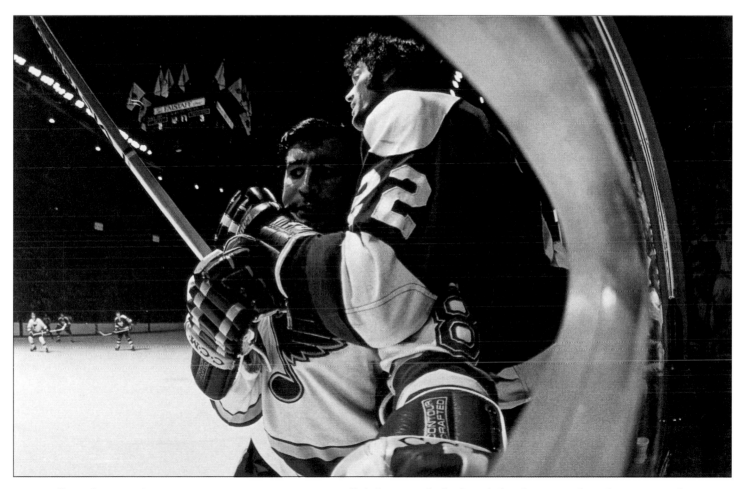

eventually to boycott the '80 Games in Moscow, Portnoy still did a great deal of work for the network and was integral in the photography for the '84 Summer Olympics in Los Angeles.

During the seventies, Portnoy's pictures represented all major, and many minor, sports. He covered the Stanley Cup finals (1971–76), five NHL all-star games (1972–76), five World Series, four MLB all-star games, five US Open tennis championships, six Super Bowls, three NCAA Final-Four tournaments, and everything else under the sun — from rodeo and archery competitions to the Ali–Spinks title fight in 1978 (his first assignment back after suffering a heart attack in late 1977).

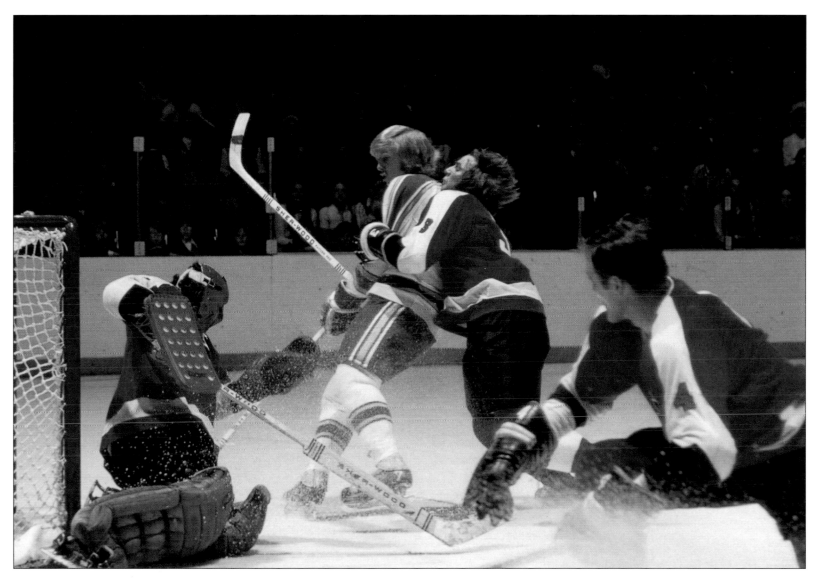

Although hockey gave Portnoy his start and taught him so much, his constant frustration with those whose support he could have used led him to leave hockey without much sorrow. In the first place, there was no one around who was particularly enthusiastic about what he was doing to expand the medium of photography and the art of taking hockey pictures, even though the relationship between the art and the commercial was becoming evermore apparent to the league (i.e., *GOAL* magazine). He fought tooth and nail every inch of the way to cut holes in the Plexiglas and to position his camera in unique locations, but the only rewards were more fighting the next day rather than a league-wide

desire to improve further. "What drove me out of hockey," Portnoy said, "was that finally I had a camera or lens in every location I could possibly think of. I never wanted to do tomorrow what I did yesterday." That was the rub. The one place the NHL refused to let him go was to cut a section out of the boards at ice level. Portnoy felt that the last frontier of hockey photography was to eliminate the ice altogether from the image, but he could never get league approval.

When Ray Volpe left the NHL to become commissioner of the LPGA (Ladies Professional Golfers' Association), he recruited Portnoy to take over all photography assignments for the tour — everything from publicity shots and tour events, to game action for the magazine *FAIRWAY,* the golf equivalent to *GOAL.* Along the hockey way, Portnoy made many, many memorable pictures, including a famous shot through a fish-eye lens of Garry Unger taking a slap shot. To get the image, Portnoy lay on the ice with camera in position and asked Unger to skate in and shoot past the camera. In order to get the warp of the stick, Portnoy had to anticipate the shot and keep his cool while the puck flew by him just inches away. Portnoy loved shooting Unger. He was the fair-haired boy in St. Louis, the good-looking, talented idol, and his blond hair made him the easiest player to photograph effectively under the strobes.

Another of his favorite images is of two of the Plagers, Bob and Barclay, together at the side of the St. Louis net. Portnoy was so ecstatic about the shot that he showed general manager Lynn Patrick the next day. But Patrick could only exclaim, "Look at those guys! Out of position again!" He wanted a copy of the picture to take to the Plagers, but using the image to make the players look bad would hardly have stood Portnoy in good stead with the much-loved brothers so Lew demurred. Bob's favourite expression was, "Number 5 in your program, number one in your hearts." He was right on the mark, such was his enormous popularity in St. Louis.

The Hemingway of hockey, Portnoy learned very early in his career how invaluable throwing a few dollars in the right direction was to capturing great images. Twenty dollars here, a hundred there, might seem like a lot at the time, but in the end, the money would pale in significance to the freedom it afforded him to take pictures of the highest quality and originality (that's how he got Arena staff to cut the Plexiglas!). At one Kentucky Derby, for instance, he parked across the street from the track, paying a home-owner $75 for the privilege of using his driveway. At race's end, Portnoy bolted to the house to get his car, drove to the airport, and made it back to St. Louis in time to shoot the Blues' game just a few hours later. He never could have made both events without a little monetary persuasion. Another time, he covered the Belmont Stakes and was a little late getting to the airport after the race. He left his rental car right at the departures gate and ran to the check-in for his flight back. Once there, he explained to the stewardess what had happened. She took the keys, told him the car would be taken care of, and upgraded him to first class. Life was very, very good in those days.

The importance of his hockey photographs came to the attention of Craig Campbell, manager of the Resource Centre at the Hockey Hall of Fame, after seeing one of many great Unger pictures. Campbell initiated contact, and the negotations between Portnoy, President Jeff Denomme, and London Life brought the collection to the Hall of Fame in

Toronto in December 1996. (Some 40,000 color transparencies and 60,000 black-and-white images were purchased and then donated by the insurance company, which has since been bought by Great West Life.) Because of the breadth and quality of the Collection, this is certainly the finest photographic testament to the NHL in the 1970s. It is both archivally and artistically the most comprehensive documentation of the early years of expansion in the league, its successes, its failures, its superstars, its cup-of-coffee call-ups, its history.

Andrew Podnieks

CURT BENNETT — FAMILY MATTERS

AS GERRY CHEEVERS well knows about horses (see Plate 4), genes are extremely important in recognizing the potential success of a pony. Once a great horse has run its last race, it is put out to stud and used to sire foals and fillies which, in turn, because of their excellent bloodlines, have a better chance of becoming successful furlong fliers themselves.

Curt Bennett's father Harvey played goal for the Boston Bruins in 1944–45, splitting the netminding responsibilities with Paul Bibeault. Like his father, Curt was born in Saskatchewan, but he was raised in Rhode Island and played for the United States in the 1976 Canada Cup. While father/son combinations are rare enough in the NHL, a goalie/skater pair is even rarer. And the Bennett family is even more amazing considering that two of Harvey's other children — Bill and Harvey the Younger — also played in the NHL.

In fact, Bill Dineen is the only other NHLer to sire three NHL children: Peter, Gord, and Kevin. Cal Gardner had two pro-playing kids in Dave and Paul, as did Gordie Howe with Marty and Mark. Bill McCreary saw Bill Jr. and Keith make their way to the bigs, and these six are the only ones in which a father sent two or more children to the NHL. (For more on the sixth, see the Patrick family below.)

Then there are the incredible Conachers. They are the only two brothers — Lionel and Charlie — who *both* had children go on to play in the NHL (Lionel's son Brian and Charlie's son Pete). Further, Lionel and Charlie had a brother Roy who also played in the NHL, though he was not able to bequeath his skills to any pro-playing progeny.

The longest-represented families in hockey must surely be the Patricks and Hextalls, both of whom are the only ones to have three generations of players lace up NHL blades. Lester Patrick fathered two hockey players — Lynn and Muzz — and Lynn's sons Glenn and Craig also went on to play, in the seventies. Bryan Hextall played for the Rangers from 1936 to 1948, and two of his children made it as well — Dennis and Bryan Jr. Ron, Bryan Jr.'s son, was the Flyers' main man in goal for most of the last decade.

Incredibly, though, families tend to breed like-positioned players. Only six father/son combinations have ever featured one goalie and one skater: the aforementioned Hextalls, skating-father Bryan Jr. and goalie-son Ron; goalie-father Hank Bassen and skating-son Bob; goalie dad Emile Francis and skating-son Bobby; goaler Bert Lindsay and famous forward Ted; and goalie Harvey Bennett and his three skating-children Curt, Bill, and Harvey Jr.

The rarest duo of all are fathers and sons who were *both* goalies. Under this rubric can be found but two surnames: LoPresti and Riggin. Sam LoPresti played goal for Chicago from 1940 to 1942, and his son Pete minded the nets for Minnesota and Edmonton from 1974 to 1981. Dennis Riggin played nine games for the Red Wings in both the 1959–60 and 1962–63 seasons, and his son Pat played goal for five NHL teams from 1979 to 1988.

That Curt Bennett was raised in the United States addresses a demographic characteristic of the fathers and sons who have played in the NHL. Even in Original Six days, there were four American teams to two Canadian ones. Thus, while the majority of the fathers were Canadian, the children were sometimes born on US soil. Both Marty and Mark Howe were born in Detroit; Curt's two brothers Bill and Harvey Jr. were born in Rhode Island; Lynn Patrick's two sons Glenn and Craig were also born in the US. Only in the case of the LoPrestis were both generations born in America.

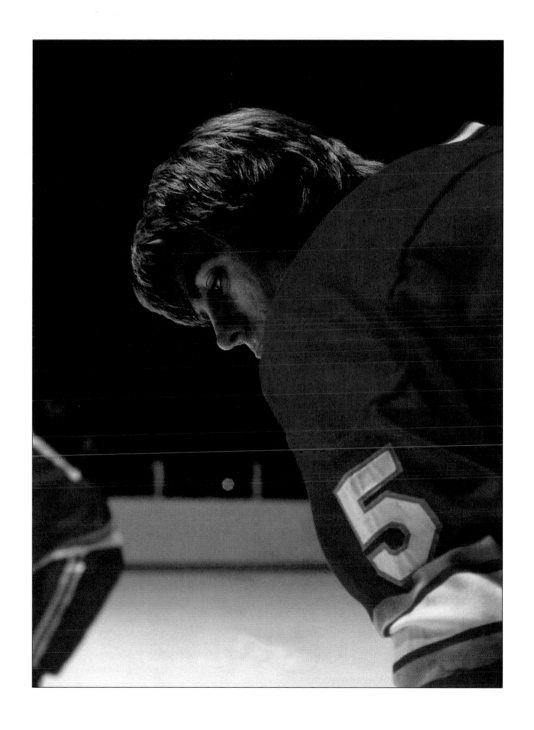

PLATE 1

IVAN BOLDIREV AND THE OSHAWA GENERALS

IVAN BOLDIREV was born in Zranjanin, Yugoslavia, one of only two players from that country to make it to the NHL. (The other, Stan Smrke, played nine games with the Habs from 1956 to 1958.) In a career that spanned six teams and more than 1000 games over 15 years, Boldirev stayed in Chicago the longest — almost five years. He wore No. 12 his whole time with the team, though in his earlier days he used No. 23 and No. 22 with Boston and No. 23 and No. 9 with California. In Atlanta, he also wore number No. 12, but he was obliged to change to No. 9 when he got to Vancouver because Stan Smyl had the dozen number. When he went to Detroit, Boldirev wore No. 19 and then No. 12, until he retired after the 1984–85 season.

Before he made it to the NHL, Boldirev played for the Oshawa Generals of the Ontario Hockey Association, one of the more successful franchises in the OHA, if for no other reason than Oshawa was junior home to Number Four, Bobby Orr. Boldirev, however, missed Orr as a teammate by a couple of years, since Orr's last season was 1965–66 and Boldirev's first was 1967–68.

The Generals began play in the OHA in 1937–38 and got their nickname because the club was sponsored by General Motors of Canada. For years, the team's logo featured the letters GM with "General Motors" written in smaller print underneath. Over the decades, the team has sent many great players to the NHL. Billy Taylor began in Oshawa, as did the McAtee brothers, Jud and Norm. Other future stars included Bep Guidolin, Floyd Curry, Bill Ezinicki, Gus Mortson, Ted Lindsay, Alex Delvecchio, and, more recently, Eric Lindros.

However, tragedy struck that hockey town on September 15, 1953 when a fire destroyed the Oshawa Arena. In a matter of hours, the franchise was virtually eliminated, the players transferred to other clubs, and the city without a junior team. The Generals played the 1953–54 season in Bowmanville and for the next five years played in Whitby as the Dunlops. They then played at Maple Leaf Gardens for two years (1960–62) in the Metro Junior A League, competing with Brampton, Toronto Marlboros, Knob Hill Farms, and Neil McNeil Maroons. The following year, they played out of Bowmanville again for two seasons, including 1963–64, Orr's first in the OHA.

It wasn't until December 11, 1964 that the new Oshawa Civic Auditorium was completed, ushering in the modern era of Junior A hockey in the city. That first season was bittersweet for, although the new Generals made it to the Memorial Cup finals, they lost in six games to the Edmonton Oil Kings. Their star-hero Bobby Orr played with a severely pulled groin, for only about five minutes a game, in a series that took place entirely at a sold-out Maple Leaf Gardens.

By the time Boldirev arrived in Oshawa, Orr had already won the Calder Trophy and was NHL-famous. The 1967–68 Generals featured a number of NHL futures including Hank Nowak, Terry O'Reilly, and Bob Kelly. The next year, Dale Tallon was added to the team's mix. After his second year with the Generals, Boldirev was drafted 11th overall by Boston in the third round of the newly created Amateur Draft. As a result, he played the following two seasons in the minors with Oklahoma City of the Central Hockey League. He then joined the Bruins and began his career with the team in the league dominated by an alumnus of his alma mater — the NHL-led Bobby Orr.

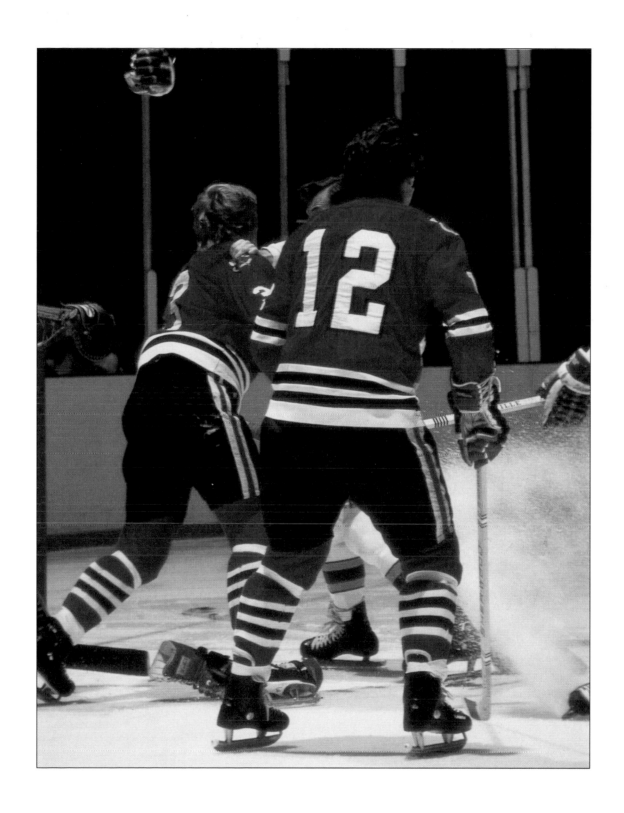

PLATE 2

HENRY BOUCHA'S TOO TOO BRIEF CAREER

HENRY BOUCHA'S career began with hope and promise. After playing at the 1972 Olympic Winter Games for the silver-medal-winning United States team, he joined the Detroit Red Wings for 16 games down the home stretch of the 1971–72 season. In his first NHL game, he scored a goal. The next year, Boucha broke Charlie Conacher's 40-year-old record for fastest goal from the start of a game when he scored after just six seconds of play, on January 28, 1973 at the Forum in Montreal. He played the next two full seasons with the Wings, wearing a red headband to complement the Detroit jersey colors. Then the problems began.

The Chippewa Indian from Warroad, Minnesota was traded to the North Stars in the off-season, and during a game against Boston on January 4, 1975, got into a fight with Dave Forbes. That was the beginning of the end for him. Forbes punched Boucha without letting go his stick, and while the glove only glanced off Boucha's face, the butt end hit him flush in the eye. Boucha needed an emergency operation, and he never regained full vision in that eye. Forbes was later charged with assault, but the case ended with a hung jury and charges were dropped. Shortly after the incident, realizing the severity and possible permanence of the damage to his eye, Boucha began legal action against Forbes, the Bruins, and, curiously, Red Wings management. He returned to action toward the end of the year, but his behavior became erratic. He began missing practice and violating team curfew. The Stars suspended him.

At the end of the season, Boucha fled the NHL and signed with its cross-town rival Minnesota Fighting Saints of the World Hockey Association. There, things went from bad to worse. He played only briefly in the new league before walking out on the team because of fear of both reinjuring his eye and the absence of team insurance if an accident occurred. "There is no protection for the players, and the Saints legally wouldn't be responsible for my medical coverage if anything would have happened," he explained.

At the same time, the two-year-old Kansas City Scouts had acquired his NHL rights from the Stars for a 2nd-round draft choice in 1978 (which they used to select Steve Christoff 24th overall) and were anxious for him to join them. For that to happen, the Saints had to agree to rip up Boucha's contract. They did, and on February 7, 1976, he officially joined the Scouts. He played 28 games in 1975–76 and nine more the following season with Colorado after the struggling KC team moved to Denver and became the Rockies. He was suspended with pay because he "was having problems picking up passes and shooting accurately." After the Forbes incident and three operations, his vision had deteriorated so much that he was forced to hang up his headband after only 247 games over six seasons. He was just 25.

Boucha experienced redemption of sorts when in August 1980, his civil suit was settled out of court. The now-retired player was quietly awarded $1.5-million in damages, the largest settlement ever made up to that time for a sports-related injury.

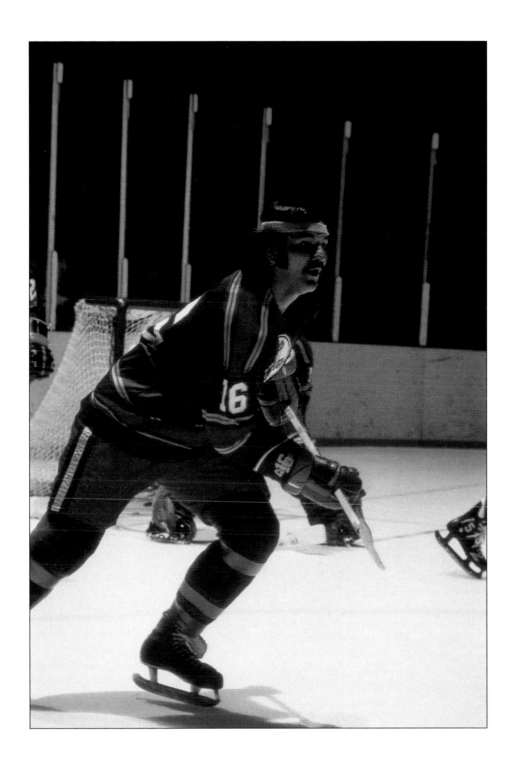

PLATE 3

GERRY CHEEVERS AT THE POST

GERRY CHEEVERS is one in a long line of hockey men who has had an avid interest in horse racing. From Conn Smythe to Frank Selke down to Steve Stavro, the track has long held an allure to hockey men, it being a place for competition that occurs primarily in the daytime and summer, times when hockeyists are idle and in need of legal distraction.

Cheevers began his racing career in 1970 when he established the Four Thirty Stable, named for his jersey number and that of his good friend Bobby Orr. Orr was more the silent partner and good-luck charm for Cheesie, who did most of the work at the stables. His first horse to win was thoroughbred Cenacle's Image at Suffolk Downs with Charlie Maffeo on top wearing the yellow and black of the Bruins. Four Thirty's most successful horse was a gelding named Cynical Image which Cheevers and Orr claimed for $3000. It went on to win six straight races. By 1973, Cheevers had a stable of eight horses between Delaware Park and Rockingham Park, including Class Blazer which won a feature race at Delaware that summer.

The upturn for Cheevers came at the 1975 Keeneland Fall Sales where the goaler paid $20,500 for a yearling named Royal Ski, sired by Raja Baba, a son of Bold Ruler. The dam was Coz O'Nijinsky, a cousin to the legendary Nijinsky, winner of the Triple Crown in Britain and the finest offspring of Northern Dancer. Originally, Cheevers had wanted to name the horse Royal Orr (Bobby's good luck again!), but the New York Jockey Club rejected the name. Cheevers kept the Royal, but settled for Ski, short for Nijinsky.

Ski became the number-one earning horse in 1976, but lost the Eclipse Award as top two-year-old to none other than Seattle Slew. Because of Ski's success (more than $300,000 in winnings that year), Cheevers was able to buy more expensive horses and upgrade his stables more than somewhat. He had several triumphs. Native Goal won the Granite State Stakes for him, Timothy's Champ won five in a row ($100,000 at Rockingham), and Lady Fulcrum, Cheryl Lisa, and Lady Whig all performed admirably for Cheevers. Whig went on to win more than a hundred grand as well.

But Royal Ski was the closest Gerry came to big-time success at the races. In 1976, Ski ran nine times on nine different tracks and won six, five of which were stakes races. Ski won the Heritage and Laurel Futurity (both $100,000 rides) and the prestigious Remsen in New York, a mile-and-an-eighth feature for two-year-olds and driven by the great saddle-bearer, Angel Cordero Jr.

Ski's value shot to $2 million, and Cheevers planned to syndicate it. He had eight investors lined up to pay $125,000 each for one-sixteenth ownership (for half the horse; he'd keep the other half himself), but a virus infection almost killed Royal Ski, and Cheevers diplomatically withdrew the offer of sale.

Over the years, a number of his horses have had hockey names such as At The Crease, In Alone, Score For Orr, Wayne Cashman, Two On One, In The Net, and Around The Boards. Shortly after his retirement from hockey in 1980, Cheevers was appointed promotions director for Rockingham Park in Salem, New Hampshire.

PLATE 4

MIKE CHRISTIE AND TUUKS

I T'S THE DETAIL, the smallest observation in the frame, that leads to the most interesting documentary information that could possibly accompany this great photograph of a behind-the-net check thrown by Colorado's Mike Christie. Look at Christie's skate blades, then at Mike Walton's. There is a difference in design, a huge difference. Christie is wearing the new, modern Tuuk blades — Walton, the traditional "tube" skates.

Tuuk is an Inuit word meaning "ice chisel," and the blade was invented and introduced to hockey by the Baikie brothers, Roger and Hugh. As Canadians, they knew that one of the most important things about our culture was hockey. Yet, as entrepreneurs, they also knew that it was something Canadians rarely exported. They sought to invent a blade that would be unique and marketable worldwide. They also wanted to improve the skate itself, which had not changed substantively since the 1920s; the only thing different was the white plastic safety tip at the back end of the blade. The Baikie brothers were successful beyond their wildest dreams.

Their selling scheme was simple and practical. First, the blade was 4 ½ ounces lighter than the tube blade. Players skated faster because they carried less weight. The blade was made from Swedish steel and, much like a razor blade, held its sharp edge and remained waterproof (snow doesn't stick to stainless steel). Players who routinely sharpened their skates every day were now doing so once a month with their Tuuks. Lastly, the plastic boot encased the full length of the blade, thus preventing the previously exposed ends from getting caught and leaving one susceptible to injury, or, in turn, injuring others.

After testing the blade to perfection, the Baikies persuaded players on the McGill University hockey team in Montreal to try their revolutionary new skate. They called their old friend, Canadiens' general manager Sam Pollock, to enlist NHL support. Pollock told them to talk to then-Hab right winger Jim Roberts, who agreed to try the Tuuks in practice. Impressed, he used them in a game for the first time on January 11, 1977 against the Rockies. Over the next year, the entire Montreal team, with the exception of goalies Ken Dryden and Michel Larocque, made the change. Soon, everyone on the Sabres and Bruins was also using them, and it was only a matter of time before the rest of the league — and the world — caught on. Another group of players that was converted early on was the 1978 Canadian team that represented the country at the World Junior Championships in Quebec. A member of that team was the 16-year-old Wayne Gretzky who commented: "I'm not a good skater and I turn a lot on my ankles. But I find these [Tuuks] give me more flexibility so that I can turn my ankle right over." They seemed to work well enough for him.

One of Gretzky's teammates, Bobby Smith, who wrote a daily column for the *Ottawa Citizen* during the tournament, had this to say: "I had a chance to use the Tuuk blades for the first time today. Over half the team is now using them, and everyone thinks they're great. It's easier to turn sharply, and I think I can go faster with them because they're lighter."

Initially, players complained about the plastic holder breaking, but after Roger Baikie explained that it was due to a defective batch, which was recalled, the blade proved remarkably durable as well. Within a year, production reached 200,000. Today, every skate made worldwide is designed on the Tuuk formula — truly a boot and blade combination that revolutionized the world of hockey equipment.

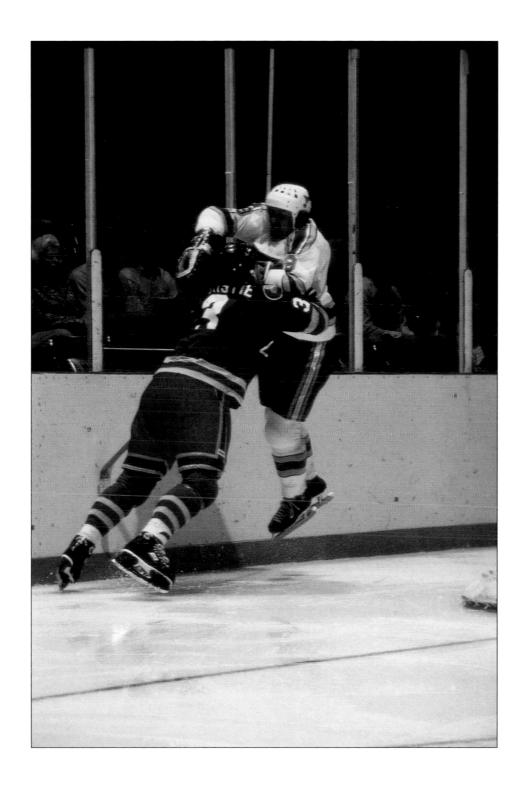

PLATE 5

BOB CLARKE'S INSPIRATION

YOUNG BOBBY CLARKE first learned he had diabetes when he was 15 years old. Once discovered, it meant he had to have 55 units of insulin injected by needle into his arm every morning to allow his body to cope with the excess sugar in his blood. He was drafted 17th overall at the 1969 Amateur Draft by the third-year Philadelphia Flyers. He was taken that low because, although everyone knew of his immense talent, scouts and general managers felt the rigors of an NHL season would be too much for a diabetic. Initially, their worries seemed justified. At his first training camp, Clarke passed out twice, the result of skipping breakfast before early morning practice. However, Flyers' trainer Frank Lewis made it his personal job to look after the nervous Flin Flonian, ensuring Clarke had plenty of sugar before, during, and after games, and forcing him to adhere to a strict diet during the season.

Diabetes, like the "small-player" tag that some players have had to live with, didn't hinder Clarke. It just made him more determined that no matter what, he wasn't going to fail because he was diabetic. "Not talented enough" was OK, but no other excuses would do. The result was that Clarke not only became the prototypical team leader, he became incredibly resilient and physically tough. In 15 years in the league, he averaged more than 76 games a year — not bad for someone who was considered too much of a health hazard to draft.

Toward the end of his career, he wrote a letter to a diabetic fan. It summarizes both his position as a role model in society — as the most famous diabetic ever to play in the NHL — and his fierce determination not just on the ice, but in life:

It has come to my attention that you are having some health problems.

I was just a youngster back in Flin Flon, Manitoba, a small Canadian mining town, when I first discovered I had diabetes. Quite naturally, I was very upset at first.

I guess I felt I wasn't normal … that I was different from everyone else. I guess I began feeling a bit sorry for myself because I thought I wouldn't be able to do the things normal people do.

All I ever wanted to do was play hockey, and my first reaction was that diabetes would prevent me from doing that. How wrong I was!

Once I got over the initial shock and stopped feeling sorry for myself, I made up my mind that diabetes, or anything for that matter, wasn't going to stop me from doing the things I wanted to do. I found that with the proper care, I could lead a normal life. And you can, too.

There is only one thing that can stop you, Mike, and that is YOU! If you have the determination to succeed, you can. If you want to feel sorry for yourself, you won't accomplish your goals. But, then, neither will someone without diabetes under those conditions.

I can honestly say that diabetes has not prevented me from doing even one thing that I wanted to do. If you take care of yourself, if you listen to your doctor, you'll be able to say the same thing. Diabetes, or no, you can be what you want to be.

Good luck,

Bob Clarke

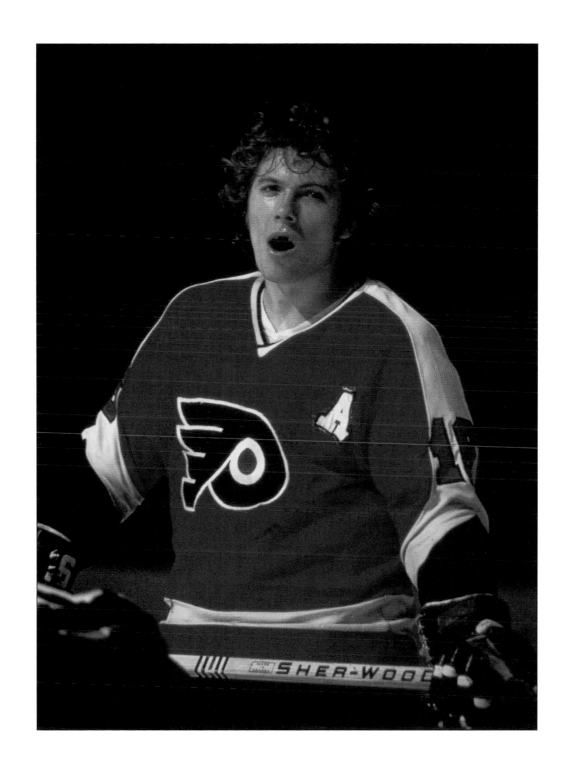

PLATE 6

THE COLORADO ROCKIES — A BRIEF HISTORY

WHEN THE KANSAS CITY SCOUTS transferred to Colorado for the 1976–77 season, it was not exactly moving into hockey country. In all of Denver, there were about 400 children playing hockey. Only 11 high schools had hockey teams, and there were only three rinks in the whole city. The first souvenir program for the team's opening game against the Leafs pointed out that the Rockies would have to compete with Colorado College and Denver University for the "fans' dollar." This was not a good sign, especially since Colorado College was averaging around 2000 fans per game.

In June 1976, amazingly, Denver almost got the California Seals rather than Kansas City. But Seals' owner Mel Swig was not prepared to give the City of Denver all the monetary concessions it was after, from use of McNichols Arena, and he wound up moving to Cleveland instead (evils made so much the *greater* by comparison because there is no lesser of the two!). It wasn't until August 21 that the nickname Rockies was officially announced in Colorado and that financial backing was arranged to move the Scouts to the Mile High City. That left the team only six weeks to drum up interest in NHL hockey before its home opener. Eventually only about 2000 could be found, a figure that did not bode well for a new team in a new city.

The Rockies moved into the new 17,500-seat McNichols Sports Arena, where tickets were eight dollars for a "rinkside" or "loge" seat, and five dollars for a copy in the "gallery." The game night program also provided useful information about the sport, beginning with this tidbit of syntactical glory: "Above all, the object is to put the puck in the other team's goal and to keep it out of your goal."

A fitting explanation of the rink was also provided for those new to the game: "Ice hockey is played on an ice surface known as the 'rink.' The official size is 200' long x 85' wide. It is surrounded by boards four feet high with shatter-proof glass on top of the boards. The red and blue lines divide the rink into three zones: offensive, neutral, and defensive. There is a goal at each end of the ice."

The Rockies' opener saw just 7359 fans drag themselves into McNichols to see their charged players beat the Leafs 4-2, though without team captain Simon Nôlet, who was out with a wounded right leg. The team's first goal was scored by Larry Skinner (who had only signed a contract the previous day), and Doug Favell was credited with the win in goal for the Rockies after having been released by said Leafs just three weeks earlier.

The Rockies had the distinction of ensuring that each new season brought with it a new coach. For their inaugural foray, they hired Johnny Wilson, who had previously been with Los Angeles and Detroit. Then, in 1977–78, he was replaced by Pat Kelly, and midway through the following season, Kelly was replaced by Aldo Guidolin. The great Don Cherry took over for a year before being summarily dropped in favor of Billy MacMillan. MacMillan gave way first to Bert Marshall and then to Marshall Johnston during the team's last year in Denver, a six-year run that saw the team win a total of 113 games and fail to qualify for the playoffs each and every year.

In 1982, the Rockies were transformed into the New Jersey Devils, while the new and current Colorado Avalanche was born in 1995 when an American company, Ascent Entertainment Group Inc., bought the Quebec Nordiques and moved the franchise to the now outdated McNichols Sports Arena.

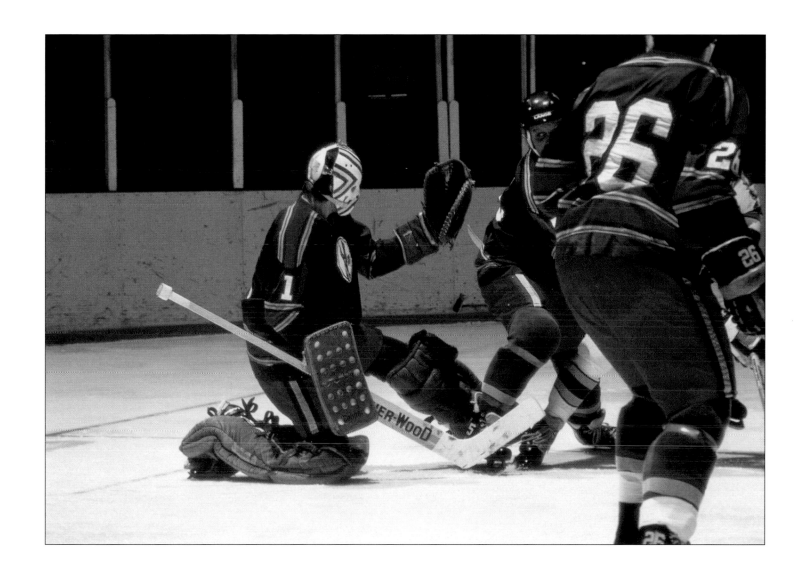

PLATE 7

ROGER CROZIER — A GOALTENDER'S DEMONS

PERHAPS THE GREATEST change in hockey in the last 30 years is the moral responsibility felt by the players who skate out before thousands of fans night after night. Morality is not a principle usually admitted into the hockey code, and yet, in Original Six days, morality, as much as the C-form or autocratic owners, was what kept the players motivated. To this day, Glenn Hall's habit of throwing up before each game is well known. He retired in the summer of 1966, only to come back for more a few months later. Terry Sawchuk left the game for a short time during the '56–'57 season because of nerves. Goalie Roger Crozier was cut from the same cloth.

He was playing in the minors as Chicago Blackhawks' property, but in 1963 he was traded to Detroit for Howie Young. At the time, the joke was that hockey's biggest headache (Young) was being traded for hockey's biggest stomachache (Crozier). Even in the minors, Crozier's ill health was common knowledge. But when he finally got to the NHL, he took the league by storm. He won the Calder Trophy in 1965 and the Conn Smythe the following year as his Red Wings lost the Stanley Cup final to Montreal. But his stomach troubles persisted and his glory faded over the next three years.

The story for the goalie was a familiar one: to win was merely doing your job, to break even in the eyes of the fans. To lose was cataclysmic. "It tears you up when you're not playing to your capabilities," Crozier admitted at the time. "It's humiliating. I wake up in the morning and I think about it. I can be doing something, anything, not related to hockey, and I think of it. It's just always there … you just can't imagine how bad I feel about the way I've been playing. I've let the team down. I've let [coach] Sid [Abel] down. I've let the fans down."

At the same time, Crozier was repeatedly felled by attacks of pancreatitis, limiting his playing time and eroding his confidence even further. The fire that burns within the goalie to make him so competitive is also the blaze that causes many of his problems. That love-hate, good-evil dichotomy is singularly applicable to the netminder who has no allies, no second chances, no safety valve, no tomorrow. That is both the magic of the position and the bane of the profession. Crozier once confessed as much: "I've hated this game for longer than I can remember. I had hoped that I would never come back. If I had had some lucrative business, there's no way I'd be here now." These are confessions not of a coal miner, but of an NHL superstar.

All these years later, Crozier's crease mandate is upsetting just to read: "The only way a goaltender can look good is to get a shutout," he said. "It's impossible to look good when a goal is scored against you, even if you didn't have a chance… the pressure's on you all the time." The pressure was as real to Crozier as he made it out to be. There were six teams, but only four playoff spots. Six goalies, each with a backup who stood to play at most ten games in 70 during the season. No masks, wicked slap shots, low-scoring games, 15,000 fans screaming, "what have you done for us lately?" all night long. Eighteen skaters, one goalie.

He died of prostate cancer at age 53. But then again, great goalers, it seems, tend to die young. Terry Sawchuk was only 40; Jacques Plante, 57; Turk Broda, 58; George Hainsworth, 55; Frank McCool, 55; Georges Vezina, 38; Lorne Chabot, 46; Alex Connell, 57; Bill Durnan, 57; Bruce Gamble, 44; Michel Larocque, 40; Roy Worters, 57. In the preexpansion days, the position created a heavy moral burden for the goalie — the desire to play well versus the obligation to produce results. Excuses are for minor leaguers. By the end of the night, being hit in the face by a shot was the least of a goalie's worries.

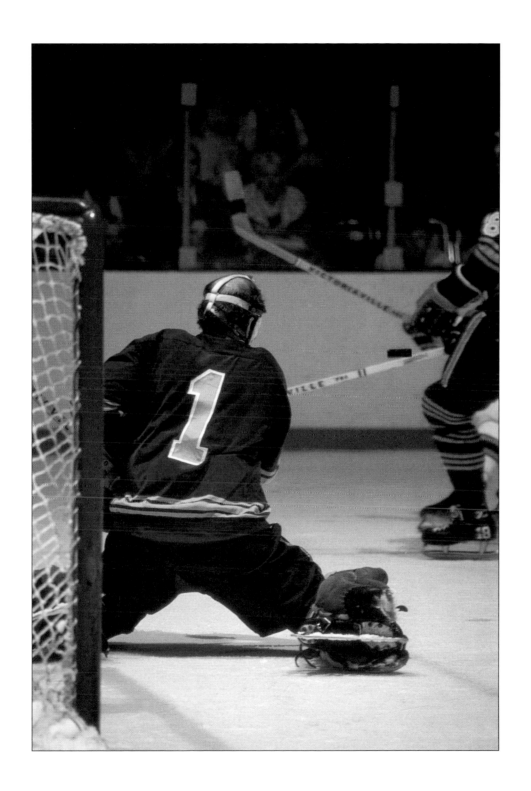

PLATE 8

ALEX DELVECCHIO AND THE HOCKEY HALL OF FAME INDUCTION

He was called "Fats" from early on in his career, not because of any weight problem but because of his round, cherubic face. By the time he retired from the NHL, his name graced the record books in many categories. He is one of only three men to play in the league for 24 seasons, Gordie Howe (26 years) and Tim Horton (24 years) being the others. He is second to Howe in career games played (1,767 to 1,549), and was Detroit's team captain from 1962–73. He won three Stanley Cups and three Lady Byng Trophies, and is one of a small group of players to be named to the All-Star team at different positions: In 1952–53, he was a second team All-Star at center, and in 1958–59 was again a second teamer, this time at left wing. He was inducted into the Hockey Hall of Fame in 1977, and therein lies another story.

The Hall opened in Toronto in 1961 and each year it hosted a ceremony for its newest Honoured Members. However, there was on occasion a difficulty with the induction, as this excerpt from a letter to the daughter of "Riley" Hern indicates; the letter informed her of her deceased father's induction in 1962:

> At the Canadian National Exhibition each year . . . there is a luncheon at which part of the ceremony is the presentation of the Crests for the new members of the Hockey Hall and Sports Hall.
> These I may say are Male affairs and the fair sex are not invited.
> Presentations are made to Living Members and in some cases to a near relative—if Male.

In 1966, this stag approach did not sit too well with one of that year's inductees, Delvecchio's longtime teammate Ted Lindsay. "Terrible Ted" began his career six years earlier than "Fats," in 1944, and he retired in 1965. They were teammates in Motown for eight years, and won Cups together in 1952, 1954, and 1955 with Howe, Red Kelly, and Terry Sawchuk, among others. Lindsay was team captain from 1952 to 1956, and his induction just a year after he retired put him in select company. Only Dit Clapper and Maurice Richard had had the then five-year waiting period waived in their honor. The "Male affair" business, however, upset Lindsay.

"I felt strongly that if my wife and children could put up with me when I was grumpy, they should share in any celebration," he explained. "My personality wasn't the greatest when we were losing, so I told them [at the Hall] if my family can't come, I'm not attending. And I didn't."

In the years that followed, those stag restrictions were of course eliminated, and wives often came up to Lindsay at later events to thank him for taking a stand in 1966. "I knew I did the right thing," he said with firm voice and honor.

One sentence from the Hall's letter to Delvecchio informing him of induction in 1977 reflects well the appropriate change in attitude:

> This is essentially a stag affair, but inductees are permitted to invite their wife, mother, and daughters if they wish.

In the 1990s, the Hall's induction is the highlight of the NHL's social year, and is attended by more than 1400 people, generally as many women as men.

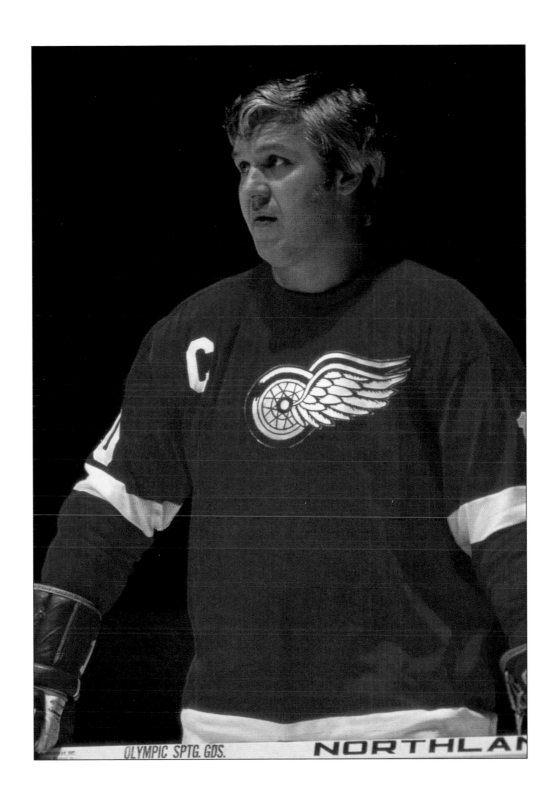

PLATE 9

MARCEL DIONNE WITH THE WINGED WHEELS

LONG BEFORE he was inducted into the Hall of Fame, before his No. 16 was retired by the Los Angeles Kings in 1990, before his six 50-goal seasons and seven of his eight 100-point seasons, before his 500th or 700th career goal or 1,000th career point, before all the statistical records he amassed, Marcel Dionne was, for four years, a member of the then-hapless Detroit Red Wings.

It was a turbulent, promising time, full of tempestuousness and glory. It ended in the worst player loss in Red Wings' history when Dionne was signed as a free agent by the Kings on June 23, 1975. As compensation, Los Angeles also received Bart Crashley but had to send three players to Detroit — Terry Harper, Dan Maloney, and a 2nd-round draft choice in 1976 (later traded to Minnesota — Jim Roberts.) The Wings missed the playoffs seven of the next eight years.

In his first year in the league, 1971–72, Dionne set a rookie record with 77 points, and into December of his second year, was leading the team in scoring after a great performance at training camp with Team Canada in preparation for the Summit Series. But after a poor showing at one early-morning Sunday practice, Dionne was sent home by coach Johnny Wilson and told not to return until he was serious about making a contribution. Believing his dismissal was to last the whole day, Dionne failed to show for the game that night and was immediately suspended.

The next year was even worse. On November 4, 1973, Dionne was again suspended by the team after going scoreless in the first 12 games to start a dismal season with a record of 2-9-1 for Detroit. The suspension was handed down, not coincidentally, while his agent Alan Eagleson was in China. Upon the Eagle's return, the message he delivered to Wings' GM Ned Harkness was loud and clear: "Either trade Dionne or lose him to the World Hockey Association." The suspension was lifted.

Things got better by the time the 1974–75 season rolled around. Harkness and Wilson had been fired and replaced by Alex Delvecchio as GM-coach, and on October 7, 1974, Dionne was given Sid Abel's prestigious No. 12 jersey and named team captain. Dionne justified the additional show of support by scoring 121 points, a team record and career high. As the season came to an end, he was set to become a free agent when his contract expired on June 1, 1975. Negotiations between Delvecchio and Eageleson turned nasty.

Under the Collective Bargaining Agreement (CBA) of the day, a free agent could sign with any team he wanted, but the two teams involved had to work out a trade within two days. If they couldn't agree on which players to exchange, an arbitrator would be brought in and he had to decide which of the two offers was the fairer. This was done to prevent the team losing a player from making extraordinary demands for the compensation, which would scare teams away from signing a star if it meant risking the loss of four or five regulars. That is what Eagleson claimed the Wings were doing to his prize client Dionne. So his counterstrategy was to begin talks with WHA teams, primarily the Edmonton Oilers.

In the end, Dionne preferred to stay in the NHL, and two teams — Toronto and Los Angeles — offered the most favorable package to Delvecchio's Wings. But when Detroit was adamant about taking Darryl Sittler and Ian Turnbull from the Leafs, Toronto GM Jim Gregory backed away from the negotiations, leaving LA (and five years for $1.5-million) the team for the man the Wings had dubbed "Little Beaver."

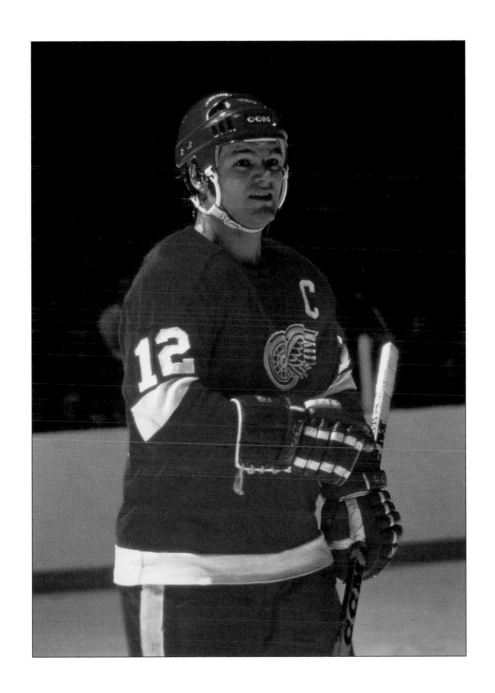

PLATE 10

JUDE DROUIN LOSES CONTROL

JUDE DROUIN was at the very eye of a storm on February 13, 1971 when he had a confrontation with referee Bruce Hood. In a game against Pittsburgh, Drouin became increasingly upset with Hood's interpretation of play which climaxed at 16:18 of the second period. Prior to a face-off, Drouin skated by Hood and commented, "You're like all the rest." Hood dared Drouin to repeat his words, which he did, and a misconduct was assessed.

This pushed Drouin over the top. He charged the referee and hit him on the shoulder with his stick before being restrained by North Star teammates. League president Clarence Campbell fined Drouin $150 and suspended hockey's samurai for three games, concluding, "assaulting an official is the most serious offense that anyone can commit in sports, and there can never be any justification or excuse for such conduct. Fines are completely inadequate in these circumstances."

Beneath the surface, the story was a bit more complex. The Stars had played the previous night and had been upset by the work of referee Art Skov during their 2–2 tie with Philadelphia. They became, as a team, equally riled by Hood's whistle-tooting efforts and felt his objectivity had been clouded by his having been in the press box the previous night.

Referee Hood recalled the incident in his 1988 autobiography *Calling the Shots: Memoirs of an NHL Referee*. In a chapter titled "Weird, Wonderful, and Wacky Games," he wrote:

> Jude Drouin had been acting up the whole night — a real pain in the neck — and had something to say every time I made a call. I had already warned him once and had no intention of putting up with more. We had a saying that carried over from the days when misconducts cost $25.00, that a player who is bothersome throughout a game uses up portions of it. Drouin had already spent $24.95.
>
> Later in the game, Pittsburgh scored on a power play. I was getting ready to drop the puck at center ice when he skated up to me and made some remark about how I and other officials were all the same. I asked him to repeat it, which he did. The remark in itself wasn't serious, but he had just spent his last nickel, and I gave him a misconduct.
>
> Drouin went crazy! He came charging at me with his fists clenched like he was going to hit me. His teammates intervened, so I don't know if he would have or not. He had spent the whole amount for a game misconduct and Drouin was gone. I went over to the penalty time-keeper to report it.
>
> Then Drouin came charging at me again, this time with his stick. The linesman stepped in his way, but he still managed to get in a pretty good blow that hit me on the shoulder. The other linesman also tried to restrain him, and finally his teammates dragged him away and off the ice.
>
> At the [disciplinary] hearing, Drouin agreed with the facts as I had reported them but said he hadn't been trying to hit me with the stick, just the glass close to me, and that the stick had slid down and struck me on the shoulder.
>
> He ended up with a fine and a three-game suspension, which was pretty hefty in those days.

PLATE 11

PHIL ESPOSITO — THE FORMATIVE YEARS

WHILE PLAYING for the Boston Bruins, Phil Esposito led a ritualistic life that would have frightened the Aztecs. He wore the same black tie every game day and drove to the Boston Garden from his home stopping at the same toll booth. In the dressing room, he would don his usual black turtleneck that he had first put on years earlier to help nurse a sore throat. He would then put on his equipment in exactly the same order every game. He put a pack of gum, and one single piece as well, beside him and arranged his accoutrements like this: a roll of white tape on top of a roll of black tape; gloves beside him, palms up, on either side of his stick; and the blade of his stick aligned with the thumbs of the gloves. During the national anthem, he recited a Lord's Prayer and a Hail Mary, prayed that his team played well, and that no one on either side got hurt. Then it was time to score.

Before he was a Bruin, he had been a Chicago Blackhawk for four years, and before that, he was Blackhawk property in the minors.

When Phil was 13, he tried out for the Algoma Contractors, a bantam team in Sault Ste. Marie, Ontario, coached by Angelo Bombacco. Esposito didn't make the team until the following year, by which time Bombacco, who scouted for the Blackhawks, realized Espo could be the best of the best one day. When it was time, in 1960, he contacted Chicago's chief scout Bob Wilson and arranged a tryout for the 18-year-old Espo with the St. Catharines Teepees, the Hawks' OHA affiliate. At the end of camp, the Hawks asked Phil to play for the Sarnia Legionnaires in Junior B, a league below, a cut below, a grade of quality below the vaunted Junior A Teepees. St. Catharines' coach Rudy Pilous left Esposito with these words of encouragement: "Hey, fatso! Get down to 200 pounds by the start of next season and you make the team." In the fall of 1961, he weighed exactly 196 pounds and made the team.

As a Junior A amateur, Esposito apprenticed in St. Catharines with future greats Roger Crozier, Dennis Hull, Fred Stanfield, and Ken Hodge. At the end of the '61–'62 season, he played six games in the EPHL (Eastern Professional Hockey League), the exact number needed to invalidate his amateur status. He was now officially on his way to a career as a professional hockey star. At training camp in 1962 with the NHL Hawks, however, Espo was not impressive, recovering slowly from a wrist injury and playing himself into the minors. He wound up skating for the next year and a half with the St. Louis Braves in the Eastern League.

One day, while still with the Braves, he got called up by the Blackhawks who told him to be in Montreal for the Chicago-Habs game. Fortunately, the number seven he had always worn since before his days in the Soo was available with the big team. Nine days later, he scored the first of his career 717 goals against the great Terry Sawchuk of Detroit. He would never again play in the minors, and after 3 ½ seasons in the Windy City, he was part of one of the most one-sided trades in the history of the game. On May 15, 1967, he was sent to Boston with Ken Hodge and Fred Stanfield for Gilles Marotte, Pit Martin, and Jack Norris.

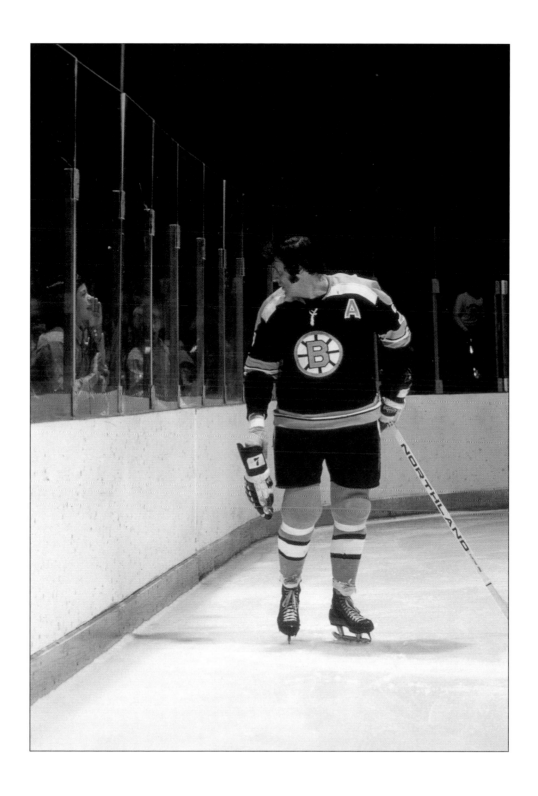

PLATE 12

PHIL ESPOSITO BECOMES A BLUESHIRT

BECAUSE OF HIS stature in Boston as the most prolific scoring threat in the history of the team, the two trades in which Espo was involved, one near the beginning and the other toward the end of his career, helped shape the NHL in the 1970s. After four years of Original Six hockey with the Chicagos (1963–67), the Hawks traded Esposito with Ken Hodge to the Bruins on May 15, 1967 for Pit Martin, Gilles Marotte, and Jack Norris (see Plate 12). The trade gave the Bruins two forwards who could score and, with Bobby Orr, helped make the team a Stanley Cup champion.

From 1967 to 1974, the Hawks made it to the finals twice, losing both times to the Montreal Canadiens (in 1971 and 1973), while the Bruins won the Stanley Cup in 1970 and 1972 and lost in the 1974 finals to the thug-studded Flyers. In 1970–71, the Bruins accomplished something no other team had or has ever done — they placed the first four scorers in the race for the Art Ross Trophy: Esposito had 152 points, Orr 139, Johnny Bucyk 116, and Hodge 105. And they did it again in 1973–74.

But by 1975, the era of the Big Bad Bruins was playing its endgame. The Flyers had won the two previous Cups, Orr was to miss most of the season with another debilitating knee injury, and the Canadiens were becoming the dominant team on the cusp of a four-Cup roll of their own. Beantown GM Harry Sinden wanted a rushing defenseman to replace Orr and thought immediately of Brad Park. Ranger GM Emile Francis said Park was available, but the asking price was Espo. On November 7, 1975, Sinden made *the* trade of the 1970s, sending Esposito and Carol Vadnais to the Rangers for Park, Jean Ratelle, and Joe (the trivia answer) Zanussi.

The trade worked, in part, for the Bruins as they finished first in the Adams Division the next four years. For Phil the Great, the story wasn't so happy. The Rangers finished dead last the next three seasons and second last in 1978–79 in the Patrick Division. Now, instead of having remarkable passing wingers such as Wayne Cashman and Ken Hodge, Espo found himself in the middle of Rod Gilbert and Steve Vickers, scorers in their own right who wanted to *receive*, not give, the passes.

To make matters worse, Esposito arrived in Manhattan only to see Gilbert, in his sixteenth year as a Broadway Blueshirt, wearing the valued No. 7. Espo had to choose another number for the year, the unfamiliar No. 12, and for the start of the 1976–77 season, he donned No. 77. He retired abruptly on January 9, 1981, a decision made not just because of age and loss of touch, but also due to emotional drain.

It was only the previous day that he made the career-ending announcement at the posh 21 Club in Manhattan. He had been considering the move ever since he began to find it difficult to play for fun. "After the Islanders game last Friday [a week ago], I said to myself, 'if I can't get up for all the games the way I could get up for this one, and I wasn't having much fun, I should retire,'" he explained. "When I was down — and I was down a lot more than I was up this season — the energy wasn't there like it always used to be."

Retirement night against the Sabres ended in a 3-3 tie. The stands were chock-full of hockey's luminaries — President John Ziegler, Gordie Howe (who presented Espo with a No. 77 jersey in a pregame ceremony), brother Tony, and many former Bruins teammates. At game's end, organist Ashley Miller played *Auld Lang Syne*. Esposito skated out as the fans roared his name. He dropped a puck onto the ice, shot into the empty net, and then gave the puck to his dad. Parting was such sweet sorrow.

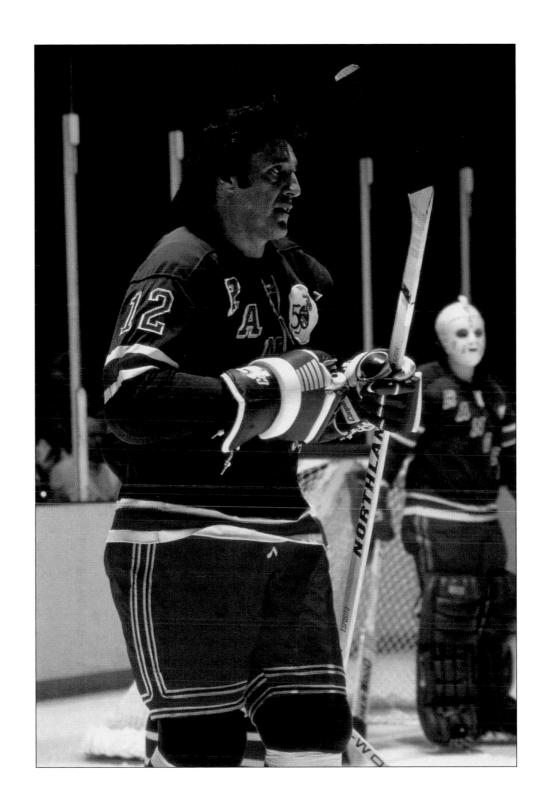

PLATE 13

TONY ESPOSITO — CHANGING TEAMS

TONY O RECEIVED a scholarship to Michigan Tech after his one and only season of Major Junior A hockey with his hometown Soo Greyhounds. After graduating, he was assigned to play with Vancouver of the WHL (coached by Jim Gregory). Then he was moved to Houston of the CHL, the sibling franchise of the Montreal Canadiens, the NHL team that owned his rights.

Esposito played 13 games with the Habs in 1968–69, enough to get his feet wet in hockey's deepest waters but not enough to disqualify him the following year as a dry rookie. He had been given this chance to play as a result of injuries to regulars Gump Worsley and Rogie Vachon, and went 5-4-4 with two shutouts during his brief stay with Montreal. On June 11, 1969, however, Hab GM Sam Pollock made a rare and significant mistake. In the annual Intra-League Draft, he protected goalies Worsley, Vachon, and Phil Myre and left 26-year-old Esposito unprotected. Chicago pounced.

That Espo was claimed by the Hawks was ironic given that two summers earlier, they had traded his brother Phil to the Bruins in one of the worst trades in Chicago team history (see Plates 12 and 13). Tony lasted a bit longer, winning the Calder and Vezina Trophies his first year, and accomplishing everything during his career but the forever elusive Stanley Cup win.

That he was available in the Intra-League Draft dispels the notion most people have that Original Six hockey meant players would stay for 10 to 15 years with one team. Yes, this certainly happened, and much more than it does today, but player movement was by no means severely restricted. In the "old days," a team could sign any player it wanted to a contract (a C-form), and once signed, that man could not voluntarily play for any other team.

The Intra-League Draft, though, was one way of making sure that the best players in the country were always playing in the NHL. No matter how many players a team had under contract, if they were of professional quality, the team had to play them or risk losing them to the draft. Much as in today's Waiver Draft, a team could only protect so many players each year. In other words, if a team had signed Worsley, Plante, Hall, Esposito, Sawchuk, and Cheevers to contracts, it could only protect three in the Intra-League Draft. Acquiring talent was considerably easier than hoarding it. Over the years, many great players — more often goalies — were lost by a team this way. The reason many great players didn't make it to the NHL was that there were only six teams and 120 spots to fill on the collective rosters.

For example, Toronto drafted Terry Sawchuk from Detroit in 1964. The next summer, the Leafs lost Cheevers to the Bruins and Pat Stapleton to Chicago. In many cases, players who were in the minors because their NHL teams were so deep in talent were then claimed by weak NHL teams and got the chance to play in the bigs. Sometimes it was a case of a player on his last legs being given one final shot; other times it was a young, unproven talent that one team was willing to gamble a look on. But all in all, it fostered player movement more than is generally realized by today's generation of nostalgia-seeking fans. In fact, of the 209 men who have played more than 15 years in the NHL since 1917, only 29 played with just one team.

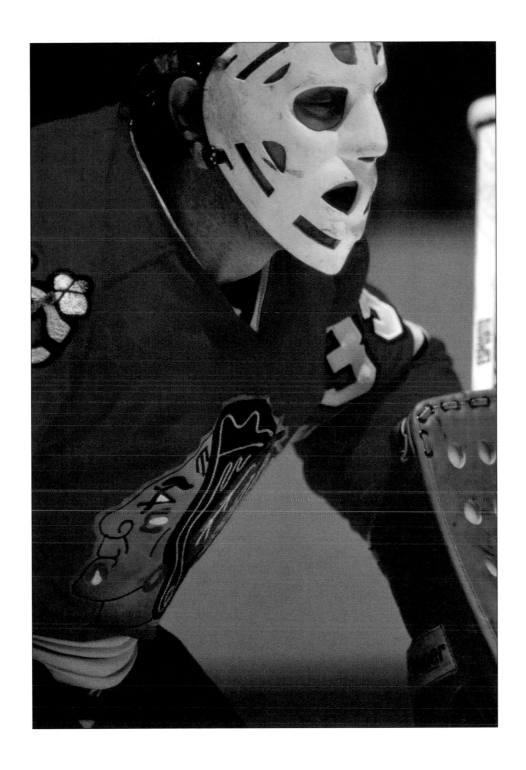

PLATE 14

DOUG FAVELL REPLACES BERNIE PARENT

DOUG FAVELL was acquired by the Leafs from Philadelphia on July 27, 1973 with a 1st-round draft choice (Bob Neely) for the rights to Bernie Parent and a 2nd-round draft choice in '73 (Larry Goodenough). The key to the deal was the phrase "rights to," for in trading away Bernie Parent, the Leafs began a prolonged downward spiral even while they were assembling a very good hockey team that would peak in the late seventies before collapsing altogether in the eighties.

With the arrival of the WHA in 1972, the NHL had to accept the fact that salaries were going to rise and that competitive (some would say exorbitant) bids were being offered the players by the "pirate" league. No team was more adversely affected than Toronto. Its tyrannical, obstinate, and ultimately criminally unsuccessful owner Harold Ballard refused to acknowledge the existence of the other league.

Parent had been acquired by the Leafs on February 1, 1971 from the Flyers with a 2nd-round draft choice in '71 (Rick Kehoe) for goalie Bruce Gamble, forward Mike Walton, and their 1st-round draft choice in 1971 (Pierre Plante). It was perhaps GM Jim Gregory's finest trade. Parent was on his way to becoming a world-class goalie, and he was arriving in Toronto to be tutored by the man whose style he was learning — Jacques Plante — in the twilight of Plante's career.

By the end of the 1971–72 season, Parent began receiving serious, big-money WHA offers. However, Leaf czar Ballard refused to believe Parent would leave the Leafs or the NHL for some league that existed more in name than game. He was dead wrong. Parent became insulted and then by degrees incensed by the Leafs' refusal to talk contract, and as the Miami Screaming Eagles continued to pursue the goalie, the Leafs continued to deride the nonexistent franchise. When the Eagles relocated to Philadelphia, they offered Parent a contract he couldn't refuse and one Toronto wouldn't match. Parent signed and the Leafs got nothing.

That summer, an incredible 12 players left the Leaf organization to join the WHL: Parent, Jim Dorey, Rick Ley, Brad Selwood, Steve King, Gavin Kirk, Guy Trottier, Rick Cunningham, Doug Brindley, Jim Harrison, Bob Liddington, and Ken Desjardine. In future years, the Leafs also lost longtime captain Dave Keon as well as Paul Henderson, Mike Pelyk, Blaine Stoughton, Dave Dunn, Lyle Moffat, and many, many others.

After one season in the WHA, Parent announced his desire to return to the NHL with the stipulation that he would never again play for the Leafs, so insulted was he by Ballard's egregious treatment of him the previous year. While in the WHA, his NHL rights were worthless, but now that he wanted to return, his stock had some value. Leaf GM Gregory, though, had no choice but to trade Parent if he hoped to get something for the goaler. Thus, as in the earlier trade, the Leafs swapped Philly goalie for goalie and got Favell, who wound up playing just 74 games over three seasons with the Leafs. Parent, meanwhile, won back-to-back Stanley Cups and Conn Smythe Trophies (the first goalie to do so) and is currently enshrined in the Hockey Hall of Fame — in Toronto.

But, then again, Favell's mask, which debuted September 17, 1973 and was painted by Flyers' trainer Frank Lewis, is also in the Hall of Fame.

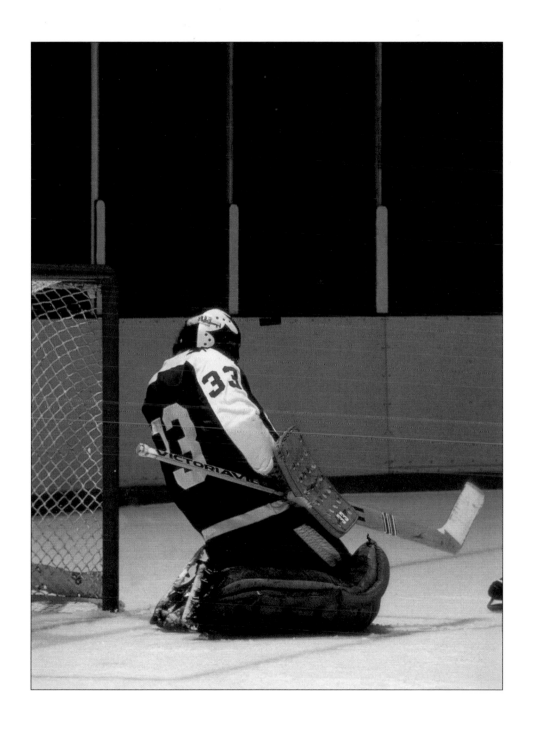

PLATE 15

BOB GAINEY AND THE SELKE CONNECTION

T HE FRANK J. SELKE TROPHY was introduced by the NHL's board of governors in the summer of 1977. It was to be awarded for the first time the following spring "to the forward who best excels in the defensive aspects of the game." It honored a man — Selke — who had given his life to the game and who was one of the most successful builders in the history of the NHL. Selke began his career working with Conn Smythe in Toronto, and when the Hollerin' Major went off to war, Selke took over as general manager of the Leafs and of Maple Leaf Gardens. Upon Smythe's return, it was clear that one team was not big enough for the two superb hockey minds, and in 1946 Selke went to Montreal. Between then and his retirement in 1964, Selke led the Habs to five Stanley Cups and was inducted into the Hockey Hall of Fame in 1960.

The Selke Trophy was also a watershed in NHL honors in that it did not cater to the "bigger, stronger, faster" mentality or to tangible elements such as goals and assists. Rather, it acknowledged that defending against the best on the other team was a worthy and valuable skill in itself. The point of the trophy was epitomized by Bob Gainey. Those who moved in NHL circles often said the trophy was made with him in mind, but the qualities of his game really focused attention on the skills behind winning the trophy. In the old days, one might argue, *every* player had to be exceptional when a scoring chance presented itself and just as good at getting back to prevent a like chance against one's own goal. But with expansion, rushing defensemen, offense records, statistics, and big contracts on everybody's mind, the need to pay homage to a lost art became increasingly important. Gainey could score, but he was even better at preventing opposing forwards from doing likewise. It was during the 1979 NHL playoffs that visiting Russian national coach Victor Tikhonov proclaimed: "Bob Gainey would have to be rated as technically the best hockey player in the world today." Offense and defense *do* great bedfellows make.

The award is voted on by the Professional Hockey Writers' Association (PWHA), using a simple first-second-third place system: first place was worth five points; second, three: and third, one. In 1978, a total of 30 players received at least one vote. Gainey received a total of 159 points, followed by: Craig Ramsey, Buffalo, 79 points; Don Marcotte, Boston, 60; Bobby Clarke, Philadelphia, 28; Don Luce, Buffalo, 20; Walt Tkaczuk, Rangers, 19; Doug Jarvis, Montreal, 16; Bill Clement, Atlanta, 14; Clark Gillies, Islanders, 13; Ross Lonsberry, Philadelphia, 12; Billy Harris, Islanders, 7; John Marks, Chicago, 6; Terry O'Reilly, Boston, 6; Gary Dornhoefer, Philadelphia, 5; Jean Ratelle, Boston, 5; Bryan Trottier, Islanders, 5; Ron Ellis, Toronto, 3; Bob Kelly, Philadelphia, 3; Danny Gare, Buffalo, 3; Darryl Sittler, Toronto, 3; Paul Woods, Detroit, 3; Butch Goring, Los Angeles, 3; Grant Mulvey, Chicago, 3; Ed Westfall, Islanders, 2; Lanny McDonald, Toronto, 2; Doug Risebrough, Montreal, 2; Nick Libett, Detroit, 1; Red Berenson, St. Louis, 1; Ted Bulley, Chicago, 1; Bob Nystrom, Islanders, 1; Jacques Lemaire, Montreal 1.

Interestingly, a team-by-team breakdown of vote-getters suggests an inconsistency among the vote givers. The Islanders, for instance, had *five* different forwards nominated for best defensive player! The Habs and Flyers both had four, and Buffalo, Boston, Chicago, and Toronto all had three. That's an inordinate number of defensive specialists in the eyes of the writers. Importantly, the names of the members of the PWHA who vote on the award, and the players each writer votes for, remain strictly confidential.

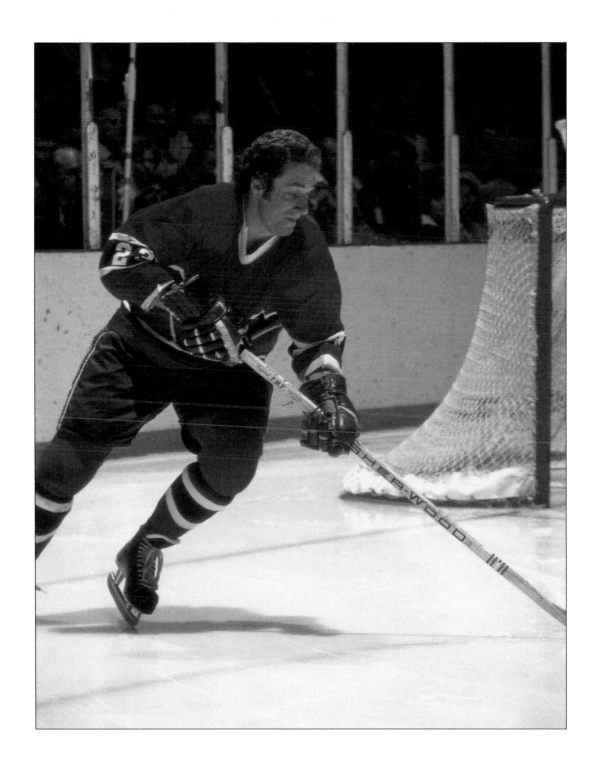

PLATE 16

ED GIACOMIN TAKES AND LEAVES MANHATTAN

ED GIACOMIN was among that generation of goalies who began his career playing without a face mask but later adopted one in mid- to late-career. He played his first game with the Rangers in 1965 but did not wear a mask until the start of the 1970–71 season. Early the following year, he was hit point-blank by a Dennis Hull shot. He went down, arms akimbo, literally shot by the shot, and suffered a deep gash from the mask being drilled back into his nose by the puck. A bandage was put on, and he won the game 4–1.

On another occasion, Dennis's Golden brother Bobby cut across the crease after Giacomin left a rebound while making a sprawling save. Hull skated over Eddie's glove, cutting both the leather and the goaler's hand. Giacomin refused to leave the game, so Ranger trainer Frank Paice put a bandage on. During the intermission, the hand was stitched properly. "It made me sick to look at it," confessed teammate Brad Park. "The bandage kept coming loose and Eddie's glove was all bloody. The cut must have been a quarter-inch deep and the skin was ripped and hanging loose."

Overcoming physical adversity was one quality that helped Giacomin become the Iron Man he was in the late sixties and early seventies. Growing up in Sudbury, Giacomin suffered a frightening, life-threatening injury. His kitchen stove blew up in front of him and he suffered second- and third-degree burns to his legs and feet. Skin grafts were needed, and for a full year his legs were in bandages.

While working as a mechanic in the day and playing hockey at night, Giacomin got his big break through his brother. When Rollie was called up by Washington to play goal in the Eastern League in 1959, he declined the invite and sent younger brother Ed in his stead. He must have impressed somebody because the next year, Ed was bought by the Providence Reds of the AHL, thus ensuring his NHL rights were owned by the Red Wings. Detroit had little interest in him, but Rangers GM Emile Francis knew a good goaler when he saw one (he looked at one every morning in the mirror). He acquired Giacomin from the Reds for four players — not minor leaguers, mind you, but NHLers. Jim Mikol, Sandy MacGregor, Aldo Guidolin, and Marcel Paille were on their way to Providence, and Fast Eddie was Broadway-bound.

Giacomin became renowned for his perambulations from the net which both enthralled and terrified his fans. He became the first goaler to record two assists in a game — on March 19, 1972 against the Leafs — and once hit the post with a shot late in a game with the enemy net empty. He became the all-time shutout leader for New York with 54. But perhaps the truest testimony to his popularity as a Blueshirt came *after* his Ranger days were over.

As the saying goes, what goes around comes around, and though Giacomin was beholden to Francis for bringing him to the NHL, it was also Francis who put the 36-year-old on waivers on October 31, 1975. The Red Wings claimed him for the $30,000 waiver price, and Giacomin finally was going to play for the team that had first owned his NHL rights some 15 years earlier. Unfortunately for Francis, Detroit's next game was against the Rangers at Madison Square Garden. Giacomin stopped 42 of 46 shots and the Wings won 6–4. Literally all night long, the fans chanted "Eddie! Eddie!" by way of thanks for the memories, and the Ranger players wished him their best during action around the net. After scoring, one Ranger, whom Giacomin refused to identify, even apologized for his small transgression in Eddie's homecoming!

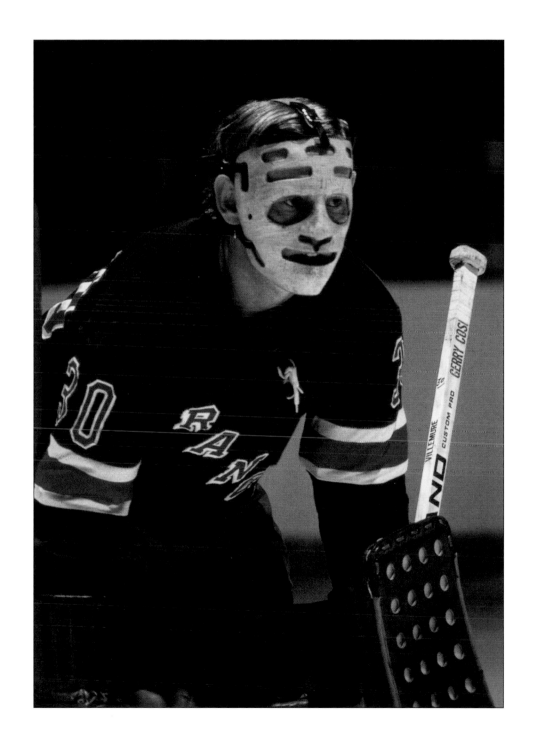

PLATE 17

LLOYD GILMOUR — AN OFFICIAL'S STORY

FEBRUARY 4, 1975 saw the Leafs beat the Blues 5–3 in St. Louis. A number of points of anecdotal history can be gleaned from this game and image. Leaf defenseman Claire Alexander sat in the penalty box three times, once for his own infraction, once to serve goalie Doug Favell's penalty, and a third time to serve a bench minor! Tiger Williams had a Gordie Howe kind of night — scoring once, getting an assist, and fighting twice. Half of his contributions came in the first minute of the first period. The Tiger scored just 27 seconds into the game, and then at 1:07, Pierre Plante crashed the Leaf goal and bowled over Favell. When Plante got up, Williams greeted him with a scowl, and in the ensuing melee, Darryl Sittler fought Floyd Thomson before referee Lloyd Gilmour restrained the future Leaf captain (pictured here).

This fight was nothing compared to the brouhaha Gilmour had to adjudicate the afternoon of January 11, 1976 in Philadelphia for the historic game between the Flyers and the Moscow Red Army team. The Flyers were at the height of their Broad Street Bullies powers and were winning the game in the alley and on the scoreboard. Flyer defenseman Ed van Impe took a run at the Army's star Valeri Kharlamov when Russian linesman Yuri Karindin skated over and told the fallen idol to stay down to draw the penalty. Matt Pavelich, the other linesman, heard and understood the Russian exchange and conveyed the message to the man with the orange armband. Gilmour called a delay-of-game penalty on the Soviets. Coach Victor Tikhonov then pulled his team off the ice while *Hockey Night In Canada* commentator Bob Cole reeled with stunned amazement, "They're going home! The Russians are going home!"

It wasn't until after NHL president Clarence Campbell threatened to withhold payment to the Russians that the team returned, but by the time the 5–1 Flyers' win was in the books, the result was overshadowed by the drama of the Red Army leaving the ice in the first period.

The last chapter in referee Gilmour's hockey career is an interesting one: he became a color commentator for Vancouver Canucks' telecasts. His is one name in a very short list of zebras who stayed in the game after hanging up his whistle, and one of a very few to combine reffing with a related hockey endeavor. In hockey's early days, Lou Marsh used to referee NHL games and then write a column the same night for the *Toronto Telegram*. Impartiality on the ice led to honest, though by nature subjective, opinions in his reports and columns. Red Storey wrote for the papers in Montreal after retiring as a referee. But it was more common for a player (i.e., King Clancy) to go on to become a referee than for a ref to do something else.

Gilmour is perhaps only the second ref to continue in the game as a commentator (the first was Bill Chadwick), but it's odd that more haven't. After all, officials know a great deal about the game and are trained to be objective. Ironically, though, a referee's unbiased color TV comments become, to some extent, biased as soon as he utters them, for he is then commenting on that which he, as a ref, shouldn't. However, Gilmour did not shy away from defending the very nature of player-referee relations: "We wind up in the same hotels and on the same planes sometimes. We're in the same business. We talk shop …. If a referee can't be trusted to make the right calls impartially on players he knows, he doesn't belong in the profession."

PLATE 18

WAYNE GRETZKY AND THE OILERS —
WELCOME TO THE 1980S

IN THIS PICTURE, "The Great One" looks like no one so much as Diana, Princess of Wales.

After playing minor hockey with Toronto Young Nationals, Gretzky played 1977–78 with the Sault Ste. Marie Greyhounds, his only full season in junior hockey. It was a mixed year for him and the Soo. He won the William Hanley Trophy as the Most Gentlemanly Player, the Emms Family Award as the Rookie of the Year, and set an OHA record for most points by a rookie with 182 (70 goals and 112 assists). But he wasn't the league's leading scorer. That honor went to Bobby Smith, with 192, and the Greyhounds didn't even make the playoffs, finishing fifth in the Leyden Division with a 26-32-10 record.

For 1978–79, the 17-year-old Gretzky signed with the Indianapolis Racers of the WHA. He was clearly ready for life beyond junior but still had more than two full years to wait before becoming eligible for the NHL Draft (which, at the time, set 20 as the minimum age). Since the WHA had no age restriction, he signed a personal services contract with Racers' owner Nelson Skalbania.

Skalbania, however, was losing money big-time, and his Racers weren't exactly packing the 16,500 seat Market Square Arena in Indianapolis. Gretzky was sold on November 2, 1978 to Peter Pocklington, owner of the Edmonton Oilers, along with Peter Driscoll and Ed Mio for $800,000, arriving in a city that was thriving and poised to join the NHL the following season. Gretzky registered 110 points between the two WHA clubs in his only pre-NHL pro season. (The Racers folded six weeks later.)

It seems ridiculous to think that Wayne Gretzky, holder of so many records, who has accomplished so very much, is now in the twilight of his career, and that we look back at what he has done not in a sense of year-end summary or review, but in a larger perspective. Some say he was lucky to have played in an era of offense, while others call him one of the greatest ever to play the game. What is undoubtedly the case, however, is not that he played during an offensive boon, but that he and his teammates *created* that boon. Granted, goaltending is better in the 1990s than it was in Gretzky's heyday, and defensive play is now paramount, but against the Oilers, it was tough to play the trap when the team was down 3-0 after five minutes of play. And, of course, when you opened up to try to get back in the game, it was 6-1 by the end of the second period.

In 1978–79, the last year before the Oilers joined the NHL, the Islanders led the league with 358 goals. In the next five years, Edmonton scored 301, 328, 417, 424, and an incredible 446 goals in 1983–84. In '78–'79, the entire league scored 4757 goals, and in '83–'84, that number shot up to 6627. The wide-open league was led by the Oilers who boasted Gretzky, Jari Kurri, Mark Messier, Glenn Anderson, and Paul Coffey — phenomenal offensive talents all.

Along the way, Gretzky scored numbers that now seem as impossible as they would have if someone suggested they could be reached before he joined the league. Recall that in 1981–82 he scored 92 goals, shattering Phil Esposito's decade-old previous record of 76. On four occasions, he scored more than 200 points in a season, surely a record that can't be broken. He has 50 career hat tricks. In 1983–84, he scored a point in 51 consecutive games, a record likened to Joe Dimaggio's 56-game hit streak in baseball, not just for the achievement but also for the closeness of the numbers. He scored his 1,000th point in just his 424th career game, and his 500th goal in his 575th game. Remarkable numbers, all.

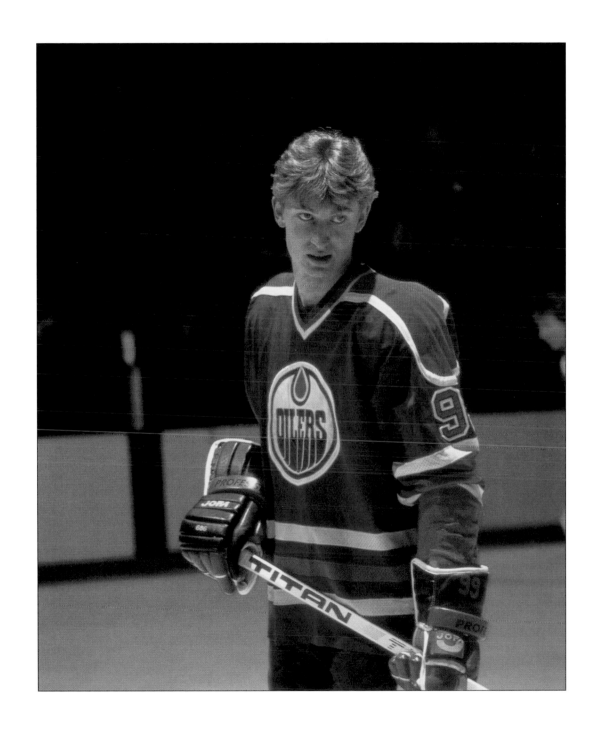

PLATE 19

GLENN HALL RELENTS

LIKE MANY GOALIES in the mid- to late-1960s, Hall wore a flimsy plastic mask in practice. But he did not move to full protection in actual games until the 1968–69 season — his second with the expansion St. Louis Blues and seventeenth in the NHL. One problem with the plastic mask, as explained by Johnny Bower, was that it fogged easily. When the China Wall played for Cleveland in the AHL, he wore what was called a St. Mary's mask in practice. It was really a glorified welder's mask but because of its construction, it fogged too much for him to wear in games.

Another more serious concern was that if it cracked upon impact, the goalie's face would be badly cut, as happened to Roy Edwards during his early days in Detroit. Later, Edwards became the first to incorporate a helmet with the mask.

Hall's game mask was made by Seth Martin, a teammate in St. Louis the previous year, a member of Canada's 1964 Olympic hockey team, and easily the most famous Canadian player on the international hockey scene. "It was different in the early days," Hall recounted, "because it was hard to find people who could make masks. Lefty Wilson made my practice one — he made one for Sawchuk as well — but companies weren't willing to do something for maybe a hundred goalies in the country." Manufacturers weren't about to go to the expense of making a piece of equipment that would be worn by so few. It was simple supply and demand.

Hall adopted the mask primarily to protect his eyes but found that there were disadvantages as well as advantages in wearing one. "I didn't trust it," Hall confessed. "I was just as frightened with it on as with it off. And I opened the eyes [i.e., made the eye holes bigger] because it affected my peripheral vision, which was so important to being a good goalie." Bower concurred: "I had problems seeing the puck around my feet," he recalled, "so I had to work a lot more with my defensemen. They'd say, 'Don't move! The puck's in your feet!' because it was hard to tell sometimes where it was."

Hall was wearing a mask at the time the big booming slap shot was just coming into vogue, thanks largely to Bobby Hull and a new crop of strong players that included Rod Gilbert and Vic Hadfield. "Bobby always had the guys [goalies] hitching a little bit … he was very intimidating, and it worked," Hall admitted 30 years later. "It was always the puck we were most concerned about. The mask's intent was to protect the eyes. They could stitch you up and do a lot of other things, but an eye injury was career ending."

Unlike Bower, Hall never had trouble finding the puck close to his feet. "I didn't have to count pigeons in the arena, just keep the puck out. I kept my head down anyway, so I didn't have to change my style at all." Edwards concurred: "I find the mask helps me when the puck is flopping around between skates and sticks in front of the net. I don't feel as hesitant about diving in to grab it." Bower agreed: "I wasn't afraid to dive around or do the poke check, and I didn't worry about a player coming over me with his skate. But sometimes I eased up with the mask, and bang! I'd get hit in the collarbone. Two or three times I had a cracked collarbone."

Not Glenn Hall. During the three years he wore a mask, he doesn't recall getting hit badly once!

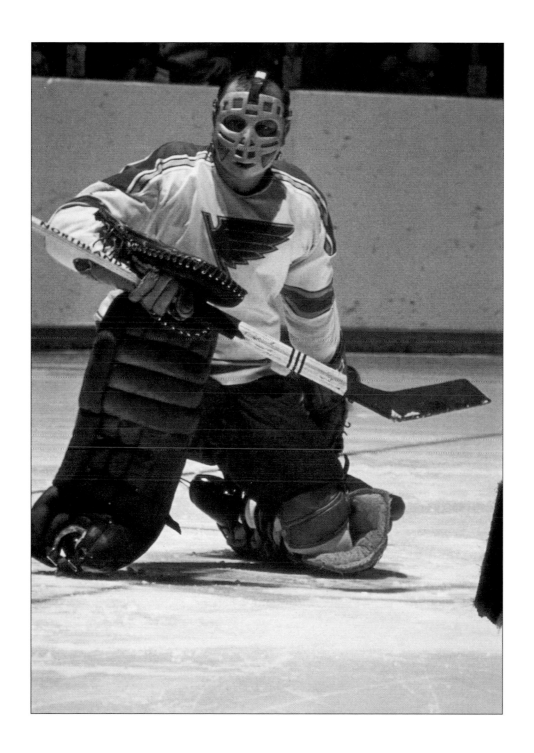

PLATE 20

GLEN HANLON — GOALIES IN THE DRAFT

THIS PHOTOGRAPH of Glen Hanlon was taken near the start of the 1980–81 season. Over the course of the schedule, 17 goalies played more than 40 games in the NHL for their teams during that 80-game season: Don Beaupre (44 games, Minnesota), Dan Bouchard (44 games, Calgary and Quebec), Richard Brodeur (52 games, Vancouver), Jiri Crha (54 games, Toronto), Don Edwards (45 games, Buffalo), Tony Esposito (66 games, Chicago), John Garrett (54 games, Hartford), Gilles Gilbert (48 games, Detroit), Mario Lessard (64 games, Los Angeles), Mike Liut (61 games, St. Louis), Greg Millen (63 games, Pittsburgh), Ed Mio (43 games, Edmonton), Mike Palmateer (49 games, Washington), Pete Peeters (40 games, Philadelphia), Chico Resch (40 games, Islanders and Colorado Rockies), Billy Smith (41 games, Islanders), and Rogie Vachon (53 games, Boston).

These 17 goalies were clearly the most important players on their team. They were relied on for half of the season or more, and in the 21-team NHL, just about every club had a number-one man who played the bulk of the games.

Every general manager will admit the cardinal rule of success is to build from the goal out. First, you need a guy in net who can steal a win for you every time he straps on the pads. Then you need a solid defense that can support the goalie. Only then is scoring of paramount importance. Defense wins Stanley Cups, and the best defense begins in goal. Here's the incredible part. Of these 17 on the above list, not one was drafted into the NHL in the first round, and most were drafted so low that if even *one* had made the NHL as a backup, it would have seemed like a miracle. Beaupre went 37th overall, Bouchard 27th, Brodeur 97th, Edwards 89th, Garrett 38th, Gilbert 25th, Lessard 154th, Liut 56th, Millen 102nd, Mio 124th, Palmateer 85th, Peeters 135th, Smith 59th. Glen Hanlon was selected 40th overall by Vancouver in 1977, and Glen Resch, who played 14 years in the NHL and won a Stanley Cup, was not drafted at all! Any team that was prepared to give him a tryout was free to do so. Crha defected from Czechoslovakia, Vachon's rights were owned by Montreal from predraft days, and Esposito was left unprotected in the Intra-League Draft by Montreal.

The truth is that before or since this arbitrary year of analysis, goalies have never been given their due on draft day. Grant Fuhr was selected an amazing 8th overall by the Oilers in 1981, and Tom Barrasso, 5th by Buffalo in 1983. But Curtis Joseph, Glen Healy, Jon Casey, and Ed Belfour followed in the ignominious footsteps of Resch and were not even drafted at all! Many of the biggest goalie names in the NHL since the Amateur Draft began in 1969 were taken insultingly low. Dominik Hasek was taken a preposterous 199th at the 1983 Draft, Martin Brodeur was selected 20th by New Jersey in 1990; Sean Burke, 24th in 1985; Ron Hextall, 119th by the Flyers in 1982; Nikolai Khabibulin, 204th in 1992; Kirk MacLean, 107th in 1984; Chris Osgood, 54th in 1991; Felix Potvin, 31st in 1990; Patrick Roy, 51st in 1984; John Vanbiesbrouck, 72nd in 1981; and Bill Ranford, 52nd in 1985.

When the Islanders selected Robert Luongo fourth overall at the 1997 draft, it marked the highest selection ever used to choose a goalie. The attitude is patently clear: the draft is not for acquiring goaltending. It's for acquiring the franchise forward, the scorer, the big, dominant, good-looking marquee player (see Plate 55). A top-flight goalie can always be acquired through trade, somehow. He might well turn out to be the franchise player, but his bailiwick is the goal crease, not the draft.

PLATE 21

GERRY HART — SCOUTING FOR A CUP

GERRY HART was an Islander original, selected by the new New Yorkers on June 6, 1972 at the Expansion Draft. Of those original 21 players chosen, only Hart and Billy Smith were around when the Islanders won their first of four successive Cups in 1980. The Isles took goalies Gerry Desjardins and Smith and a mostly anonymous group of skaters: Bart Crashley, Dave Hudson, Ed Westfall, Gary Peters, Larry Hornung, Brian Lefley, Brian Spencer, Terry Crisp, Ted Hampson, John Schella, Bill Mikkelson, Craig Cameron, Tom Miller, Brian Marchinko, Ted Taylor, Norm Ferguson, Jim Mair, Ken Murray — and Hart.

They selected Neil Nicholson, Don Blackburn, Conley Forey, and Dennis Kassian in the Inter-League Draft. Fourteen more players were chosen in the Amateur Draft: Billy Harris (first overall), Lorne Henning (17th), Bob Nystrom (33rd), Ron Smith (49th), Richard Grenier (65th), Derek Black (81st), Richard Brodeur (97th), Don McKaughlin (101st), Derek Kuntz (113th), René Lavasseur (117th), Yvan Rolando (129th), Bill Ennos (133rd), Garry Howatt (144th), and René Lambert (146th). Of all these, only Howatt won the 1980 Cup, and only Billy Smith won all four Cups from 1980–83.

However, most of these players stuck with the Islanders for a number of years, a powerful testament not just to their abilities, but to the superb advanced scouting reports the Isles brought to the various draft tables that inaugural summer. The team's head scout was Ed Chadwick, and his associates included Henry Saraceno, Jack Hynes, Jim Devellano, Earl Ingarfield, Aut Erickson, Hank Bassen, and Jim Fullerton.

Chadwick had been head of scouting for the Oakland Seals and Fullerton was his associate when Bill Torrey was the executive vice president there. When Torrey moved east, Chadwick, the former NHL goaler with Toronto and Boston, was only too happy to move as well. Erickson was another Toronto connection, having played very briefly in the 1967 playoffs when the Leafs won the Cup. A career minor-leaguer, he retired at age 32 to become coach of the team he had been playing for — the Phoenix Roadrunners of the WHL. From there, he joined Torrey's team.

Bassen was also a former NHLer but mostly minor-leaguer, a goalie who subbed a few times for injured goalies but whose career never amounted to much in the way of wins, fame, fortune, and glory. Earl Ingarfield was also a former player who wound up becoming coach of the Islanders in January 1973 after Torrey fired incumbent Phil Goyette. Ingarfield turned down the job when it was first offered him before the franchise started playing.

Jim Devellano, now senior vice president of the highly successful Detroit Red Wings, began his career in the NHL as a scout for these Islanders, became GM of the team's CHL affiliate in Indianapolis in 1979, and climaxed his New York career with four Cups with the Isles in the early 1980s. Henry Saraceno, not as well known, was the man who scouted Mike Bossy and encouraged the Islanders to draft the future Hall of Famer in 1977. He died suddenly of a heart attack in January 1979 at age 46.

The players who won four Stanley Cups from 1980–83 were highly deserving of their honors, but the scouts were as important as any other members of the front office or on-ice team in developing a winning organization. Bill Torrey was a genius in his own right. He surrounded himself with suitably intelligent people to complement and enhance his abilities — a unique skill in itself.

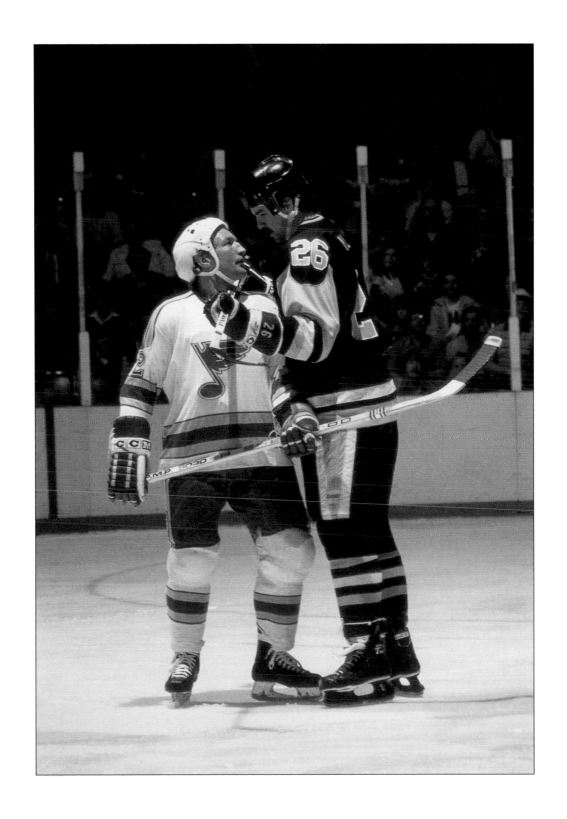

PLATE 22

PAUL'S CASE

EVER SINCE Paul Henderson scored what is now known simply as The Goal on September 28, 1972 to give Canada its win over the Russians in the Summit Series, the debate has raged within the hockey community whether he should be inducted into the Hockey Hall of Fame. The debate intensified in 1997 when the team celebrated the twenty-fifth anniversary of the series — and The Goal — and many felt this silver opportunity would be an appropriate time to grant him his honor. Alas, Mario Lemieux and Bryan Trottier were inducted into the player category, but not Paul Henderson.

The argument is a compelling one, not because of its certainty but because of its infinite debatability. For starters, look at Henderson's NHL career. In 13 years, he played 707 games, scored 477 career points, and never played on a Stanley Cup team. Clearly these stats do not place him among the elite. Nor was he a player who excelled as a great checker or team captain or contributed in a way which might count against using sheer scoring statistics as the basis for his induction. If he deserves to be in the Hall of Fame, then, it is because of his Summit Series efforts and not his NHL career. Agreed.

Of the 35 players invited to Team Canada's training camp in the fall of 1972, 28 played at least one game in the series and only seven played in all eight games: Henderson, Phil Esposito, Bobby Clarke, Yvan Cournoyer, Brad Park, Gary Bergman, and Ron Ellis. Of those, only Ellis, Bergman, and Henderson are not in the Hall of Fame. Numerous other Hall of Famers from that remarkable team include Tony Esposito, Ken Dryden, Rod Gilbert, Jean Ratelle, Gilbert Perreault, Frank Mahovlich, Serge Savard, Stan Mikita, and Guy Lapointe. Most were inducted because of their NHL careers and not anything they had done at the Summit Series. If that is the case, however, why was a putatively *average* NHL player such as Henderson selected by NHL staff to be one of the 35 best players in the country? And if he was so average, why was he able to score not just one game-winning goal but *three consecutive* game-winning goals? In fact, arguably the best goal of the series was his winning one in Game 7, splitting the defense and beating Tretiak while falling to the ice.

The counterargument is that he had one great series and scored one historic goal, but that does not an Honoured Member make. Thus, out of the debate to induct or not came the suggestion that perhaps great *teams* should be inducted to honor a particular accomplishment rather than an individual career. Another possible solution was to honor great *moments,* to acknowledge a particular feat as contributing to the game, but not acknowledging that that feat had a career-lasting, inductible impact for a particular player.

In the end, one must consider carefully the Hall of Fame's qualifications: "Candidates for election as Honoured Members in the player category or veteran category shall be chosen on the basis of their playing ability, sportsmanship, character, and their contribution to their team or teams, and to the game of hockey in general." Henderson's sportsmanship and character cannot be questioned, nor can his contribution to hockey in Canada and to that team in 1972. But playing ability? By its very reason of inclusion as a qualification, it implies a necessary comparison between those already in the Hall and those being considered for induction. And surely Henderson's playing ability is nowhere near that of Bobby Orr, Milt Schmidt, Frank Mahovlich, and all the other finest hockey players in the history of the game.

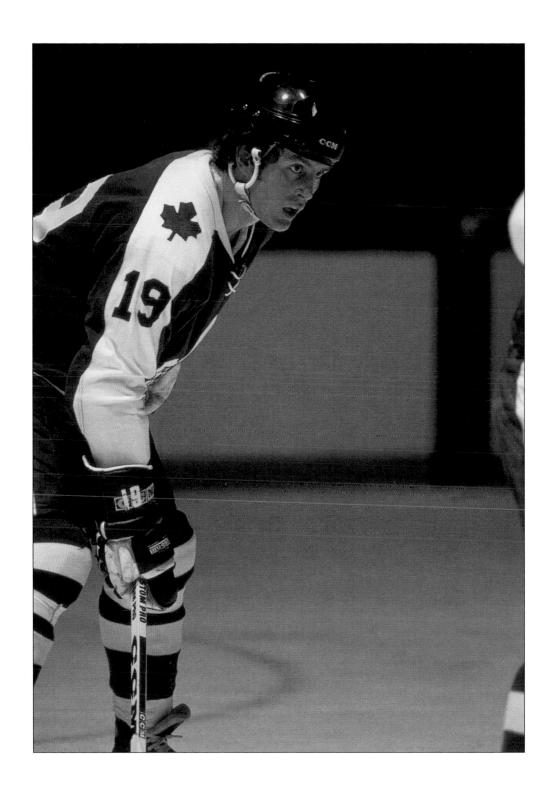

PLATE 23

DOUG HICKS AND THE AUSTRIAN LEAGUE

SINCE 1973, the Stanley Cup Finals have involved two Original Six teams only three times, all during the late 1970s, all involving Montreal: in 1977 and 1978 against Boston, and in 1979 against the Rangers. From 1967, the first year of expansion, until 1979, the old clubs won every Stanley Cup with two exceptions: the 1974–76 mini reign of terror of the Philadelphia Flyers. Since 1980, however, the fortunes have been reversed. In the ensuing 18 years, the ancient clubs have won the Cup only five times. Montreal beat Calgary in 1986 and Los Angeles in 1993, the Rangers beat Vancouver in '94, and the Wings beat the Flyers in 1997 and the Capitals in 1998.

Doug Hicks came painfully, woefully close to winning Cups with the Oilers, but was traded a blink before the fun began. Just ten minutes prior to the trading deadline in 1982, Oiler GM Glen Sather traded Hicks to Washington for Todd Bidner who wound up playing not one minute for the Oilers. At the time of the trade, Hicks had been scratched the previous 15 games in which the Edmontons had gone undefeated. "I look in the standings every day," he confessed days after the trade. "I check to see if the Oilers have lost the night before. I'm so jealous — I want them to lose. I want them to lose in the first round of the playoffs to make it show that they needed me. I want to be able to think that it wouldn't have happened if they hadn't let me go."

Hicks played only 18 games in Washington over the next two years and then in 1987-88 played in the Austrian league with Salzburg, centering two former czars of Soviet hockey, Victor Shalimov and Sergei Kapustin. The first division of the Austrian league played a twenty-four-game schedule and consisted of seven teams: KAC/Die Karntner, EHC-IWW-WEV-Colonia, EC Raiffeisen Innsbruck, Salzburger Eissportclub, Villas VSV, Die Neue VEU Feldkirch, and GoldStar Lustenau. The top six teams then advanced to a ten-game, double round-robin playoffs (much like the World Championships), and the team that finished in first place (two points for a win) was the league champion.

Shalimov finished sixth in league scoring with 56 points, and Hicks ranked third in penalty minutes with 63, including a league-leading three ten-minute misconducts (to go with four goals and 21 assists in 33 games). The league was filled with names familiar to NHL fans of the time: Ken Strong (Villas), Grant Martin (Villas), Greg Holst (Salzburg), Dave Shand (KAC), Kevin Lavallee (EC Raiffeisen), Jim McGeough (KAC), Ray Côté (EHC), Richard Grenier (EHC), Larry Floyd (EC Raiffeisen), Brian Tutt (GoldStar), Brian Hill (GoldStar), Cam Plante (Villas), and Dave Farrish (Villas). They were among the many who finished their playing careers in Europe. The league may have been less skilled than the NHL, but stick, skates, and puck are all you need to have fun and continue playing.

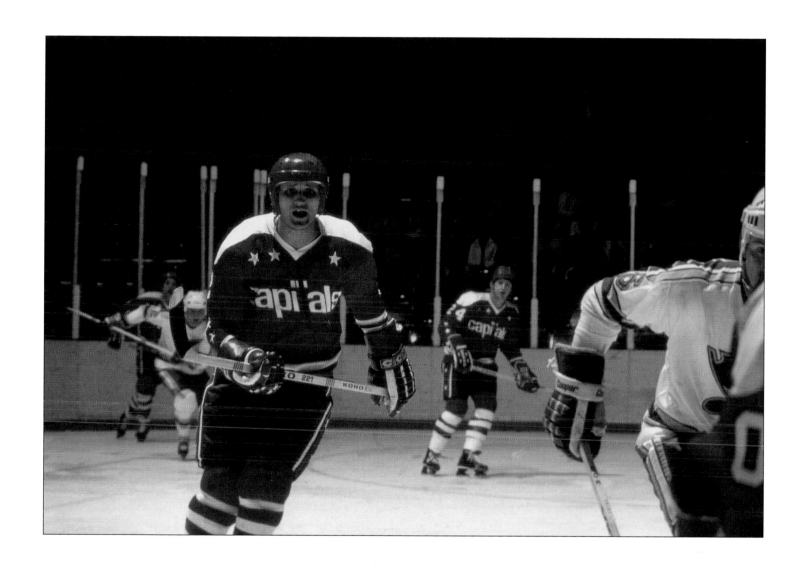

PLATE 24

MILES "TIM" HORTON NEVER SCORED MUCH

WHEN THE BUFFALO SABRES were granted a franchise by the NHL for the 1970–71 season, the first job for owner Seymour Knox was to hire a general manager. He went with the best of the previous decade and hired fomer Maple Leaf dictator George "Punch" Imlach, the man who dominated hockey by winning four Stanley Cups with Toronto in the 1960s before being fired after the embarrassing 1969 playoffs in which the Leafs were swept by the Bruins in four games by scores of 10-0, 7-0, 4-3, and 3-2.

Imlach created a team for Buffalo in much the same way he had developed the Leafs when he took over as bench boss from Billy Reay in 1958. Blending youth (through the draft with the Sabres) and experience (trades and signings), he produced a mix of speed, poise, and solid defense. In the 1970 Amateur Draft, he chose the soon-to-be great Hall of Famer Gilbert Perreault (1st overall), took Richard Martin the next year (5th overall), acquired René Robert in a steal of a deal with Pittsburgh (for Eddie Shack on March 4, 1972), and surrounded this great French Connection line with veteran goaler Roger Crozier, defenseman Tracy Pratt, and checking forward Larry Mickey.

However, key to the team, both on and off the ice, was Tim Horton, claimed by Imlach at the Intra-League Draft on June 5, 1972. Horton would turn 43 during the '72–'73 season, but his presence alone was intimidating. It was not just because of the four Cups he had won with Punch at Maple Leaf Gardens, nor that he was in his twenty-third season in the NHL, but because he was still the strongest, most feared defenseman in the game, a rock who could overpower anyone and who himself was an immovable feast of a man.

Horton has the distinction of being one of the lowest-scoring, longest-playing players in the history of the game. While most hockey fans concern themselves only with the biggest numbers, others might be interested to know that Horton is in a rare group of small-numbered players. Of the 95 retirees to have played more than 1000 career games in the NHL, only 15 have scored *fewer* than 120 goals: Leo Boivin (1150 games/72 goals), Terry Harper (1066/35), Doug Harvey (1113/88), Horton (1446/115), Harry Howell (1411/94), Dave Lewis (1008/36), Brad Marsh (1086/23), Jim Nielson (1023/69), Marcel Pronovost (1206/88), Gord Roberts (1097/61), Phil Russell (1016/99), Serge Savard (1040/106), Harold Snepsts (1033/38), Allan Stanley (1244/100), and Jean-Guy Talbot (1056/43). Not surprisingly, each and every man on the list is a defenseman, proving that although not a glamorous job, a defensive defenseman is an always-needed commodity (eight of the 15 have won at least one Stanley Cup). Horton ranks twelfth on this list in terms of fewest goals per game. Leading the way in nonscoring is Brad Marsh who averaged but one goal every 47.21 games during his career, and thus has the distinction of being the least effective scorer among 1000-game NHLers! Horton was positively filling the net by comparison, scoring once every 12.57 games.

Tragically, after a Leafs-Sabres game in Toronto on the night of February 20, 1974, Horton died in a single-car crash on the Queen Elizabeth Way (QEW) outside St. Catharines while driving back to Buffalo in a car Imlach had given him as a signing bonus. In hockey terms, Tim Horton was one of the oldest men of all time. In life terms, he was just 44.

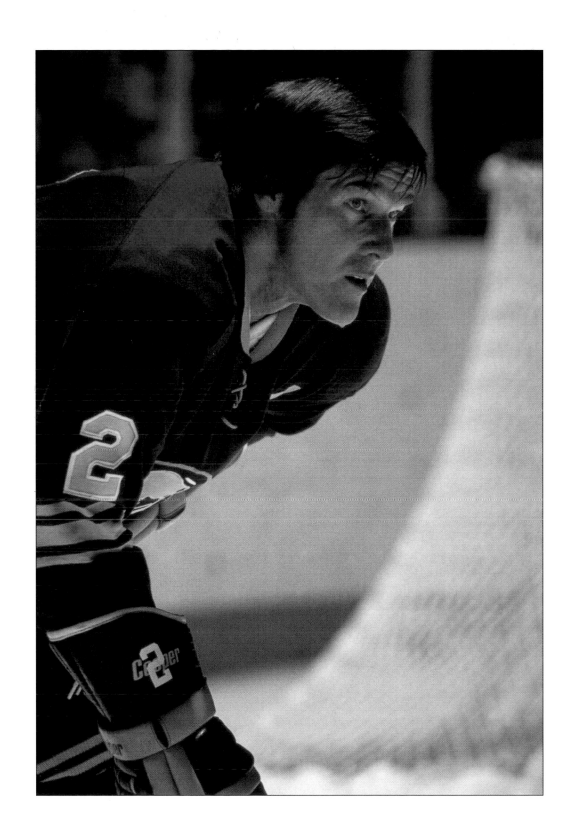

PLATE 25

GORDIE HOWE — A LONG ROAD TO THE FIRST CUP

THE EXTRAORDINARY CAREER of Mr. Hockey knows no parallel in all of sport. He played his first game with the Red Wings on October 16, 1946 against Toronto, scoring a goal in a 3-3 tie at the Olympia. His last of 801 was on April 6, 1980, more than 34 years later! In 18 of his 26 seasons, he didn't miss a game, including his final year during which he turned 52. In between, incredibly, he never scored more than three goals in a game, though he could always be counted on to eat a mess o' shrimp on game day!

It was fate and destiny that gave him a professional career as a Red Wing and not as a New York Ranger. As a 15-year-old, he was invited by scout Russ McCrory to the Rangers training camp at the start of the 1943–44 season in Winnipeg, the first time he had traveled any distance alone and, in fact, the first time he had ventured so far from his Saskatoon home. Howe was so lonely and grew so unhappy that when manager Lester Patrick and coach Frank Boucher tried to get him to commit to signing a C-form, making him Ranger property, Howe quietly refused, saying he wanted only to return home. Patrick offered him a scholarship at Notre Dame College in Wilcox, Saskatchewan, a stone's throw from "home," but young Gordon still demurred.

That season, he was scouted by Fred Pinkney of the Red Wings who was thrilled by the chance to sign the rising star. But a player could not legally sign a C-form until he was 16, so Pinkney gave Gordie's father Ab $100 to phone Gordie the night before his birthday. The day Howe turned 16 — March 31, 1944 — Pinkney was at the Howes' front door, and after some persuading, Gordie agreed to sign the form and come to the Red Wings' training camp in Windsor that fall. Howe played one more year with the Saskatoon Lions Club Juveniles, then, in 1945–46, for Omaha in the USHL. He joined the Wings as an 18-year-old in September 1946.

He scored a goal in his very first game, against the Leafs, and in the years leading up to their Cup win in 1952, helped Detroit win more and more games: 22 in '46-'47, 30 in '47-'48, 34 in '48-'49, 37 in '49-'50, and 44 in '50-'51 and '51-'52. This pattern repeats itself for many of the greatest players. Bobby Orr entered the NHL in 1966 and won his first Cup four years later. Wayne Gretzky started in 1979 and also won four years later. It took Mario Lemieux from 1984 to 1991 to win his first Cup, Bobby Clarke five years (1969 to 1974), and Frank Mahovlich from 1957 to 1962. In fact, most of the game's superstars have taken a few years to become dominant, in part due to the need to adjust and develop, but also due to the general manager's need to build a team around that player. Just as Rome wasn't built in a day, neither was a Stanley Cup champion or dynasty. But once the role players are in place and the marquee player understands the NHL … watch out!

PLATE 26

GORDIE HOWE PLAYS WITH HIS KIDS

GORDIE HOWE retired after the 1970–71 season, a veteran of 25 NHL seasons, the all-time leader in virtually every offensive category. Mr. Hockey was 43 years old, had arthritis in his wrists, and was coming off a 52-point season reminiscent of his earliest years rather than his greatest years. He had done it all. A sure Hall of Famer, he was considered the greatest player of all time.

But — and it's a big but — the temptation of playing professional hockey with his sons Marty and Mark was too great for him to resist. Two years later he came out of retirement and signed with the Houston Aeros of the WHA with the understanding his dream would come true. For an incredible six seasons it did, Mark becoming a scorer in the WHA, Marty a steady defenseman, and dad Gordie a fast-moving, majestic fan favorite. The Howe family played four years with the Aeros before they all joined the New England (later Hartford) Whalers. But the bubble finally burst during the team's first NHL season in 1979–80. While Mark and Gordie stayed in the NHL the full year, Marty played just six games, spending the rest of the time with Springfield in the AHL. This was, of course, the only time in NHL history a father and son played *together* in the NHL.

To put this achievement into perspective, by the time Brian Conacher played with the Leafs, his dad Lionel had been retired for 24 years. Cal Gardner had been out of the game 15 years by the time his son Dave played his first NHL game. Bill McCreary had retired nine years prior to Bill Jr.'s NHL debut, and goalie Dennis Riggin was 15 years past blocking his last shot when his son Pat tended goal in the bigs.

Gordie, amazingly, didn't miss a single game his last year and retired at the end of the season after having defied all odds for yet another year. He had played in five decades and was 52 when he skated in his final NHL game. Yet through all his big-time, big-city success, his prairie upbringing is revealed in the simplest of all things: his signature. Check a cereal box, a hockey card, or anything else he signed. To this day, he still spells his name Gord*on,* rather than Gord*ie* that everyone but he uses!

PLATE 27

HARRY HOWELL — OL' WHITE TOP

HARRY HOWELL has the distinction of having played more games than any other retired player in the history of the NHL without having won a Stanley Cup — 1411. He ranks second only to Tim Horton for career games by a defenseman, and the name Harry Howell is also the answer to the trivia question: who was the last man to win the Norris Trophy before Bobby Orr made it his personal award from 1968 to 1975? Ironically, Howell and Orr were both inducted into the Hall of Fame in 1979, though Orr began his career in 1966 and Howell his in 1952.

Howell's career was remarkable in many ways, an unusual list of firsts and records that were rare, indeed. He was the youngest captain in the history of the New York Rangers when, at 22, the "C" was sewn on his jersey in 1955. He played but one game in the minors, and went on to play 1160 games for the Broadway Blueshirts, a club record. His 17 seasons is also a club mark that won't likely be equaled for many a year.

Howell was the very first Ranger to be given a tribute night. On January 25, 1967, Harry Howell Night was truly an unique honor at Madison Square Garden; it was the first time a Ranger had been given such personal recognition before the hometown fans. In April 1969, Howell underwent a serious spinal fusion operation, and just two months later, the Rangers sold him to the expansion Oakland Seals, figuring his career was at an end.

They were wrong. Howell played two years with the Seals and was sold on February 5, 1971 to Los Angeles where he continued for another 2 ½ seasons, his white hair and good looks belying his toughness and defensive resilience. He went on to play three more years in the WHA and then became a coach, first for the Cleveland Barons and then Minnesota in the NHL. He also coached Team Canada's entry to a bronze medal in the World Championships in Prague in 1978. This team included many players Howell had actually played with or against: Garry Unger, Marcel Dionne, Dennis Kearns, Pat Hickey (in the WHA), Don Lever, Guy Charron, Mike Murphy, Jean Pronovost, Bob MacMillan (WHA), Dennis Herron, and Dan Bouchard.

This was only the second year after Canada returned to the World Championships, having boycotted the event from 1970 to 1976 after a prolonged fight with the International Ice Hockey Federation (IIHF) over Canada's use of pro players. Howell, though, must have been pleased with the team's third-place result with this inaugural group of NHLers who had not qualified for the playoffs (and were thus available for the annual April tournament). Canada's 4-3 record was the result of beating the Swedes 7-5, the United States 7-2, East Germany 6-2, and West Germany 6-2, and losing to the Czechs (gold medal) 5-0, Soviets (silver medal) 4-2, and Finns (eighth place) 6-4.

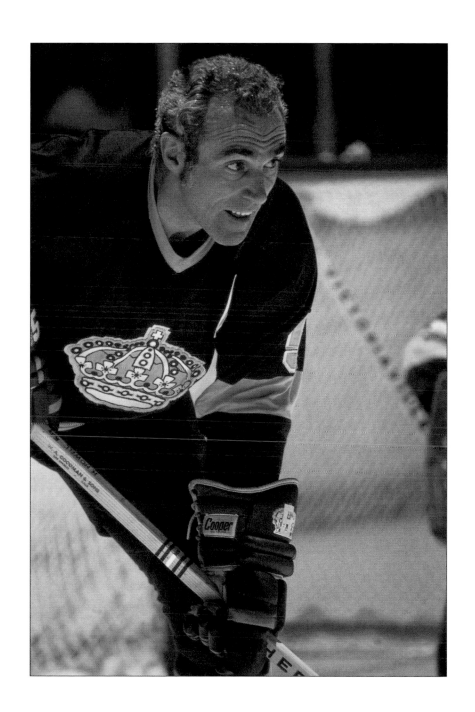

PLATE 28

BOBBY HULL WINS HIS DUES

THE "GOLDEN JET" was the first and one of only four 1000-point men to have more career goals than assists (610-560), the others being Mike Gartner, Mike Bossy, and Dino Ciccarelli. Having played 15 remarkable years with the Blackhawks, Hull literally established the expansion league World Hockey Association (WHA) when he signed a lucrative deal on June 27, 1972 with the Winnipeg Jets that paid him $1 million up front and $250,000 a year for 10 seasons. The move, however, while profitable, excluded him from the 1972 Summit Series against the Russians, as Hull would otherwise have certainly been selected to the NHL-oriented Team Canada.

For Hull, the move to the WHA was motivated as much by symbolism as by money. He announced that although the NHL might be the superior league, it had monetarily mistreated its players long enough and he, for one, wasn't going to continue to take a financial hit if he could make a pile of money elsewhere. Furthermore, by 1972, he had been in the league 15 years, had played more than 1000 games, and had scored more than 600 goals. His place in history had long ago been solidified. He was among the elite in hockey circles, but at 33, he was also in the twilight of his career.

Hull made a similar gesture in 1982 when he demanded the Hockey Hall of Fame return all his memorabilia, souvenirs, trophies, and sticks to protest the Hall's new policy of charging an admission of $2. What Hull had always admired about the Hall, since its opening at the CNE grounds in Toronto in 1962, was that a child, pensioner, or millionaire had equal access to the same wonderful collection. He felt that an admission fee was instantly exclusive, and on principle, he no longer wanted to be associated with the museum.

The climate of the 1990s is so vastly different. Player cards are worth hundreds of dollars, jerseys thousands, and the Hall, in an effort to provide superb entertainment as well as history, must now charge an entrance fee in keeping with other tourist attractions. Many souvenirs are now worth as much as most players used to get paid for a full season's play. A Bobby Hull Topps card for 1958–59 in mint condition is worth $2500 and a Hull stamp from 1961–62 goes for $210.

In November 1975, while with the WHA Jets, Hull sat out one game by way of drawing attention to his protest over what he saw as the ever increasing violence of the game. After seven years with Winnipeg, Hull was one of many players who returned to the NHL, thanks to its annexation of four teams — the Jets, Edmonton Oilers, Quebec Nordiques, and Hartford Whalers. He started the 1979–80 season with the Jets and then was traded to the Whalers for future considerations on February 27, 1980. Incredibly, that Whalers team boasted three of the greatest players of all time: Hull, Gordie Howe, and Dave Keon.

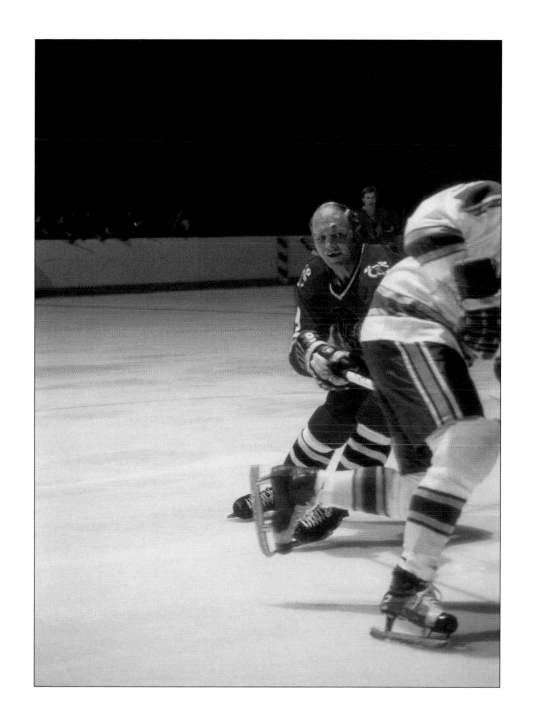

PLATE 29

BOBBY HULL — THE BEGINNING AND END OF THE WINNIPEG JETS

P ERHAPS THERE is no greater irony in all of hockey than the story of the rise and fall of the Winnipeg Jets. The rise was made possible by the arrival of one of the great stars of his generation — Bobby Hull. The demise was the result of the inability of the franchise to support the great stars of another generation — Teemu Selanne, Keith Tkachuk, and Alexei Zhamnov.

Hull shocked the hockey world on June 26, 1972 when he signed a 10-year, $3.5 million contract with the WHA Jets, thus taking the NHL's leading active scorer away from the NHL after 15 years with the Blackhawks (to put the terms in context, Wilt Chamberlain was pulling in $250,000 per NBA annum and Hank Aaron $200,000 in baseball).

The contract money was put up not just by Winnipeg, but by all 10 teams in the WHA in an effort to lure the biggest name in the game to the newest game in town. Although the WHA had already lured 94 NHLers before the Golden Jet signed, it was his name alone that authenticated the "pirate" league. (His younger brother Garry also signed a contract for one year with the Ottawa Nationals.) The move also weakened one of the top NHL clubs in the process and was the boldest announcement to date that the WHA would do anything to offer fans quality hockey and players quality contracts. For the players, the gamble was twofold: join the competition and risk permanent excommunication from the NHL, and risk signing a contract with a potentially financially unstable franchise.

Hull's signing also prompted the NHL to take the WHA to court in defense of the "reserve clause," which had previously ensured that once under contract to a team, a player did not have the freedom to move to another. The new league won the court battle and thus helped initiate what amounted to a form of free agency for all pro hockey players after the life of any *one* contract.

The Jets were one of four teams — along with Edmonton, Quebec, and Hartford — to join the NHL in 1979, and the team's future looked healthy. But in the 1990s, Gary Bettman became NHL commissioner, and salary disclosure was among new NHLPA president Bob Goodenow's first mandates. Salaries escalated to the point where providing and promoting stadium luxury boxes became the most important part of running a hockey team. Winnipeg became a member of the NHL's inner city delinquents, a "small market team." That is, lots of hockey tradition but not many dollars.

The Jets' inevitable move south was postponed for a full year while a group of local Winnipeg businessmen established the Spirit of Manitoba Inc. On June 16, 1995, they agreed conditionally to buy the team from owner Barry Shenkarow on three conditions: NHL approval, tax breaks from various levels of government, and raising enough capital. Addressing the third point over the summer, Winnipeggers donated an astounding $13 million toward building a new arena, but it was not nearly enough. The three levels of government had agreed to ante up $111 million, provided Spirit could match that amount to cover operating costs.

While Spirit came up with $40 million, that too was not enough, and Shenkarow sold the team to Richard Burke of Minneapolis and Steven Gluckstern of New York. The pair wanted to move the Jets to downtown Minnesota but eventually settled on America West Arena in urban Phoenix, a rink that seats 18,000 for hockey and provides 88 luxury boxes. Salaries, which the Jets initially inflated to become a successful hockey market, had, in the end, been the cause of the demise of the team. The new Bobby Hulls were too rich for the old Winnipeg barn to accommodate.

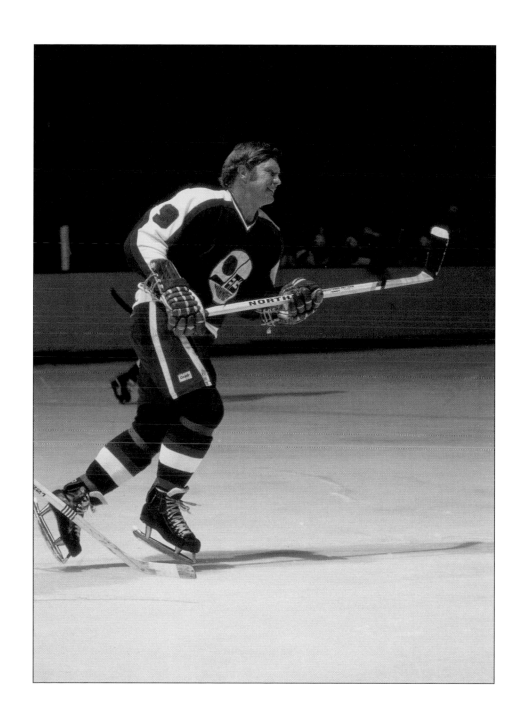

PLATE 30

PIERRE JARRY'S TRADE TREE

TRADES ARE one part of hockey that fans find most interesting. Your favorite team sends one player away hoping to get a better one in return. When successful, you happily wonder why the other team made the deal. Sometimes a trade works out well for both teams, but it's always better when one team is the clear winner because it generates more animated discussion and debate. It's also fascinating to see how a series of trades work, looking at the lineage of player exchanges and seeing the immediate and net result from start to finish.

Pierre Jarry was acquired by the Leafs on February 20, 1972 from the Rangers for Jim Dorey. Dorey was a Toronto draft choice in 1964, so the origins of the trade are very simple: each team is given one draft choice per round, and the Leafs used the 23rd selection overall (in the fourth round) to select Dorey.

What's more intriguing, though, is to see what happened *after* Jarry left, the connected series of deals that resulted from the Leafs' acquiring him. Jarry was traded on November 29, 1973 by Toronto to the Red Wings for Tim Ecclestone. Ecclestone was then traded with Willie Brossart on November 2, 1974 to Washington for Rod Seiling. Seiling left the Leafs on September 9, 1976 when he signed as a free agent with St. Louis, and as compensation Toronto received cash and a 2nd-round draft choice in 1978. The Leafs used that choice to select Joel Quenneville, and he was traded on December 29, 1979 with Lanny McDonald to the Colorado Rockies for Wilf Paiement and Pat Hickey.

Hickey was traded on October 16, 1981 to the Rangers for a 5th-round draft choice in 1982, and the Leafs selected Sylvain Charland, a prospect who had never played in the NHL. (That ends half of Jarry's trade tree.)

Paiement, however, was traded on March 9, 1982 to the Quebec Nordiques for Miroslav Frycer and a 7th-round draft choice in 1982 (Jeff Triano, who also never played in the NHL). Frycer was traded on June 10, 1988 to the Red Wings for Darren Veitch, and Veitch was then sent to St. Louis on March 5, 1991 for Keith Osborne. Osborne was claimed by Tampa Bay on June 18, 1992 in the Expansion Draft, and since the Leafs received nothing in return, that is where the Jarry "trade tree" ends, some 14 players and 28 years after the Leafs chose Jim Dorey at the 1964 Amateur Draft!

PLATE 31

JERSEY TRIVIALIS

EVERY PICTURE that is worth its anecdotal salt truly tells a story. Look at the image on the facing page and try to figure out what is different about it. It's a scrum, not unusual at the goalmouth. There are six Penguins and only two Blues, which is a bit odd. But what else?

Who are the players in the picture? Don't guess. Who is the only player who can be identified absolutely? Why? St. Louis players have names on their jerseys, and the Penguins don't!

It was not until the start of the 1977–78 season that the NHL made it mandatory that all teams had to have the players' names on the back of their jerseys, a rule intended to help create interest in the game in the United States. The logic was that if the fans were able to identify and know the names of the players better, they might take a greater interest in what they were watching. A contradictory argument is that if the names aren't on the jerseys, fans have to buy a program to find out who's who, thus generating added income for the teams.

While all team jerseys had names beginning in 1977, there were a few oddities in the early seventies regarding this modern feature. The Cleveland Barons had names on their jerseys for their inaugural season (1976–77), while the Kansas City Scouts (née 1974, RIP 1976) never had names on theirs. For the 1971–72 season, the Oakland Seals were the first team to use names, another entrepreneurial decision by team owner Charlie O. Finley. They abandoned the practice, though, for the next season, and did not adopt it again until the 1974 playoffs in April. For the next two seasons, the names were removed, and the team never again qualified for the playoffs.

The Rangers wore their names in the 1972 playoffs only for home games against the Bruins, and the Bruins, Flyers, and some other teams sometimes wore their names when NBC televised games on Sunday afternoons. This was done in an attempt to help the novice American fans to identify the players while watching.

The Blues, in fact, also have one of the oddest jersey-names histories. The first time they used names on their home sweaters was February 2, 1974 when they were playing against the Buffalo Sabres midway through the 1973–74 season. Three days earlier against California, their previous game at the Arena, the team had not had names but from that day on, the St. Louis players have had their names on the jerseys.

The names game took an odd twist when Toronto Maple Leafs owner Harold Ballard refused to comply with the legislation at the start of the 1977–78 season. His Leafs were nameless most of the year until he relented on February 26, 1978 in his inimitable style. That night, the Leafs were in Chicago to play a road game against the Hawks. The Leafs had the names on their jerseys, to be sure, but the lettering was blue, the same color as the jerseys! The names were there, but no one was the wiser. Ballard was fined $10,000 by league president John Ziegler for his stunt, and thereafter, the Blue and White had names one color, jerseys the opposite. The joke had been made.

PLATE 32

MIKE KASZYCKI FORGETS TO SIGN A WAIVER

THE LIFE and hockey times of Kas reflect the full range of experience over a career that spanned a dozen years and as many hockey teams at five different levels of play. Born in Milton, Ontario, Kaszycki played junior with the Memorial Cup champion Toronto Marlies. After one season, he was traded to the Soo Greyhounds and set a record with 51 goals and 170 points, besting Marlie teammate Bruce Boudreau's 165 points of the previous season.

That summer, he was the New York Islanders' 2nd-round draft choice (32nd overall) and spent the following season with Fort Worth of the Central Hockey League (CHL). After starting 1977–78 with their farm team in Rochester, Kas was called up to the Island for the rest of the year. The following year was his second modest season with the club (16 goals and 34 points). At the start of '79–'80, he found himself sitting out many games, a fifth center behind Bryan Trottier, Lorne Henning, Bob Bourne, and Swedish rookie Anders Kallur. While the Islanders were that close to becoming a dynasty and usurping the Montreal Canadiens as Stanley Cup kings, Kaszycki was becoming less and less a piece of the highly successful Long Island puzzle.

On December 7, 1979, he was traded to the terrible Washington Capitals for Gord Lane. The Islanders got the better of that trade since Lane remained with the team until 1985, after four Stanley Cups, the first of which came the very next year. Kaszycki, on the other hand, remained in the American capital long enough to buy a house, but not much longer. He became one of a few players to play for three different NHL teams in the same season when, after just 28 games, he was traded to the Toronto Maple Leafs for Pat Ribble who, ironically, started the year in Chicago and was also going to his third team in the same season. In fact, since 1917, only 65 players have dressed for three teams in one year. An even rarer group is the four-in-a-year team man: in 1977–78, Dennis O'Brien played for Minnesota, the Rockies, Cleveland, and Boston. The only other man to duplicate this feat was Dave McLlwain who played for Winnipeg, Buffalo, the Islanders, and Toronto, all during the 1991–92 season!

Kaszycki finished the 1979–80 season with the Leafs, but after just six unimpressive games the next season at Maple Leaf Gardens, he was sent to their CHL farm team in Dallas (shared with Chicago). In one of those matches, against the Hawks on February 22, 1981, the helmetless Kaszycki was forced to sit on the bench the last two periods after a unique NHL rule was brought to the attention of the official scorer. Any player could play without a helmet only under two conditions: one, that his contract was dated before June 1, 1979, and two, that the player had signed a waiver form. Kaszycki hadn't done the latter and was thus benched.

The following season he played entirely with New Brunswick in the American Hockey League (AHL) where he seemed to get his career back on track. He won the Les Cunningham Plaque (as the league's MVP), the John B. Sollenberger Trophy (as scoring champ), the Fred T. Hunt Memorial Trophy (for sportsmanship, determination, and dedication), and was selected to the league's first all-star team. Based on these successes, the Leafs gave him another chance the following season, but after scoring only one goal in 22 games, he was farmed down to the minors (now in St. Catharines). There he remained for three years, continuing with Moncton in 1984–85 after the franchise moved.

At this stage, his career wasn't over so much as it was just changing. That summer, he signed with Ambri-Piotta, a First Division team in the Swiss league, joining Leaf alumni Dale McCourt and Ron Wilson. That September, he became a Swiss citizen and has lived happily ever after.

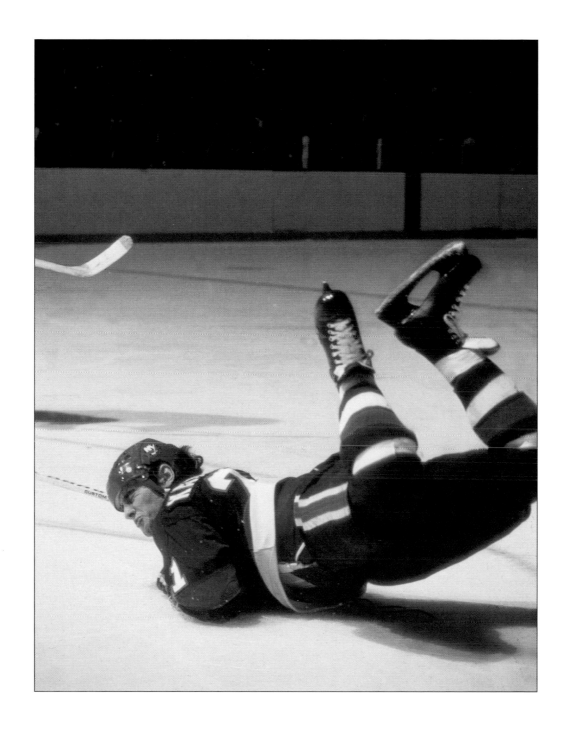

PLATE 33

DAVE KEON — A MAPLE LEAF FOREVER

DAVE KEON played for the Blue and White for 15 full seasons. He won the Calder Trophy in 1960–61, the Conn Smythe in 1967, won four Stanley Cups with the team, and succeeded George Armstrong as captain, a position he held from 1969 to 1975. An iconoclast and competitor, he was one of the greatest Toronto Maple Leafs of all time. Yet because of his bitter departure from the club (Ballard more or less turfed the classy Keon out of the city), his name was not honored or remembered by the Leafs' front office in the years following. The first and most egregious insult to Keon's lifelong dedication to the team came the very next season when Stan Weir was allowed to wear Keon's hallowed No. 14. In future years, the what-should-have-been-sacred number was worn by Ron Wilson, Mike Kaszycki, René Robert, Miroslav Frycer, Dave Reid, Rob Cimetta, Dave Andreychuk, and Darby Hendrickson — worthy players all, but players who should have gotten their own numbers.

The Leafs are unique in the NHL in that since the previous owner died, the current management has officially retired two numbers and created eight honored numbers in dedication to those brilliant Leafs of days gone by. The two retired numbers are Ace Bailey's No. 6 and Bill Barilko's No. 5. In the case of Bailey, his career ended tragically on December 12, 1933 when he was viciously checked by Boston's Eddie Shore. Bailey lost consciousness the instant his bare head smashed against the ice and was in a coma for 10 days. Three brain operations saved his life, but his career unquestionably was over. Later, in the sixties, he gave his permission to young Ron Ellis to wear the number, but when Ellis retired, so did the number.

Bill Barilko was not the greatest Leaf, but he certainly scored the most dramatic winning goal of all Toronto's 13 Stanley Cups when he scored in overtime to beat the Canadiens in 1951. That summer, he died in a plane crash and no one has worn the No. 5 since, partly out of recognition of his great feat, and partly out of superstition — no one wants to adopt a dead man's number.

Rather than follow the lead of Boston and Montreal, which have a record seven retired numbers each, the new Leafs decided to create honored numbers by raising banners in the Gardens' rafters to commemorate great players. They also decided to keep the numbers in use and sewed patches on the jerseys worn by the current users as acknowledgement of the past players. The first men so honored, on October 3, 1993, were Syl Apps (No. 9) and Ted Kennedy (No. 10), men whose achievements with the Blue and White are incomparable. The succeeding year No. 1 was honored for both Turk Broda and Johnny Bower, and in November 21, 1995, two No. 7s were privileged, one each for King Clancy and Tim Horton. And, this past year, the Leafs honored two more treasures: George Armstrong's No. 10 and Charlie Conacher's No. 9.

The Leafs could continue this tradition for many years to come as so many greats, whose numbers are worn by current players, deserve lifelong aristocracy: Happy Day (No. 4), Babe Dye (No. 6), Red Horner (No. 2), Harvey Jackson (No. 11), Red Kelly (No. 4), Dave Keon (No. 14), Frank Mahovlich (No. 27), Joe Primeau (No. 10), Borje Salming (No. 21), Darryl Sittler (No. 27), Allan Stanley (No. 26), and Harry Watson (No. 4). These are among the most notable and easily identified heroes, Hall of Famers all, Leafians through and through.

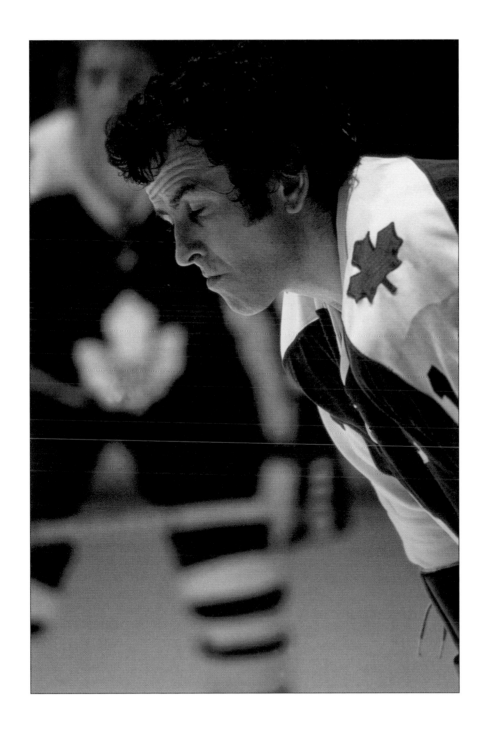

PLATE 34

DAVE KEON'S REMARKABLE PENALTIES RECORD

HAD THE SELKE TROPHY been around when Dave Keon was in his prime, he would have won it 10 times over. He was the quintessential two-way player, but statistically speaking, his claim to fame must surely be his penalty minutes totals. In 1296 regular season games, he received exactly 49 penalties, and in 92 playoff games, a mere three minors. His one great transgression was on the final night of the 1973–74 season. Keon was finishing his fourteenth season with the Leafs, but on that night, he got into the only fight of his career — against Greg Sheppard of Boston who, needless to say, began the altercation when he high-sticked Keon in the face. Sheppard got the extra minor.

Keon also received two 10-minute misconducts in his NHL life. The first was handed out by linesman Walt Antanas on December 22, 1968 after Keon argued about what everyone in the building knew to be a blown offside call that had led to a Detroit goal in the second period. The other came on March 21, 1981 as a member of the Whalers when all 10 players on the ice were given misconducts during a scrum (the NHL was just starting to crack down on multiple-player skirmishes). Keon never received two penalties in any game. Of the 49 called against him, 19 were given in the first period, 18 in the second, and 12 in the third. To continue this walk through the land of trivia, it must also be noted that Keon was penalized most frequently in March, that month seeing him sent off 11 times. He was called nine times each in October and November, eight in December, six in January, and just three times each in February and April.

Keon was called for hooking 15 times; tripping 14 times; five holding; four interference; two each for roughing, high-sticking, and slashing; and one each for elbowing and playing with a broken stick (in addition to his fighting major and two misconducts). In the playoffs, his three minors came on March 2, 1964; April 6, 1965; and April 3, 1969. Furthermore, of the 95 retired players who have played 1000 games, only nine have fewer than 300 career penalty minutes: Dave Christian (1009 games, 284 minutes), Ron Ellis (1034/207), Butch Goring (1107/102), Don Marshall (1176/127), Rick Middleton (1005/107), Bob Nevin (1128/211), Craig Ramsay (1070/201), and Jean Ratelle (1281/286). Keon averaged one two-minute minor for every 22.16 games, the lowest total among these nine.

Here is a complete chronological list of all his regular season penalties (infraction and period in brackets): October 16, 1960 (tripping, second); November 13, 1960 (hooking, first); December 1, 1960 (hooking, third); October 14, 1961 (tripping, third); January 12, 1963 (high-sticking, second); October 16, 1963 (tripping, first); December 18, 1963 (hooking, second); March 22, 1964 (roughing, second); October 24, 1964 (tripping, first); November 22, 1964 (roughing, second); March 7, 1965 (hooking, first); March 10, 1965 (hooking, first); March 24, 1965 (high-sticking, second); November 6, 1965 (tripping, third); January 9, 1966 (hooking, second); March 25, 1967 (tripping, second); December 9, 1967 (elbowing, first); March 9, 1968 (tripping, second); December 22, 1968 (misconduct, second); January 26, 1969 (hooking, first); November 30, 1969 (tripping, second); February 22, 1970 (tripping, second); April 4, 1970 (playing with a broken stick, first); December 13, 1970 (interference, first); March 25, 1971 (hooking, third); November 6, 1971 (interference, first); December 25, 1971 (slashing, third); October 22, 1972 (interference, first); October 11, 1973 (hooking, second); April 7, 1974 (fighting, second); November 13, 1974 (tripping, first); December 4, 1974 (hooking, third); October 24, 1979 (hooking, second); December 19, 1979 (hooking, third); January 21, 1980 (tripping, first); February 23, 1980 (slashing, second); March 1, 1980 (hooking, second); October 22, 1980 (tripping, first); November 1, 1980 (tripping, third); November 6, 1980 (holding, third); January 9, 1981 (holding, second); January 28, 1981 (hooking, first); February 15, 1981 (hooking, first); March 21, 1981 (misconduct, third); March 22, 1981 (holding, first); April 1, 1981 (holding, third); October 23, 1981 (interference, first); November 14, 1981 (holding, second); and March 3, 1982 (tripping, third).

PLATE 35

CHUCK LEFLEY — WHITHER OR HITHER?

DESIRE AND FATE go hand in hand. The ambition for one leads to the inevitability of the other almost as if the good that results from fate cannot be helped so long as desire is all. Chuck Lefley's career was the product of a desire to make it to the NHL, but then he lost control of that desire and without it, inadvertently ended his NHL life.

He began as a Montreal Canadien, drafted sixth overall in 1970 as a result of his excellent play with Father Bauer's Canadian national team. He was with the Habs from 1970 to 1974, during which time he helped win two Stanley Cups in a supporting role with the club. In his last two seasons he scored more than 20 goals, but he had a rough start to the '74-'75 season and was traded to the Blues for Don Awrey. In St. Louis, he blossomed, finishing the year with 23 goals, bolting to 43 the next season (a team record). But the following year, he scored just 11 times, and by season's end, he was in despair.

On October 8, 1977, just before the start of a new season, he announced his retirement. He claimed he no longer enjoyed the game and was now ready to begin his life as a farmer with his brother, Bryan, on a 700-acre business in Grosse Isle in their home province of Manitoba. (Brother Bryan had a five-year career with the Islanders, Scouts, and Rockies.) The news came as a shock to the Blues, particularly as Chuck had signed a three-year contract just a month earlier. But the hockey season is like the school year, and just as a student becomes restless after an idle summer if nothing is happening in the fall, Lefley too grew itchy. Within a few weeks of his retirement, he was back on skates, playing with club team Jokerit in Finland. "I didn't go over there to play hockey," he said later. "I went over there to have fun, and I did."

St. Louis general manager Emile Francis was not amused. In the first place, there was the contract "Coco" had just signed. In the second place, there was the nascent NHL-European league relationship to consider. Since the signings of Salming and Hammarstrom by the Leafs in 1973, pulling two Swedes from their club teams to play in the NHL, the two sides had made an agreement that no European could play in the NHL until the parent club overseas was compensated. Later, this became a set fee of $40,000, a sum the NHL team was usually happy to pay for a top-flight European. However, no one had considered the opposite — an NHLer leaving North America to play in Europe. Francis not only felt that Lefley was under contract to St. Louis and had no legal right to play in Finland, he also believed that he was entitled to compensation if Lefley did play there. "We placed Lefley on the suspended list, but the Canadian Amateur Hockey Association approved his transfer to Europe, something they had no right to do," Francis opined.

The following year, Lefley wanted to join Dusseldorf in the West German league, but this time Francis was successful in blocking him from playing. By then, after two years away from the big time, Lefley decided to return to the Blues to honor his contract, beginning with the '79–'80 season. As fate would have it, he separated his shoulder in an intrasquad game in Port Huron, played only 28 games, and scored just six goals. He retired permanently at the end of the season.

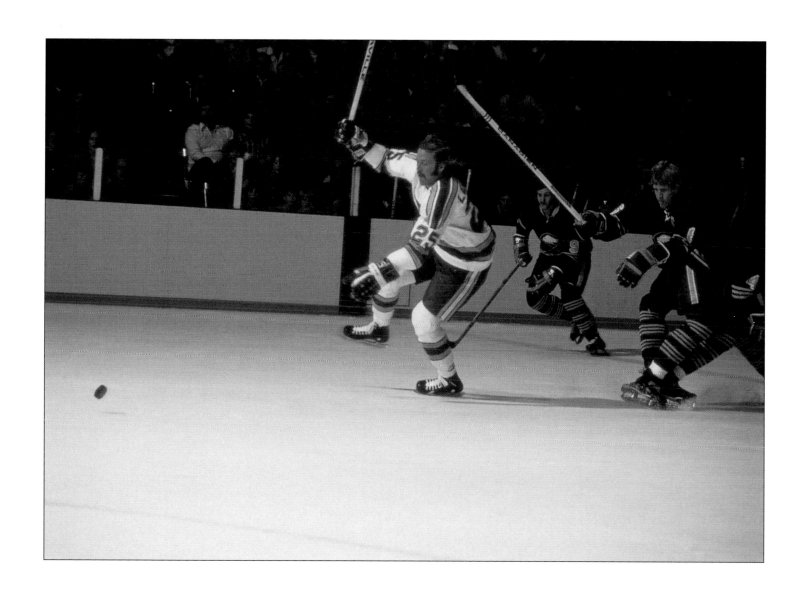

PLATE 36

RICHARD LEMIEUX AND THE INAUGURATION OF THE CANUCKS

--

THIS PORTRAIT of Richard Lemieux shows clearly the old, classic, and original Vancouver jersey which lasted until 1978. Lemieux was drafted 39th overall in the third round of the 1971 Amateur Draft, one year after the Canucks entered the NHL.

After Los Angeles received a precious NHL expansion spot for the 1967–68 season, Vancouver nearly inherited the appalling Oakland Seals for the following year as talks through the season seemed to indicate that the team was headed north from its weak and financially crippling home base in San Francisco. The Seals stumbled on, though, and it wasn't until 1970–71 that British Columbia got its own NHL team.

After paying $4 million each to join the league, the Canucks and Buffalo Sabres alternately had a chance to plunder the lowest end of the rosters from the other 12 teams in what was called the Expansion Draft. Vancouver selected Gary Doak, Orland Kurtenbach, Ray Cullen, Pat Quinn, Rosaire Paiement, Darryl Sly, Jim Wiste, Danny Johnson, Barry Wilkins, Ralph Stewart, Mike Corrigan, Wayne Maki, Ed Hatoum, Paul Popiel, Ron Ward, John Schella, Bob Dillabough, Garth Rizzutto, Dunc Wilson, and Charlie Hodge.

The first-ever Canucks game was played at the Pacific Coliseum on October 9, 1970, and Vancouver lost 3-1 to Los Angeles before 15,062 fans. The Kings' Ross Lonsberry scored the first goal of the game (and his stick was immediately whisked off to the BC Sports Hall of Fame), and Wilkins scored the first-ever Vancouver goal in a game which the NHL hoped would begin a great west-coast rivalry. The Canucks, however, finished the year 24-46-8, were out of the playoffs, and did not qualify for the post-season until the spring of 1975.

Opening night action was fittingly delayed by all sorts of pregame celebrations. A 73-man pipe band entertained the crowd, and local single-monikered chanteuse Juliette was given a rousing ovation for her rendition of *O Canada!* Mayor Tom Campbell faced off the opening puck, and 87-year old Cyclone Taylor trotted out to center ice to meet NHL prexy Clarence Campbell. Taylor was the last living member of the team that won the Stanley Cup in 1915 in Vancouver with the local Millionaires, a team that included many of the greatest pre- and early-NHL stars: Frank Nighbor, Hugh Lehman, Mickey MacKay, Barney Stanley, Frank Patrick, and Si Griffis.

Fans paid exorbitant prices for tickets to that 1970 game — anywhere from $3.50 to $6.40 — and incredibly it was not a sellout. This was partially because the game was available gratis coast to coast on *Hockey Night in Canada* even though devoted Canucks fans in Newfoundland had to stay up until 3:00 a.m. local time to see the whole proceedings from start to finish. The time difference subtly explained why the NHL had waited so long to admit Vancouver to the big time. It had only been in the past few years that teams started traveling by plane. In 1970–71, the Canucks logged 67,000 travel miles, onerous by air, impossible by train.

While the NHL of the nineties has teams in all corners of the continent — from Vancouver to Montreal in Canada and from Los Angeles and Dallas to Florida in the States — plane travel has not made life easier for the players by any stretch. The expanded schedule, and frequent back-to-back and three-in-four-days games, means that players routinely leave after a game to fly into a new city in the middle of the night. Formerly, a team would take a train, get a good night's sleep in a berth, and arrive leisurely the next morning. The current setup is more, not less, taxing with too many matches featuring tired teams. The pace drags, especially in third periods where the team that goes in leading wins 95 per cent of the time.

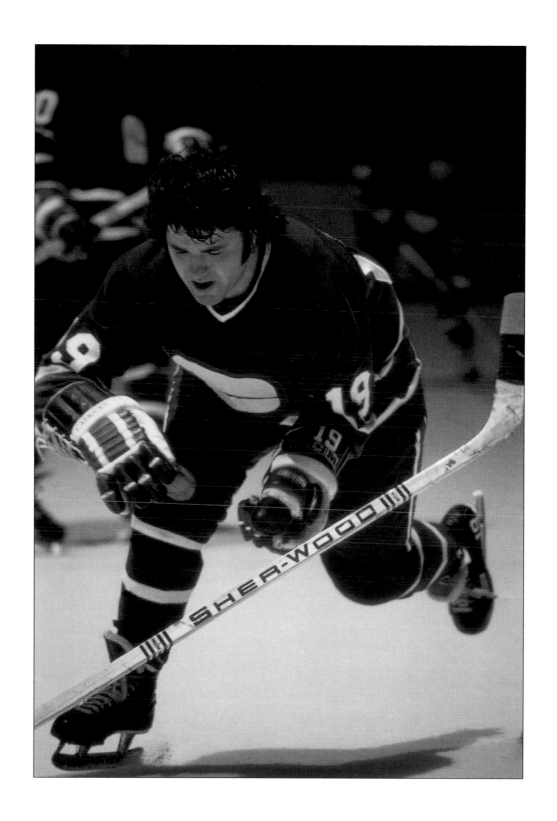

PLATE 37

MARK HOWE AND THE MEGG-NETS

HOCKEY FANS often look with wonder at old photos and are surprised by how the game has changed. They marvel at barefaced goalies; laugh at all the straight-bladed sticks; smile at the old jerseys, plain boards, and simple demarcations on the ice. Although this facing image seems just a normal close-up action shot, it is frightening in retrospect to see Jerry Butler crash into the net. Take a close look at the goal here, for this was truly the most dangerous aspect of old-time hockey (and it wasn't such a long time ago, either). The goal posts were anchored into the ice by virtually unmoveable six-inch spikes, and were further supported by the white, sharp, V-shaped metal plate along the base inside the goal. Here's the story.

On December 29, 1980, the Islanders were in the Civic Center to play Hartford. Whalers defenseman Mark Howe skated back to chase down a loose puck. He lost his balance and crashed into the net. His momentum lifted the net about two inches off the ice, and that metal plate that seems innocent and harmless in this picture all of a sudden turned into a sword. The plate speared Howe in the buttock, grazed his sphincter muscle, and narrowly missed his spinal column. He screamed, then lost consciousness, as the goalmouth quickly filled with a pool of blood. He was that close to never walking again.

Howe spent five weeks in the hospital and lost more than twenty pounds. He was able to return to the NHL but was never again the offensive threat he had been. He filed a $5-million products-liability suit against the City of Hartford, the Hartford Civic Center and Coliseum Authority, and the manufacturer of the net, Jayfro Corp. The league ordered that those horrific plates in all buildings be rounded off. On December 3, 1983, the Toronto Maple Leafs introduced Megg-nets, goals that were supported firmly but which would move on heavy impact. The vicious middle plate disappeared and today, players go to the net confident that they have little chance of sustaining even a minor injury. These new nets were designed by Dennis Meggs of Kitchener, Ontario, and the Gardens became the first NHL arena to use them. For the 1984–85 season, they became mandatory league-wide apparatus.

Prior to the Megg-net, the goal net had undergone a number of changes over the previous century. At first, two posts were frozen into the ice and the goal judge stood behind the net, on the ice. This became a problem for high shots where judgment varied, so a taut rope was strung across the top between the posts. Soon after, netting was also added, the base of the net frozen into the ice to prevent pucks from slipping underneath undetected. These were replaced by wooden boxes and then by a wire cage. With the arrival of professional, organized hockey came a more sophisticated, stylish net designed by goalie Percy LeSueur of the Ottawa Silver Seven. It was innovative in that it had a proper crossbar, was deeper at the base than at the top, and gave the cage a roof for the first time. The net Mark Howe slid into was nearly identical to the Art Ross net which was adopted by the NHL in 1928 and featured two half moons inside the base so that pucks shot from virtually any angle would be trapped inside, thus avoiding controversy about whether or not they entered the net.

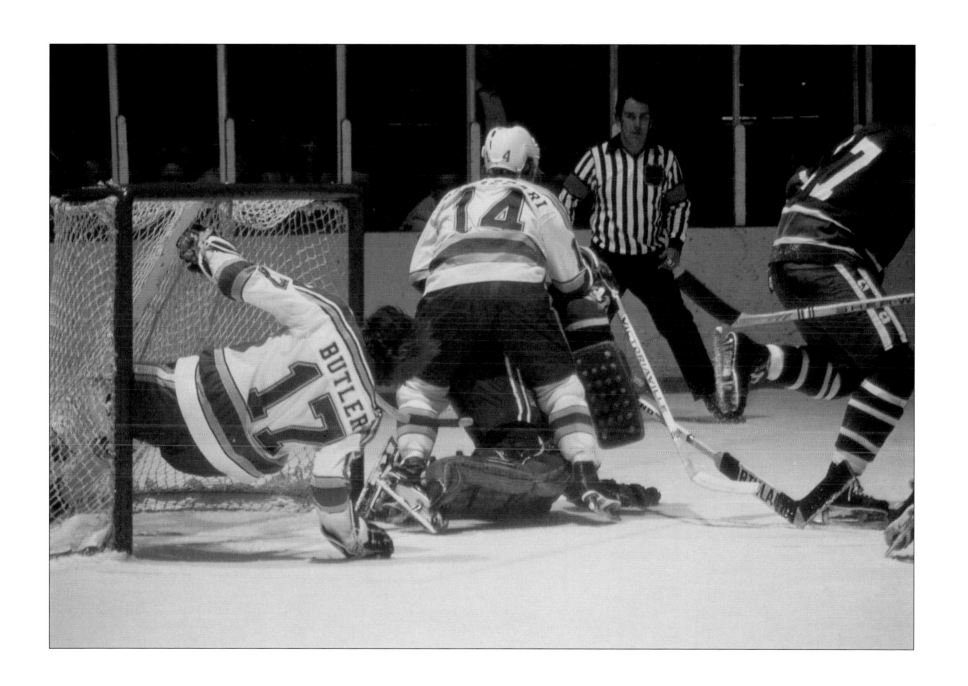

PLATE 38

FRANK MAHOVLICH RETIRED IN GOOD TIME

THE BIG M was one of many Hall of Famers who accomplished so much, but not quite everything, during his career. Another was Rocket Richard who scored 50 goals in a 50-game season, won many Stanley Cups, and had many great games, but never won the Art Ross Trophy, never had 100 points in a season, and fell short of 1000 career points. They say that Gordie Howe did it all, but he never scored 50 goals in a season, and never scored an overtime goal or a Stanley Cup winning goal. Marcel Dionne won an Art Ross Trophy but never a Stanley Cup (which was also true for many great players). Wayne Gretzky has broken virtually every career and season record but not perhaps the most coveted of all: Darryl Sittler's eternally impossible 10 points in a single game.

For Frank Mahovlich, the great un-done was the 50-goal mark. He came close with Toronto in 1960–61 (48 goals) and even closer with Detroit in 1968–69 (49 goals), but although he scored 533 goals in 18 seasons, he never reached the scorer's milestone (although he did score 52 goals in his final year at St. Mike's in junior).

Mahovlich became a Hab on January 13, 1971 when Montreal gave up Mickey Redmond, Guy Charron, and Bill Collins to Detroit to allow the Big M to join his brother Pete in the *bleu, blanc, et rouge*. They became the premier fraternal act in the league. It was, however, only misfortune that prevented Frank and Pete from suiting up simultaneously much earlier for Toronto. Frank had been Leafs' property in the fifties, playing for St. Mike's. But in 1961 the Majors withdrew from the OHL when coach and school principal Father David Bauer felt that education and life experience were being given short shrift by development-conscious NHL clubs. Frank did indeed receive an outstanding education, so when it came time to send young Pete to high school, his father rejected Neil MacNeil (the Leafs' new training ground after St. Mike's) and sent his boy to Father Bauer's care. No team had signed Pete by this time, which meant that he became eligible for the Amateur Draft in 1963, the NHL's new way of distributing talent more evenly. The Detroit Red Wings claimed the Little M, and the brothers' union was put on hold for a few years.

After 3 ½ seasons in Montreal, though, the boys chose different career paths. Frank signed a four-year contract with the Toronto Toros of the WHA which had, ironically, recently signed Paul Henderson to a contract. Henderson was part of the major deal that saw Frank leave Toronto in 1968, and the two would now be playing under former Leaf teammate and now Toros coach Billy Harris. Frank had two fine years with the Toros, but after the team moved to Birmingham, he ran into injury problems. He missed much of 1976–77 recovering from a knee operation and played in great pain the following season with calcium deposits in his elbow. After taking a year off, he decided, like so many before him, to practise the one-two punch of retirement and comeback. At age 41, he attended the Red Wings' training camp in the fall of 1979 while, at the same time, 51-year old Gordie Howe was warming up for his thirty-second pro season, with the Hartford Whalers. At the start of camp, an optimistic Mahovlich observed of his comeback: "...you look at Howe and it makes a guy think..." Apparently he thought again, because the Big M took the high road and abandoned his attempted return. His greatness was enshrined in all that he had already accomplished and was untarnished by his willingness to display publicly that he could no longer even hope to attain that level again.

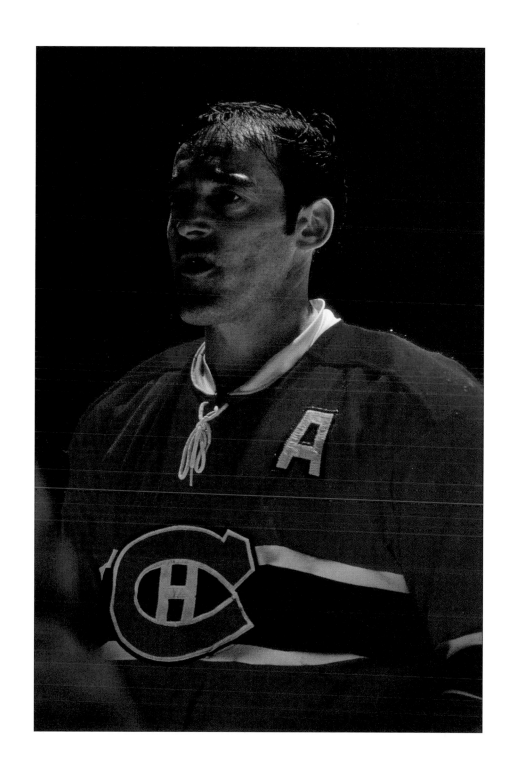

PLATE 39

CESARE MANIAGO AND THE NIGHT BILL MASTERTON DIED

BY 1966–67, the final Original Six season, the backup goaltender had finally become part of the game. The six teams used a total of 19 goalies, but still the main men were all future Hall of Famers: Glenn Hall in Chicago; Ed Giacomin in New York; Johnny Bower and Terry Sawchuk in Toronto; Roger Crozier in Detroit; and Ed Johnston, Gerry Cheevers, and Bernie Parent in Boston. The exception was Charlie Hodge in Montreal. With only six teams and six jobs, being a goalie before 1967 almost certainly meant you wouldn't make it all the way to the NHL.

Such was the fate of Cesare Maniago, a St. Mike's graduate who played seven games for the Leafs in 1960–61. At the time, the Leafs had the great Bower in net, who played every game if he was physically able. As a result, Maniago became a seasoned minor pro, playing with nine teams in the WHL, CPHL, and AHL over the next six years (with a quick 14-game fill with the Canadiens in 1962–63).

Maniago's big break came, not surprisingly, with the 1967 expansion when Minnesota claimed him from the Rangers. He then became the number-one man with the North Stars for the next nine years, and retired with a 3.27 career GAA and 30 shutouts. Not bad for a guy who couldn't find NHL work in the early sixties.

Maniago was in net the night of January 13, 1968, without doubt the darkest day in the history of the NHL. Hockey has always been a fast, ferocious, often dangerous sport. In the helmetless age, on-ice tragedies were always that close to happening, and yet almost miraculously, rarely did. Ace Bailey's brush with death in 1933 was horrific, as was the stick-swinging incident between Jimmy Orlando and Gaye Stewart. Cal Gardner and Ken Reardon engaged in a gruesome hickory brawl, as did Ted Green and Wayne Maki. But no one could have been prepared for that night when Bill Masterton was checked by two California Seals and landed on the back of his head as his wife looked on in horror from the stands.

Dave Balon recalled coming over to his unconscious teammate immediately. "We wanted him to remain still on the ice until they brought out a stretcher. Suddenly, he was coming to, trying to get on his feet. He said, 'Let me go. I'm all right.' Then he went limp. His face turned white and he went into a coma." He was removed from the ice, bleeding profusely from the head, and died two days later without having regained consciousness. It was the day before the NHL All-Star game.

Most hockey aficionados know of the Masterton Trophy but little about Masterton himself. "Bat" was born in Winnipeg and played junior with the St. Boniface Canadiens in '56–'57 and the Regina Pats the following year. He attended Denver University where he played NCAA hockey, played with Hull–Ottawa of the EPHL in 1961–62 after signing with the Habs, and then joined the Cleveland Barons of the AHL the following year. He retired and went back to Denver University where he earned his master's degree in finance in 1964 and played in a number of exhibition games for the US national team.

In the summer of 1967, his rights were purchased by the North Stars from Montreal, and because he and his family had settled in Minnesota he was pursuaded to play for the expansion team. His decision to play was also partly based on ambition and curiosity: "I had to give it a try. Once you're in hockey, you always wonder if you can play with the best," he said at the time. He played just 38 games in the NHL, scoring four times and registering 12 points, before succumbing to his injuries. Ironically, during his three years at university, he had always worn a helmet and only discarded it when he made it to in the NHL.

PLATE 40

BERT MARSHALL — PLAYERS AND COACHES

BERT MARSHALL'S NHL career was perfectly pedestrian. He played for four teams in a 14-year career that lasted 868 games and was forever a reliable defensive defenseman who blocked shots, rubbed his man out along the boards, and played against the other team's best players. After he retired in 1979, Marshall coached the Islanders' farm team in Indianapolis for two years before being hired as the head coach for the Colorado Rockies in 1981–82. He lasted only 24 games (an awful 3-17-4 record) with a team that went on to a pitiful 18-49-13 season. Marshall's career as a coach was over almost before it began.

It is significant that, of the 259 men who coached at least one game in the NHL, 179 had also played in the bigs as well. The connection is not coincidental, nor is the fact that the majority of coaches who have won a Cup behind the bench did not accomplish that feat as a player. In fact, only 12 men have accomplished the Stanley Cup double: Jack Adams, Al Arbour, Toe Blake, Frank Boucher, Terry Crisp, Happy Day, Cy Dennenay, Tom Johnson, Jacques Lemaire, Joe Primeau, Art Ross, and Cooney Weiland.

These facts should not be that surprising, for what makes a player great is not necessarily what makes a coach great. The genius of a great player is inherently individual and instinctive, and he is almost least of all likely to be able to define that genius, let alone pass it on. However, the fourth-line player must understand all team elements of the game because he has had to struggle for his ice time and has to understand the great players in order to stop them defensively. They have to *think* about what they do rather than do it spontaneously. The great player doesn't have to think about his surroundings because he can dictate the game; if he is playing well, he *defines* the game and literally *is* his surroundings. The lesser player has to prevent the star from shining and needs a strategy he can formulate in order to do so. Thus, a great coach will often begin his apprenticeship while playing.

This helps explain why the 12 men to win the Cup as both a player and then coach often had a long and difficult transition. The fastest double was accomplished by Cooney Weiland who won his last Cup as a player in 1939 and his first as a coach just two years later. Frank Boucher was next fastest, taking seven years, and Toe Blake and Happy Day took 10 years to win as coach after being on a Cup team as a player. Al Arbour and Jacques Lemaire took 16 years, and Joe Primeau 19 years. Art Ross took 21 years, the longest time between Cup wins as player and then coach.

A further trivia note: Cy Dennenay is the only man to win the Cup as player/coach, in 1928–29 with Boston. The list of player/coaches includes only 19 names, and most of those assumed double duty before World War II. The last player/coach is also part of another remarkable feat. Doug Harvey joined the Rangers for 1961–62 in that dual capacity, the same year he won the Norris Trophy. He's the only man to serve as player/coach to win a major award and the only defenseman to win the Norris with two different teams, in back-to-back seasons no less, having won it with Montreal the previous year.

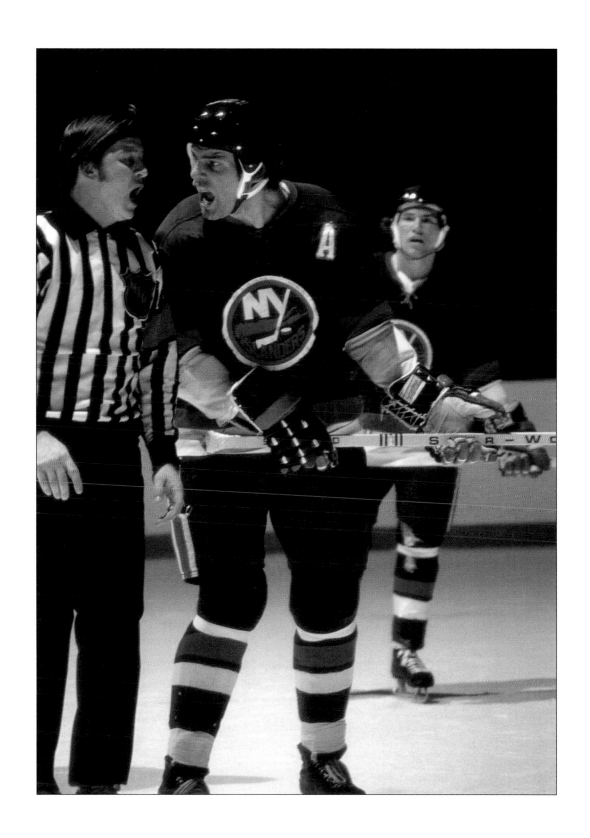

PLATE 41

RICHARD MARTIN WASN'T FAKING

NICKNAMED "RICO" by his Sabres' teammates, Rick Martin was as natural a goal scorer as there was, but his career was cut short by an injury that led to a lawsuit. The game was on November 9, 1980, the team, the Washington Capitals, and the goalie, Mike Palmateer. Martin explained: "I had a semi-breakaway and got tripped at the blue line, and I got up at the top of the circle, and he [Palmateer] ran into me. I tore something [in my knee] but it didn't show up in the tests, and I didn't have surgery for six months. I never played against Palmateer again, and maybe that's a good thing because he would have had trouble ducking my shots."

Although Martin didn't know the exact nature or extent of his injury that night, he knew something was wrong. The Sabres, however, disagreed. "I was injured, but the Sabres issued a press release saying I'd be ready by the weekend. By the weekend, I could hardly walk. Two weeks later, I started to take a lot of heat about not playing. I was starting to look like an idiot to the fans. The team said I was ready — I wasn't. The pressure was there to get back into the lineup. I rushed back. After seven games, the leg deteriorated so badly, I had to get out. I had no choice."

Martin believed it was general manager Scotty Bowman who had pushed him to play before he fully recovered. "Scotty's an excellent coach, but sometimes he's just a little inconsiderate when it comes to people's feelings. He had a good part in ending my career. When Scotty came to Buffalo, he needed a whipping boy, and I became that boy. He figured he could abuse me and I'd still be able to play well.... I had a couple of meetings with Scotty about the injury. It was an insult to my intelligence and my integrity after the career that I'd had in Buffalo to see what was going on. I had a legitimate injury and I was told there was nothing wrong."

Exasperated, the Sabres finally traded Martin to the Kings on March 10, 1981 for a 3rd-round draft choice in '81 (Colin Chisholm) and a 1st-round draft choice in 1983 (Tom Barrasso), Los Angeles also believing the knee injury was not as serious as Martin made it out to be. He played only one game with the Kings that year, another in the first round of the playoffs, and three more at the start of the '81–'82 season before being told by team doctors that he risked permanent damage to his leg if he continued to play. He retired on December 13, 1981 with these words: "I'm only 30 years old. I'm in excellent physical condition. I work out very hard and I take care of myself. I expected to play at least another five years; there was no reason why I couldn't play until I was 35. But now I'm not going to play tonight, or next week, or next September."

The following June 26, he filed a $10-million lawsuit against the Buffalo Sabres and Buffalo General Hospital, more specifically, Scotty Bowman and Dr. Peter Casagrande (the team's physician), alleging the two men forced him to play while he was seriously injured.

He explained: "My beef isn't with the Knoxes [team owners]. It's with Scotty ... I don't know what went on between Scotty and the doctor. I just know what Scotty told me. And I knew what he used to tell [coaches] Roger Neilson and Jimmy Roberts all the time. He'd say, 'there's nothing wrong with him, is there? He's faking it.'"

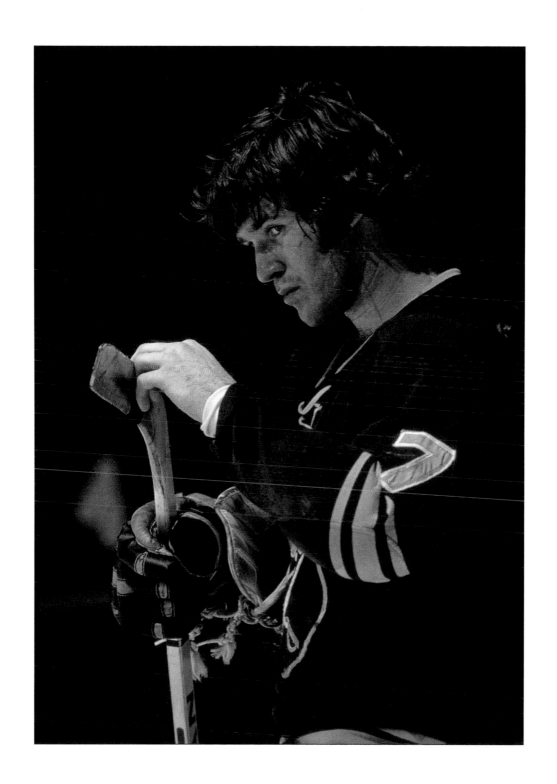

PLATE 42

JOHN McCAULEY'S TRAUMA

THE LIFE of a referee is fraught with the all but hopeless task of trying to be objective. His mandate is objectivity, but his execution must be through his own subjective interpretation. Thus, what is fair to one team is frequently considered unfair to the other. Yet, in every hockey game, there is the explicit respect of the players for the referees. It's a different story for the fans. Notice, for instance, that when the NHL schedule is released at the start of a new season, referee assignments are not made public for each game. This is deliberate because fans will build up an antipathy for certain zebras that verges on insanity. For the NHL to announce the names of the refs for games could be tantamount to promoting violence against them. It's simply too dangerous.

February 11, 1979 was the last of the three games of the Challenge Cup in which the best of the NHL played the best from the Soviet Union in a series replacing the All-Star game at Madison Square Garden in New York. The Russians won the deciding game 6-0 and after, referee John McCauley (who was in Manhattan but not officiating the game) went to the Blarney Rock bar with some linesmen friends — Matt Pavelich, Ron Finn, and Leon Stickle. They got to talking about what the Canadians could learn from the Soviet game when wham! — someone in the bar sucker-punched McCauley once to the jaw, a second time to the left eye. He wrestled the guy to the ground but let him go in the name of avoiding a public incident. His linesmen got their friend to the washroom to clean him up, and in the interim, the attacker fled into the grim Gotham night.

Three days later, prior to a face-off during a Toronto-Flyers game at Maple Leaf Gardens, Bobby Clarke tried to hand McCauley a loose piece of tape from his stick. McCauley reached out to get the tape and missed. His vision deteriorated so quickly that he had to leave the game. Nine days later he was recovering from his first of *five* operations for his double vision. The last one was horrifying but successful, and it partially restored his sight. "You have to have nerves of steel because they only use local anesthetic," McCauley explained in understatement. "The operation required me to be fully conscious so I could guide the doctor by telling him when my vision was clear You can see them fiddling around inside your eye but you can't feel anything."

Two years later, on March 11, 1981, McCauley finally returned to the rink, refereeing the Toronto-Boston game at the Gardens. "The players really helped," he said afterward. "Before the game, many of them tapped my shin pads with their sticks and told me they were glad to see me back.... Salming came over after a quick whistle and said, 'We'll give you that one, but only because it's your first game.'" McCauley had a couple of other memorable nights involving the Leafs. He was the ref the night Darryl Sittler scored his ten points (February 7, 1976), and he also had his nose broken by Sittler trying to break up a fight between the Toronto captain and the Islanders' Garry Howatt.

McCauley's comeback was short-lived, however. At season's end, he took a job with the NHL as director of officiating, a post he held until his untimely and tragic death in the summer of 1989 as a result of complications from a gall bladder operation.

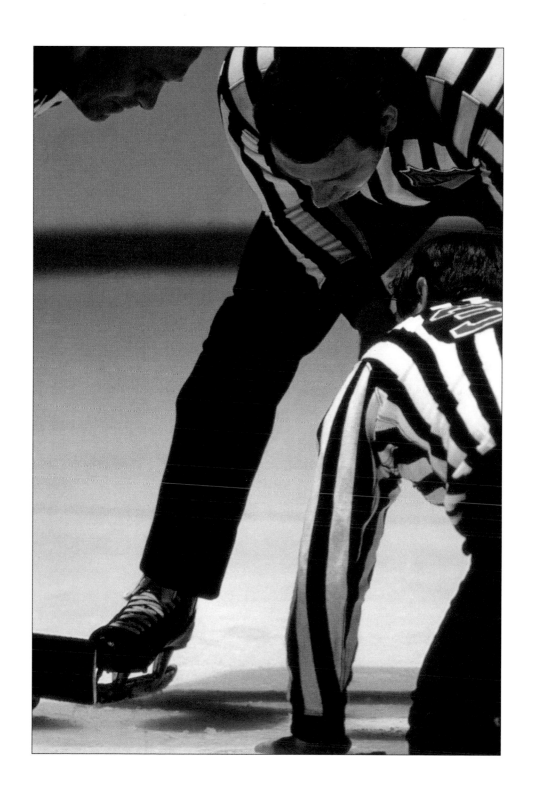

PLATE 43

WALT McKECHNIE — A LONG STICK TRAVELS FAR AND WIDE

BECAUSE THE LEAFS won the Stanley Cup in the spring of 1963, they chose sixth (last) at the very first Amateur Draft in Montreal that summer. The draft, a small affair that took place in the NHL's central office in Montreal, featured only players who had not been signed by one of the Original Six, thus limiting the pool to amateurs of the lowest order, boys who weren't likely to make it to the NHL world.

For their selection, the Leafs took Walt McKechnie, a 15-year-old playing with London in Ontario Junior B. He attended his first pro training camp in 1967 with Toronto but the next month was traded to Phoenix of the WHL for Steve Witiuk. Little did McKechnie know at the time that that would be his first of umpteen trades that saw him play for a then-record eight different NHL teams (twice with Detroit) and three minor-league affiliates in a 16-year career.

From Phoenix he went to the North Stars on February 17, 1968 for Robert Charlebois. Minnesota traded him to California with Joey Johnston for Dennis Hextall on May 20, 1971. He was lost to the Rangers at the Intra-League Draft on June 10, 1974 and traded to Boston for Derek Sanderson (whose stock was dropping) just *two* days later. Boston traded him along with a 3rd-round draft choice in 1975 (Clarke Hamilton) to Detroit for Hank Nowak and Earl Anderson on February 18, 1975. Washington acquired him on August 17, 1977 with a 3rd-round draft choice in 1978 (Jay Johnston) and a 2nd-round draft choice in 1979 (Errol Rausse) for the rights to goalie Ron Low and a Washington 3rd-round draft choice in 1979 (Boris Fistric). McKechnie's inclusion in the deal, as well as the exchange of all the draft choices, was the result of a misunderstanding by Detroit GM Ted Lindsay who thought he could sign Low as an unrestricted free agent. The NHL ruled the signing legal, but compensation was required. Thus, the complex "forced trade." (see Plate 10).

McKechnie lasted only 16 games in Washington before being traded to the Cleveland Barons for Bob Girard and a 2nd-round draft choice in 1978 (Paul MacKinnon) on December 9, 1977. In the summer of 1978, Cleveland and Minnesota merged, and McKechnie was put on the North Stars' reserve list for the Dispersal Draft on June 15, 1978. But before the season started, he was sent to his dream team — the Leafs — for their 3rd-round draft choice in 1980 (Randy Velischek) on October 5, 1978.

Originally, the Leafs gave up a 4th-rounder, but with a provision that it would become a 3rd-round choice if he played more than 50 games with Toronto. He did. The Leafs traded him to Don Cherry's Colorado Rockies on March 3, 1980 for a 3rd-round draft choice (Fred Boimistruck), and at the end of the '80–'81 season, Walt was allowed to become a free agent. Just prior to the start of the next year, the Red Wings signed him. For two years, he wore the Winged Wheel before being forgotten by the NHL.

He signed on with the Salt Lake Golden Eagles for 1983-84 as a playing assistant coach for the Minnesota farm team, although technically, the North Stars signed him as a free agent on August 5, 1983. At the end of the season, he retired. In all his years, he played only twice in the playoffs (a total of 15 games). He was forever being traded for draft choices and a who's who of nobodys. Yet the long-sticked McKechnie was always wanted by some team, and always managed to produce. Only once did he play a whole season with a .500 hockey team (Toronto in 1978–79). Yet despite these weak teams he lasted almost 1000 games in the NHL and scored more than 600 points.

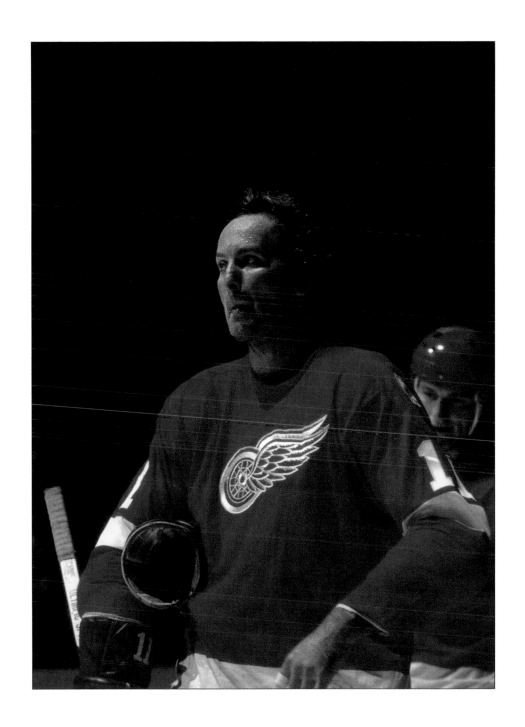

PLATE 44

BILL McKENZIE AND THE LONDON LIONS

BILL McKENZIE'S NHL debut was as amazing in occuring as any experienced by a professional hockey player. He began the 1973–74 season playing two games in London, England for a team called the London Lions. From there, he was recalled to Detroit's top farm team, the Virginia Red Wings. When big-league goalie Doug Grant sprained his shoulder, all of a sudden McKenzie found himself in the NHL. In his first game, against Los Angeles at the Olympia, he was bombarded but kept the team in a game that ended 4-4. He played only 13 games for the Wings that season and 13 more in '74–'75 before being traded to the Kansas City Scouts (with Gary Bergman for Pete McDuffe and Glen Burdon) on August 22, 1975.

The London Lions were the brain wave of Detroit owner Bruce Norris who saw the team as a cutting-edge scheme for developing talent in England. The Lions were part of the new European Professional Hockey League, though the team lasted for only one season. They played out of Wembley's Empire Pool Arena in Earl's Court, London W8 (capacity 8000). The announcement for start-up of the league was made in London on September 14, 1972 while Team Canada was in Sweden to play two exhibition games against Tre Kronor to prepare for the second half of the Summit Series against the Soviet Union. Norris and associate John Ziegler had the chutzpah to embellish the purpose of the five-country, 60-game league by declaring that "a world championship of ice hockey will take place each year between the champions of the National Hockey League (NHL) and the champions of Europe." This was certainly news to NHL president Clarence Campbell, and, of course, these games never occurred.

The Lions wore the familiar red-and-white Red Wings jersey but with an incongruous lion on the crest. The team was almost entirely Canadian and trained at Port Huron, Michigan before beginning the season in London. The schedule featured matches against European clubs, beginning with their home opener against an Austrian aggregation. They played about three times a week against a wide range of teams — from Austrian Internationals to Finnish Olympics and Helsinki IFK, Dynamo Moscow, and other clubs throughout Europe. They began the year undefeated in their first 15 games (13-0-2) and finished with a record of 49-6-12 while outscoring the opposition 416 to 207. Their schedule was divided into three large sections: October and November, mostly home games at Wembley; December through February, on the road in Europe (including participation in the Ahearne Cup in Sweden); March, back home at Wembley. The intent was to try to establish a permanent European league for the following season, a modern farm team using the best players in Europe as a training ground for the NHL (an anacronostic folly, really, given that the Wembley ice was still being scraped during intermissions by three rubber-booted, lab-coated men using Brobdingnagian shovels).

The Lions were managed and coached by former Wing player and head coach Doug Barkley. It was the lowest level in the Wings organization and chain of development. Other players on the roster that year included team captain Rick McCann, Earl Anderson (who scored 59 goals in 67 games with London), Ray Bibeau, Terry Clancy, Mike Jakubo, Dennis Johnson, Wayne Korney, Brian McCutcheon, Tom Mellor, Dennis Polonich, Nelson Pyatt, Terry Richardson, Charlie Shaw, Ron Simpson, Brian Watts, and Murray Wing. The old-time Swedes were represented by starting goaler Leif Holmqvist and superstar forward Ulf Sterner, who represented the Tre Kronor 11 times at the World Championships and who led the Lions in points with 115 on the year. After McKenzie returned to North America early in the season, Holmqvist's backup was rookie Tim McQuiston. While most of the Lions were given a shot at making the grade with the Red Wings, only Polonich can be said to have made anything of the opportunity. Most of the others, like Bill McKenzie, failed to catch on with the Wings or any other NHL team.

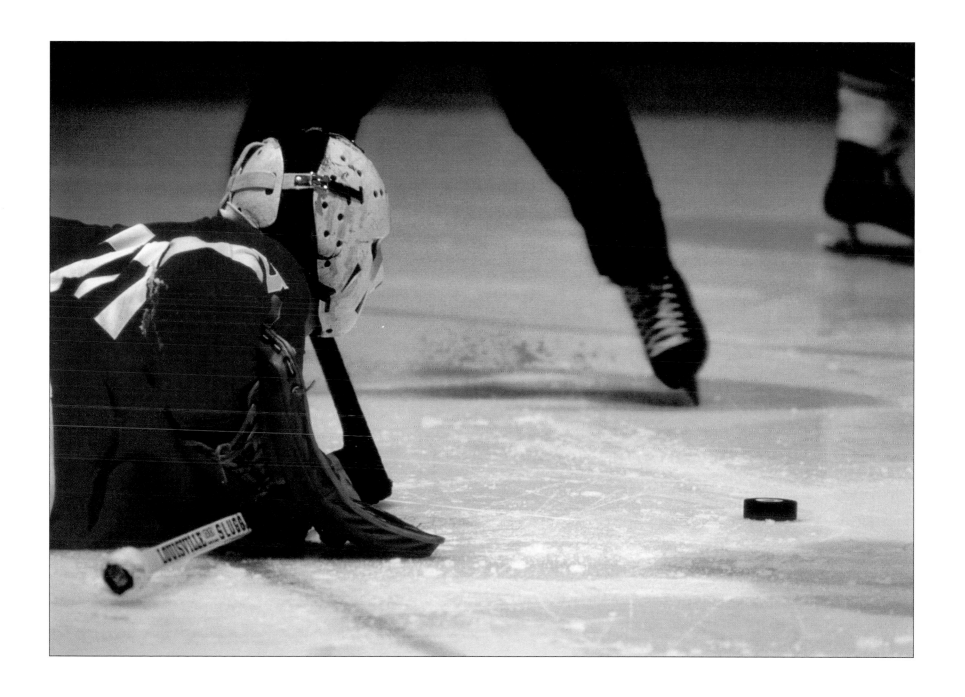

PLATE 45

GILLES MELOCHE — A CONCISE HISTORY OF NUMEROLOGY

--

ADDING NUMBERS to jerseys was an innovation in the NHL's early years, something different and eye-catching, and was conceived in an attempt to create interest and excitement among fans. While the Montreal Wanderers were the first team to have numbers back in 1914, all NHL teams were using the gimmick when the league was formed three years later. Gilles Meloche's number 27 is one part in the long and intriguing history of goaltenders' numerology.

In the early days, goalies always wore number 1, the defensemen, 2,3,4 and 5, and the forwards, higher numbers. The system came out of soccer where players were numbered according to lineup cards. The goalie was always the first player listed, the defense, second, the forwards, last. Irregular numerical behavior began early, however, and has been a delightful curiosity to fans ever since. In 1926, Montreal *defenseman* Herb Gardiner decided to wear No. 1. Goalie George Hainsworth then adopted No. 12. That same season, the Rangers used two goalies — Hal Winkler, wearing the traditional No. 1, and Lorne Chabot as No. 2. The next season in Boston, Winkler wore No. 11, while great defender Sprague Cleghorn wore No. 1.

When teams began to use two goalies on a regular basis the numerological consequences were significant. There were three possible results. One, the above-mentioned Ranger theory: one goalie wears No. 1, the second wears No. 2. Two, the second goalie wears the highest and last number on the team (because he was least likely to play). This is why goalies in the 1960s often wore 23 or 24 because they were the 23rd or 24th man on the roster. In 1929–30, Clint Benedict wore No. 1 for the Maroons, and his backup Flat Walsh wore No. 15 (since the roster size was increased from 12 to 15 players that year). The next year, Walsh was the incumbent and moved into the No. 1 jersey, while his backup Dave Kerr had to slip into the unpoetic No. 15.

Other times, the two goalies both wore No. 1 because they rarely played in the same game. If they did, the second would simply wear the first man's jersey. For instance, Joe Miller and Vernon Forbes both wore No. 1 for the New York Americans in '27–'28, as did Walsh and Normie Smith in '31–'32 for the Maroons. The record books will show that Dave Dryden began his career with the New York Rangers the night of February 3, 1962 even though he was watching the Leafs-Rangers game from the comfort of his Greens in the Gardens that night. Regular goalie Gump Worsley was injured during the game, and NHL rules at the time stipulated that the home rink had to have two spare goalies in the crowd in case of injuries. When Worsley was unable to continue, Dryden was summoned from his seat, put on his equipment, and adopted the Gumper's No. 1 jersey as part of his uniform. That was how he got into his first NHL game.

For many young fans, unusual numbers began with Wayne Gretzky wearing No. 99 when he entered the WHA and then the NHL. But long before this, players were having fun with numbers. In 1934–35, for example, the Montreal Canadiens were a veritable bingo hall of jersey numbers in an attempt to drum up interest in the lagging, sagging, flagging team that was having a tough time competing at the box office with city football. Norm Collings, Johnny Gagnon, and Paul-Marcel Raymond all wore No. 48, John McGill wore No. 55, Armand Mondou wore No. 64. Leroy Goldsworthy, John Portland, and Desse Roche all wore No. 75 at one time during that season, Roger Jenkins wore No. 88, and Leo Bourgeault and Joe Lamb wore the pre-Gretzky No. 99.

Goalie numbers took a bit of a turn in 1969 when Tony Esposito adopted No. 35 in Chicago, and two years later, Ken Dryden wore No. 29 for the Canadiens. Meloche began wearing No. 30 with Chicago in 1970–71 and the next year, when he went to California, he became the first goalie in NHL history to wear No. 27.

PLATE 46

WAYNE MERRICK AND THE CLEVELAND BARONS

CLEVELAND WAS one of a number of franchise oddities and disasters in the 1970s atlas of the NHL, becoming the Barons to start the '76–'77 season. After losing millions of dollars, the California Golden Seals up and left the West Coast. One reason the team found its way to Ohio was because of George Gund, a part-owner of the Seals and a native of Cleveland. When the team's situation became so desperate that it could no longer remain on the coast, Gund was a prime force in getting the NHL to officially approve the move east on June 30, 1976.

The Barons' logo was designed by Walter Lanci, owner of the Offset Color and Printing Company in nearby Bedford Heights, Ohio. The large "C" was a simple starting point, and Lanci felt the words "Cleveland Barons" within that "C" looked elegant and official. The "B" was a variation of old English script, in the shape of the state of Ohio, indicating a pride in Ohio's only NHL team. The Ohio theme is not only on the front of the jersey, but is also used as a frame for the shoulder numbers as well.

The team played its home games at the huge Coliseum in Richfield, Ohio, but never were the 18,544 seats filled. Average attendance hovered around 5300 to watch the 3-M line — Dennis Maruk, Al MacAdam, and Bob Murdoch — and the rest of the NHL Barons. Within weeks of its inaugural season, the team was in financial straits of the worst order. Owner Mel Swig was losing money hand over clenched fist, and by the end of January, there was a feeling that the team would fold any day. Swig went to the league, begging for a loan of $1 million to make it through the season. But after repeatedly bailing out the Seals to the tune of about $8-million over the previous nine years, such a plea was difficult for the league's governors to swallow. All the NHL would promise was to defer $250,000 owing until May 31.

Swig then asked the Baron players to accept pay cuts of 27 per cent until May 15, which they finally agreed to. Then the ultimate calamity occurred: he failed to make the players' February 1 payments. That meant that within 14 days, they would have to be paid or they would all become unrestricted free agents. On February 16, Swig unloaded an incredible 19 contracts in the system! Three NHL players — Phil Roberto, Frank Spring, and Glenn Patrick — were immediately free. Three Barons playing in the International League and 13 in the Central League were also released outright. Although the team was still in the NHL — barely — it had virtually no farm system remaining save for seven players at Salt Lake City in the Central League. That night, the team lost 5-3 to the Leafs before just 4308 fans at the Coliseum. That game had initially been postponed early in the afternoon and then resuscitated only after a league loan of $175,000 allowed Swig to meet the payroll.

A week later, the Grim Reaper took another scythe-swing at the head of the Barons, but again missed when Swig injected $350,000 into the team, an amount that was matched by the league. The NHLPA came up with $600,000 for the franchise and was promised repayment in the form of gate receipts from extra exhibition games the players agreed to play at the start of the next two seasons. The Barons were alive until season's end.

On June 9, 1977, George Gund and Sanford Greenberg bought the franchise from Swig for just $500,000, but condition of the sale in the eyes of the NHL was contingent upon the new owners clearing the Barons' $4.5-million debt and guaranteeing the operating budget for '77–'78 of some $2 million. The next year was equally moribund, and the team merged with the Minnesota North Stars for the start of the 1978–79 season.

The Cleveland Barons, 1976–1978. *Requiescat in pace.*

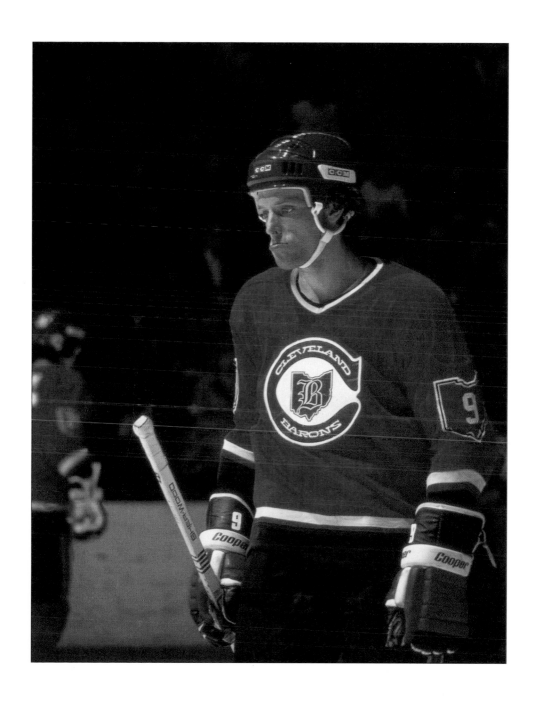

PLATE 47

THE OAKLAND SEALS COME AND GO

THE 1967–68 SEASON marked the end of the Original Six Era (1942–67) and the start of a new era of expansion in the United States, the lucrative market that was supposed to be untapped and hockey mad. The NHL went from six teams — Toronto, Montreal, Boston, Chicago, Detroit, and New York — to 12 teams, adding the Minnesota North Stars, Philadelphia Flyers, Pittsburgh Penguins, St. Louis Blues, and two west-coast teams, the Los Angeles Kings and Oakland Seals. Each expansion team paid the NHL $2-million to join the elite hockey world.

Seals owner Charlie Finley delivered nothing if not a colorful team, the uniforms comprising a rich mix of green, blue, black, and white at various times. The inaugural makeup of the team looked eerily like a group of over-the-hill and never-quite-made-it Maple Leafs. No fewer than nine of the 17 Seals on opening night had played for the Blue and White at some time: Wally Boyer, Terry Clancy, Gerry Ehman, Billy Harris, Bobby Baun, Larry Cahan, Kent Douglas, Aut Erickson, and Gary Smith. They were also coached by another former Leaf, Bert Olmstead.

The original Oakland logo featured a seal with a green body and black head holding a hockey stick and surrounded by a series of narrow black, white, and blue circles. For the start of the 1970–71 season, however, the jerseys and name were made over. The team became the California Golden Seals and the players wore golden-yellow jerseys with green bands down the arms and across the socks and green pants. A year later, they became the first team to have names on their jerseys (see Plate 32). In typical Finley fashion, the skates were now polar-bear white with green laces! The front of the jersey was emblazoned simply with the word "Seals" in green with a white outline. The team played out of the Oakland-Alameda County Coliseum Arena, a name rich in duplicity for it was in neither Oakland nor Alameda, but rather right on the Nimitz Freeway between the two.

The Seals lasted through the 1975–76 season, the only one of the six new teams not to find firm footing in its market. In its nine seasons, the team dressed more than 130 different players and finished last (of 12 teams overall), eighth, tenth, last (of 14), eleventh, fifteenth (of 16), last, sixteenth (of 18), and fourteenth, qualifying for the playoffs only in 1968–69 and the following year (and losing both first-round series). In 1967–68, the Seals were shut out 13 times and averaged just 4960 fans a game. While attendance peaked in 1969–70 at 6225, the team's overall record was an appalling 182-401-115 in 698 NHL games, and they were outscored 2580-1826. Such a woeful record in a nonhockey market was enough to ensure the team's demise. It was not until 1991, 16 years later, that California was given a second franchise again, this time in the form of the San Jose Sharks. Two years later, the Mighty Ducks of Anaheim joined the NHL, giving the state its strongest representation at the NHL level in the league's history. So long, Nimitz; hello, Disney.

PLATE 48

OFFICIALS FACE OFF

"DROP THE PUCK!!!" How many times has this been screamed from the rafters by excited and impatient fans, preferring a quick and volatile draw to a carefully orchestrated, time-consuming, drawn-out blade showdown?

In the early days of the game, players taking the face-off lined up with their backs to the sideboards rather than to their own goal. Their bodies were both neutral rather than one on defense, one on offense, as the Rule Book for 1941–42 explains: "Players 'facing' must stand with their left sides toward their opponents' goal and the stick of each player must be on the same side of the puck as his own goal."

There is a famous and funny story about King Clancy's days as referee. Once, the players weren't lining up properly and Clancy told them to smarten up or he'd throw the puck in the corner and they could chase after it themselves. They didn't, and he did, and play quickly resumed!

Rule 54 of the current rules book is a bit more complex than Clancy's informal adjudication of the ceremony:

(A) The puck shall be faced off by the Referee or the Linesman dropping the puck on the ice between the sticks of the players facing off. Players facing-off will stand squarely facing their opponent's end of the rink approximately one stick length apart with the blade of their sticks on the ice. When the face-off takes place in any of the end face-off circles, the players taking part shall take their position so that they will stand squarely facing their opponent's end of the rink, and clear of the ice markings. The sticks of both players facing-off shall have the blade on the ice, within the designated white area. The visiting player shall place his stick within the designated white area first followed IMMEDIATELY by the home player. No other player shall be allowed to enter the face-off circle or come within fifteen feet (15') of the players facing off. All players must stand on side on all face-offs. If a violation of this sub-section occurs, the Referee or Linesman shall conduct the face-off again.

(B) If after warning by the Referee or Linesman either of the players fails to take his proper position for the face-off promptly, the Official shall be entitled to face-off the puck notwithstanding such default.

(C) In the conduct of any face-off anywhere on the playing surface, no player facing-off shall make any physical contact with his opponent's body or by his stick except in the course of playing the puck after the face-off has been completed. For violation of this Rule, the Referee shall impose a minor penalty or penalties on the player(s) whose action(s) caused the physical contact.

(D) If a player facing-off fails to take his proper position immediately when directed by the Official, the Official may order him replaced for that face-off by any teammate then on the ice. No substitution of players shall be permitted until the face-off has been completed and play has resumed except when a penalty has been imposed which affects the on-ice strength of either Team.

(E) A second violation of any of the provisions of sub-section (a) hereof by the same Team during the same face-off shall be penalized with a minor penalty to the player who commits the second violation of the rule. The official must drop the puck twice in order to have a second face-off violation. Any time change on the clock during this drop will not be replaced. During end zone face-offs, all other players on the ice must position their bodies and sticks on their own side of the restraining lines marked on the outer edge of the face-off circles. If a player other than the player taking the face-off moves into the face-off circle prior to the dropping of the puck, then the offending Team's player taking the face-off shall be ejected from the face-off circle. If a violation of this Rule occurs, the Referee or Linesman shall order another face-off, unless the non-offending Team wins the draw and retains possession of the puck.

Better to have King Clancy just throw the puck into the corner.

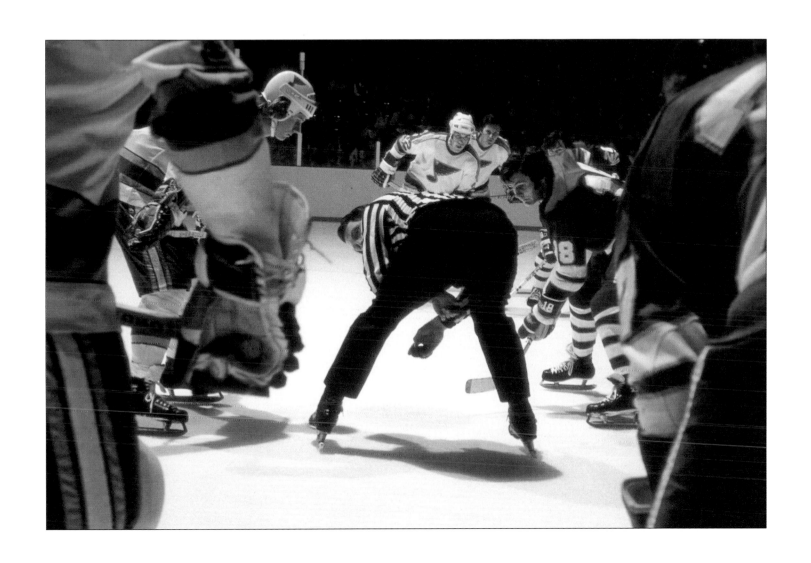

PLATE 49

TERRY O'REILLY TAKES ON ALL COMERS

TERRY O'REILLY was selected 14th overall by the Boston Bruins at the 1971 Amateur Draft, confessing at training camp that fall "I'm not a real fancy right wing." It wasn't long before he was given the moniker "Taz" — short for Tasmanian Devil — for the fierce, undying determination that kept him in the NHL and with Boston for 14 years. O'Reilly epitomized the Big Bad Bruins of the 1970s, the lunch-pail guy whom coach Don Cherry loved not for his skills, but for his heart. He was a star who made the game look ugly, but few were as successful or as respected as Taz. He became beloved by Boston fans not for raising his stick after a goal, but for skating breathlessly to the bench with blood dripping down his face, ready for a towel, a slug of water, and another shift.

His emotions, however, were not always kept in check, and he got into big-league trouble more than once. In a game on October 26, 1977 against Minnesota, O'Reilly was given a tripping penalty late in the third period. Angry, he bumped referee Denis Morel and then threw his glove Morel-ward. Although O'Reilly missed, NHL executive vice president Brian O'Neill suspended him for three games, stating, "There can be no excuse to justify abuse of officials. The league will continue to deal with these offenses very severely."

On December 23, 1979, as the buzzer sounded to end the Bruins' game against the Rangers, a fan hit teammate Stan Johnathan. O'Reilly went into the stands to remonstrate with the fan, and a bit of a brawl ensued. Once the dust had settled, NHL president John Zeigler suspended Taz for eight games and the fans involved in the scuffle began a $7-million lawsuit. "I did what I thought I should do," O'Reilly commented. "I stopped him. Then being sued and suspended and fined. I'd hate to see what would happen if I did something wrong."

On April 25, 1982, during the heat of a Game 7 Adams Division Final between Boston and Quebec, he hit referee Andy van Hellemond with his glove. O'Reilly refused to appear at a preliminary hearing into the matter on May 7 and as a result was suspended by the NHL indefinitely. The hearing was rescheduled for June 1, with O'Reilly in attendance, and four days later, he was fined $500 and suspended for the first 10 games of the 1982–83 season.

However, despite his bad behavior, "Taz" was a profound motivator who led by example. He succeeded Wayne Cashman as team captain (1983–85) until he retired, and later that year when Butch Goring was fired as coach, O'Reilly was installed behind the bench. He held that position for three years until his resignation on May 1, 1989. As a coach, he was as maniacal as he had been as a player. On April 13, 1988 a warrant for his arrest was issued by Hartford police for third-degree criminal mischief and tampering with a motor vehicle. After a game against the Whalers the previous week, the Bruins came out of the building to find a parked car preventing the team bus from leaving the garage. O'Reilly smashed the window, looking unsuccessfully for the keys, and then enlisted the services of six players to push the car into the middle of traffic. He later agreed to pay for the damages, and the charges were dropped.

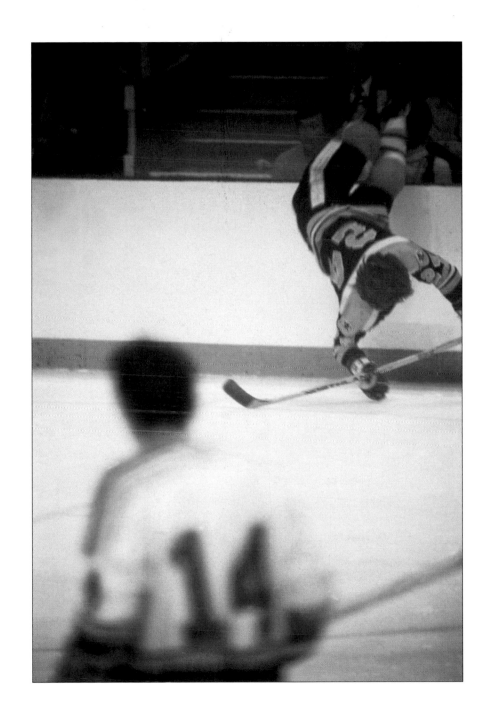

PLATE 50

BOBBY ORR — VENI, VIDI, VICI

BOBBY ORR was not only arguably the greatest player ever to play the game, he both defined and epitomized the expanded NHL of the seventies. Orr whizzed the league out of the black-and-white Original Six era to the glitz and glamor of color. He brought the players out from under the yoke of paid servility to the day of the superstar, for it was his huge contracts that dictated the pace and rate of pay increase in the league.

In a sport that had long been broadcast on radio and black-and-white television, he arrived at a time when color TV and advertisements began to promote the NHL and give greater exposure and credence to the league's superstars. Virtually every issue of *The Hockey News* used his face and words to promotional purpose: Bobby Orr says "It's A Man's World with Yardley Black Label"; Bauer Skates Score with Bobby Orr; Bobby Orr/Mike Walton Sports Camp; New Bobby Orr/Rally hockey gear. Orr was everywhere — the Shakespeare of hockey, the Beatles of blades, the Picasso of the NHL.

The sports pages were filled with Orr's Boston Bruins accomplishments. And like never before, a hockey literature evolved. There was *Dynamite on Ice: The Bobby Orr Story* by Hal Bock, featuring such chapters as "Oshawa," "The Signing," "The Rookie," "Crutches and All," "Big Money," "A Record Tune," "Babe Ruth On Ice," and "The Cup." N.H. Page wrote *Bobby Orr — Number Four: The Ice Hockey Legend.* The back cover described the book and Orr's life: "This is the story of Bobby Orr — Number Four — the great hero who changed the strategy of hockey defense and led his team to national victory during 10 exciting years. This fast-paced account highlights Bobby's wins and losses, serious injuries, and Stanley Cup victories. More than 30 action-packed photographs detail Bobby Orr's outstanding rise to fame."

Orr On Ice was ghost written by Dick Grace and provides insight into what he does on the ice, as the back cover quote reveals: *"Orr On Ice* is the way I play hockey! — Bobby Orr." There was also, *Here Comes Bobby Orr,* written by Robert B. Jackson, Al Hirschberg's *Bobby Orr — Fire On Ice,* and Marshall and Sue Burchard's *Bobby Orr: Sports Hero.*

Not only was Orr a great player, he had all the elements needed to make a great story that would be accessible to all of North America. He was born in a small Ontario town, yet excelled in big-city USA. He was incredibly successful, and yet suffered horrific knee injuries that were romanticised as appealing features to his hockey beauty, his career phenomenal yet "cut short." His name and number rhymed, short poetry that the masses could recite and catholicize. As a result, he had no nickname; "number 4" didn't need one.

PLATE 51

BOBBY ORR — A LOYALTY BETRAYED

"Guilty...guilty...guilty." (Alan Eagleson, January 6, 1998, a Boston courthouse)

THE SIGHT of Bobby Orr in a Chicago uniform is both preposterous and incongruous, forever a reminder of the untold injustices done to him by his agent Alan Eagleson. Orr was set to become a free agent on June 1, 1976. Everyone in the hockey world knew this, and negotiations with Boston to keep him in town began long before the contract expired. Boston's version of events were usually communicated to the outside world via GM Harry Sinden; Orr's, by his agent Eagleson.

According to Eagleson, there was an agreement in place by October 1975. Two days later, Boston took its contract offer off the table and Eagleson publicly denounced the move: "They reneged on the deal because in those two days, they went to Lloyds of London to insure the contract and couldn't. Lloyds told them that there wasn't any way they would touch Bobby Orr insurance-wise with his bad left knee. It was just too much of a risk. This is why they copped out."

A spokesman at Lloyds confirmed this: "We did turn Bobby Orr down on the insurance. Alan knows what he's talking about. He's done business with us before. We'd be crazy to insure Orr's knee. We've had policies on him before and we didn't include his knee, either. That would be a hell of a gamble."

A short time later, Eagleson received another offer: "They offered a five-year deal at $295,000 per season plus $925,000 or 18.6 percent ownership of the club in 1980. I didn't think it was wise for him to be a player-owner." There was one problem with this assumption: he never told his client of the offer. "I never knew," Orr said much later. "There's no way I was given the details of that kind of offer. I think anyone would remember it if he was offered a piece of a National Hockey League club."

Any offer, however, was a moot point after May 18, 1976. That was when Orr, while still under contract to the Bruins, signed an agreement with Bill Wirtz of the Hawks on Eagleson's advice, in the presence of Ross Johnson, a friend of Eagleson's, and Roger Baikie, a friend of Johnson and soon to be famous for the Tuuk blade (see Plate 5). The agreement read: "We agree to a three-year contract guaranteed commencing June 1/76 through May 31/79 at $500,000 per annum. In addition, Chicago will have options annually for a further seven years on Orr's services at $500,000 per annum." This signing, struck between the president of the NHLPA and a member of the board of governors of the NHL, violated the league's tampering rule.

After signing with Chicago, Orr was not left in peace. Boston and the Hawks began vociferous and public fighting over what compensation Chicago would have to pay for this free agent signing. Nothing could be resolved, so the season began in turmoil. The Bruins sued the Hawks after Orr's first game with his new team in an attempt to keep him off ice until the compensation had been resolved. Chicago then countersued, charging the Bruins with harassment, which gave the team 10 days in which Orr would be allowed to play.

On November 21, 1976, both teams agreed to abandon all legal action until the end of the year. During that time, a careful analysis of Orr's impact on Chicago could be determined, and fair compensation based on his performance and the strength of his knee would be more easily ascertained. Orr, unfortunately, played just 20 games that year, and the compensation matter was laid to rest.

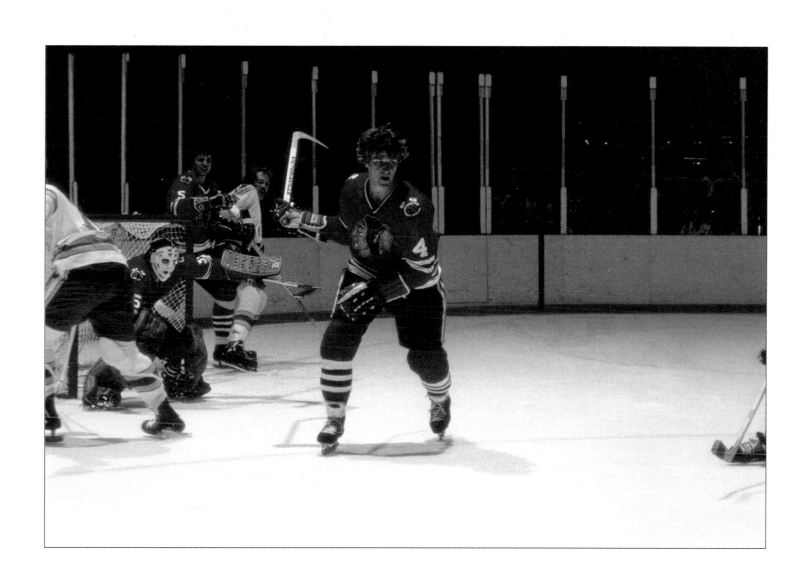

PLATE 52

BRAD PARK, BY COMPARISON

BRAD PARK played in the NHL from 1968 to 1985 with the Rangers, Boston, and Detroit. In 17 seasons, he never once failed to make the playoffs, but he never won the Stanley Cup or even a major trophy. For most of his prime years in the league, he was considered the second-best defenseman, the second most desirable player to have, the second most valuable to his team. Number one was always Number Four.

From 1968, when he played his first game with the Rangers, Park lived in Bobby Orr's shadow. It was ironic, then, that early in the '75–'76 season, he became Orr's teammate, though in team more than mate, in one of the biggest trades in the history of the NHL. At season's end, Orr became a free agent and signed with Chicago while Park stayed with the Beantowners for seven more years.

An interesting comparison is always to see how the greats play against each other. During the period 1968–75, Orr and the Bruins played Park and the Rangers 38 times, the Bruins holding a 19-15-4 edge in wins-losses-ties. In those games, Orr scored 23 goals and 33 assists for 56 points; Park scored 10 times, had 27 assists and 37 points. The only time the teams faced each other in the playoffs proved to be the ultimate battle: in 1972, Orr's Bruins beat Park's Rangers in six games to win the Stanley Cup.

Because of Orr's injuries, he and Park played together with Boston for only 18 days in November 1975, 10 games that saw the two best defensemen of a generation on the same blueline (goals-assists=points):

DATE	OPPONENT	SCORE	ORR	PARK
November 8	Vancouver	2-4	0-2=2	0-1=1
November 9	California	6-3	0-3=3	1-1=2
November 13	Minnesota	6-0	1-2=3	0
November 15	Atlanta	5-3	1-2=3	1-2=3
November 16	Kansas City	4-2	0	0-1=1
November 19	Detroit	3-3	1-0=1	0
November 20	Islanders	2-2	0-1=1	0
November 23	Toronto	3-3	1-1=2	0
November 25	Los Angeles	4-2	0-1=1	0-1=1
November 26	Rangers	6-4	1-1=2	0-1=1
TOTALS	**6-1-3**	**41-26**	**5-13=18**	**2-7=9**

After Orr signed with Chicago, he played just 20 games for the Hawks in 1976–77 and six more in 1978–79. Only once did Park's Bruins face Orr's Hawks: Boston won 5-3. Orr had an assist in the game, Park a goal.

Although not as skilled offensively as Orr, Park played a similar daredevil, hell-bent, knee-wrenching style. This, in turn, led to many operations of his own. He joined the Wings for two years after Boston and then retired after having played an incredible 1113 regular season games and 161 more in the playoffs. Toward the end, had literally no cartilage left in his pins. Three years after he retired, Park was inducted into the Hockey Hall of Fame.

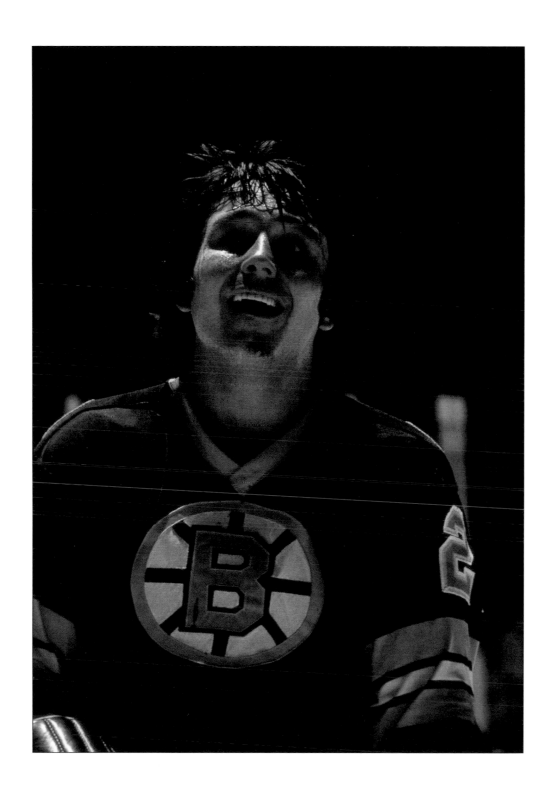

PLATE 53

LARRY PATEY — HELMETS COME OF AGE

AS LARRY PATEY is checked here by Peter Scamurra, another moment of seventies fashion is captured on film. This time, it's the changing or, rather, the donning of the guard, as helmets became the safety feature for players that masks had been to goalies the previous decade.

The question of whether to wear a helmet or not first began in earnest the day after the Leafs played the Bruins in Boston on December 12, 1933 when Ace Bailey's career ended (as his life nearly did) after crashing to the ice from an Eddie Shore check. Shortly after that horrific night, all Bruins wore leather helmets similar to those worn in football. The players complained, however, that when they sweated, the helmets became too heavy and reduced their speed. The universal helmet project died, and as Ace recovered, the players could console themselves in the fact that they were not yet risking their lives by playing without one.

Helmets became popular with the advent of the Bobby Hull howitzer when facial protection was gradually accepted by goaltenders. The speed and danger of the game were increasing; players showed up to training camp in shape; diet, off-ice conditioning, and competition all improved the size and physical abilities of the players. But for every proponent of the helmet — Stan Mikita foremost among that group — there was another player equally against it. In the 1972 Canada-Soviet Union Summit Series, played under international rules, all players had to wear helmets. This infuriated Phil Esposito, a man playing a man's sport. After the eighth and final game, in Moscow, he threw his headgear ceremoniously into the stands, wearing an expression of both relief and disgust. The torture was over.

Today, every player wears a helmet, and many wear half shields to protect their faces and eyes as well. But the helmeted generation of pros seems to have created as many problems as it has solved. Clearly, the helmet has saved players from being injured from hard checks into the boards or from falling violently and unexpectedly to the ice. But NHLers now play in a fashion in which high-sticking is as much a part of the game as the face-off and the slapshot. Plexiglas is not viewed as a wall to respect but as a means of crushing an opponent. Concussions have become a commonplace injury not because of one particular blow, but often a series of blows over the course of a few weeks or years. (Plexiglas is, for all intents and purposes, see-through concrete.)

High-sticking also means shields become needed to protect the eyes, but then again, shields mean more jousting, which can lead to more neck injuries or, as has happened, more dependence on using the stick for playing. Watch footage of old-time hockey from 20, 30, or 40 years ago. The stick was used almost exclusively for shooting and passing. Today, it is a part of equipment that is employed to hook, slash, impede, and generally reduce the level of skill in the game. Referees call penalties based not upon what was done, but upon what the results of the act were. In other words, a hook is not called unless a player goes down, and a slash is a penalty only in the event of a pained reaction from the recipient. Thus, high-sticking becomes an integral part of checking because it is always effective and intimidating but not often seriously injurious. It is violent and perhaps poses more of a threat today than the message sent by the occasional accidental injury which occurred in the old days when mutual respect among opponents took the place of helmets.

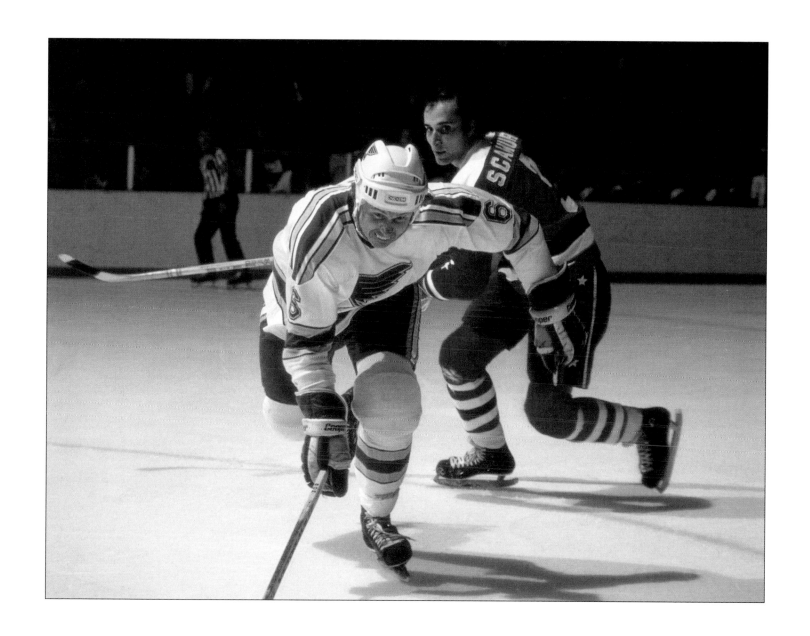

PLATE 54

GILBERT PERREAULT AND NUMBER ONES AT THE DRAFT

GIL PERREAULT was selected first overall by the expansion Buffalo Sabres in the 1970 Amateur Draft. That the Sabres, and not the Montreal Canadiens, were allowed to take him is a story in itself.

In 1963, the NHL decided that all players who had not been signed to an NHL contract (a C-form) would be "drafted." That is, no longer could any team sign any player as had always been done since 1917. Now, the league would go in order — the last place team in the Original Six selecting first and the first place team selecting last.

This meant that juniors could not be signed by an NHL team until they had been drafted. In turn, this meant only a few Toronto Marlies would play for the Leafs, Hamilton Red Wings for Detroit, Guelph Biltmores for the Rangers, St. Catharines Teepees for the Blackhawks, and Oshawa Generals for the Bruins. Furthermore, since the inception of the draft, the Montreal Canadiens had always been allowed to select the first two French-Canadian players, clearly an unfair advantage. After the Habs selected Rejean Houle and Marc Tardif one-two in 1969, that privilege ended. This paved the way for Perreault, a junior with the Montreal Junior Canadiens, to be selected by an American expansion team the very next year.

Incredibly, the first overall draft selection has seen as much failure as success. One would think selecting the very best player would be the easiest task of all, but historically this has not been the case. Here is a list of all first draft selections, 1969 to 1998, with a subjective five-star rating used to assess their eventual merits. Only five have achieved five stars.

Notice that no goalie has ever been selected first overall, and only five defensemen have received the honor. First overall has traditionally been reserved for the franchise forward, the future Hart and Art Ross Trophy winner, the captain-to-be who will carry the team to the Stanley Cup, but the team hoping for such a player is disappointed as often as it is rewarded.

Year	Player	Rating	Year	Player	Rating
1969	Rejean Houle (Montreal)	**	1984	Mario Lemieux (Pittsburgh)	*****
1970	Gil Perreault (Buffalo)	*****	1985	Wendel Clark (Toronto)	***
1971	Guy Lafleur (Montreal)	*****	1986	Joe Murphy (Detroit)	**
1972	Billy Harris (Islanders)	**	1987	Pierre Turgeon (Buffalo)	**
1973	Denis Potvin (Islanders)	*****	1988	Mike Modano (Minnesota)	****
1974	Greg Joly (Washington)	*	1989	Mats Sundin (Quebec)	****
1975	Mel Bridgman (Philadelphia)	***	1990	Owen Nolan (Quebec)	***
1976	Rick Green (Washington)	**	1991	Eric Lindros (Quebec)	****
1977	Dale McCourt (Detroit)	***	1992	Roman Hamrlik (Tampa Bay)	**
1978	Bobby Smith (Minnesota)	***	1993	Alexandre Daigle (Ottawa)	**
1979	Rob Ramage (Colorado)	***	1994	Ed Jovanovski (Florida)	too early
1980	Doug Wickenheiser (Montreal)	*	1995	Bryan Berard (Ottawa)	too early
1981	Dale Hawerchuk (Winnipeg)	*****	1996	Chris Phillips (Ottawa)	too early
1982	Gord Kluzak (Boston)	**	1997	Joe Thornton (Boston)	too early
1983	Brian Lawton (Minnesota)	**	1998	Vincent Lecavalier (Tampa Bay)	too early

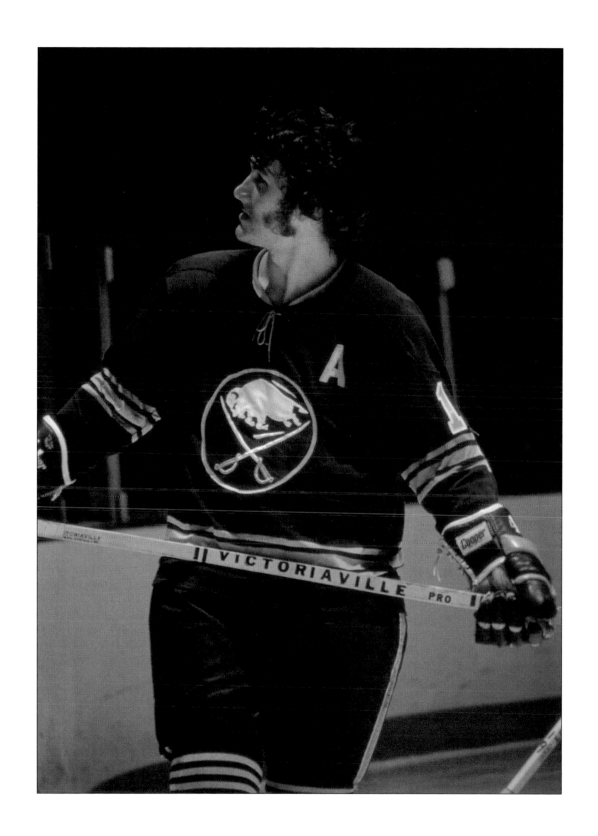

PLATE 55

THE PHILADELPHIA FLYERS — POLICING THE GAME

THE GAMES of April 15 and 22, 1976 at Maple Leaf Gardens between Toronto and the Flyers were perhaps the darkest hours of hockey in the 1970s. During those fight-filled, brawl-sprawled games, there was enough violence to cost the NHL huge chunks of reputation and credibility. After the mayhem, four members of the Flyers were formally charged by Ontario's Attorney General Roy McMurtry. Bob Kelly was charged with assaulting usherette Janis Brown after he threw his glove in the penalty box (it was intended for a Leaf face, but struck Mrs. Brown instead). Mel Bridgman was charged with assault on Leaf defenseman Borje Salming after a fight that saw Salming require two stitches in his cheek for a cut. Joe Watson was charged with assaulting police officer Arthur Malloy who was hit in the shoulder by Watson's stick as he swung it wildly over the boards at a group of abusive fans. Don Saleski was charged with using his hockey stick as a dangerous weapon in a like manner.

The incident galvanized the city, the country, and the entire NHL community. People who applauded McMurtry for his "interference" felt it was high time players were made accountable for their on-ice actions, and that assault with a stick in a rink was no different from assault with a knife on the street. NHL players were admired by all youngsters, and these brawls had an adverse effect on children and, therefore, society, since only a fraction of aspiring pros actually made it to the NHL. Those who pilloried the attorney general's involvement did so with a one-line argument: it's our game; let us police it.

The McMurtry side argued that that was a fine sentiment as long as the violence was kept on the ice. But when it hits, literally and figuratively, the fans and audience, it becomes a civilian issue. The on-ice Salming injury was hockey-related; the injuries to the usherette and police officer were not.

The issue of violence became a public relations nightmare for a league trying to expand into the American market where, statistics revealed, the sport was generally viewed as on the same level as Roller Derby and WWF wrestling. If the NHL wanted families in Peoria, as it were, to attend games, it would have to present an action-packed, but safe, clean game. To this end, many new rules related to fighting were introduced around this time: ejecting the third man in a fight (it was the third man who often seemed to precipitate a brawl); assessing a game misconduct to a player who had three fights in a game; and suspending a player for a game if he had three game misconducts during the season.

The following year, just hours before the Leafs and Flyers were to play in another playoff game, the final chapter from the previous year's violence was written. On April 15, 1977, Watson and Kelly pleaded guilty to lesser charges of common assault and were fined $750 and $200 respectively, while charges against Saleski and Bridgman were dropped. The Crown agreed that prosecution would not be a sufficient deterrent to others, whether amateur or pro, and that the owners were partly responsible because they promoted these physical aspects of the game. In short, the NHL was given the right to police itself once again.

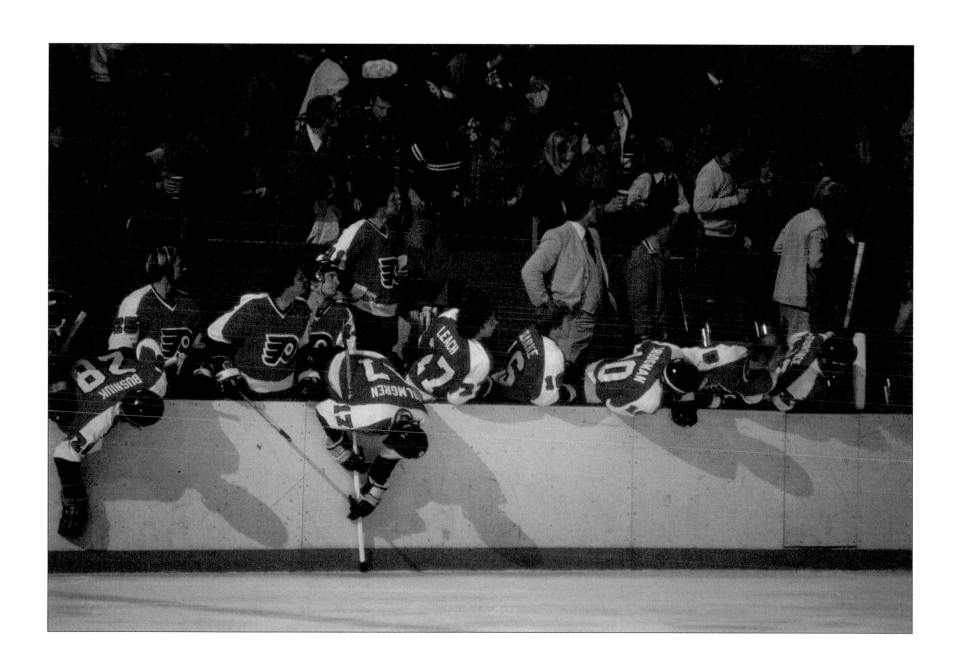

PLATE 56

JACQUES PLANTE AND THE ART
OF GOALTENDING

THE OBJECTIVE of a goalie could not be simpler: stop the other team from putting the puck in your net. The *method,* however, has been open to interpretation for as long as that net has existed, and the strategy for goaltending has changed with every era as much as any other aspect of the game.

In hockey's early years, a goalie was not allowed to fall to his knees to make a stop. This was considered an unfair advantage, and if caught, he could be penalized. Clint Benedict earned the nickname "Praying Benny" for just this habit. He performed it with such frequency that the rule was amended to allow all goalies to stop the puck any way they wanted.

The rule book of 1931–32 stipulates another important restriction on the goalie: "No goal-keeper shall be permitted to hold the puck with his hands or arms. He may catch the puck in his hand but must clear immediately and must not throw the puck forward toward his opponents' goal. For infringement of this rule a "face off" must be made ten feet in front of the goal with no players except the goal-keeper standing between the "face off" and the goal line."

With time, of course, these rules were modified or eliminated, giving the goalie more freedom to do what he could with the puck. In the 1940s, Charlie Rayner pushed the puck-stopping envelope by trying to realize a goalie's skating potential. He wandered from his crease regularly and came close a couple of times to deking through the whole team and scoring a goal! (A rule was implemented later which now prevents a goalie from skating over center ice.) His was an unusual method, though, and the wandering goalie never became fashionable. Rayner was forever the iconoclast in his time. The forties was also the decade which saw the practice of pulling a goalie in the dying moments of a game become an accepted strategy.

In 1972, Jacques Plante became the first man to write a book dedicated solely to the art of goaltending in which he preached from 20 years' of experience and discussed the latest trends in stopping the puck. He pointed out that, "You will never be a good goalie unless you learn to skate as well as the forwards, so you can stop the puck more easily or race after it outside your net." He goes on to emphasize the importance of balance for the art he perfected: "Stopping the puck behind the net is not as easy as it looks. The goalie must know how to pivot, on both sides, out of his net."

Plante covers every possible situation a goalie will face during a game — from cutting down the angles and playing out at the top of the crease, to moving from side to side, playing breakaways and penalty shots, and handling the puck. One of his last chapters is on the butterfly style (knees together, feet apart) an art introduced by Glenn Hall and mastered by Tony Esposito, and that has now become the vogue because equipment is so light today that most of the problems goalies of the seventies had with the style have been alleviated.

Plante lists three advantages to the butterfly: "1) fewer rebounds because you play more pucks with the body than the pads; 2) fewer goals along the ice; and 3) fewer goals on screen shots because you are low and most screen shots are low." He also notes two disadvantages: "1) high corners are left open; and 2) many goals may come in between the legs." Whereas Esposito was just about the only butterfly goalie in the early seventies, today, virtually every goalie employs that style to effect. Plante was one of the last of the true stand-up goalies, and one of the game's great innovators.

PLATE 57

HENRI RICHARD (THE POCKET ROCKET)

UNTIL THE LATE 1980s, the captaincy of the Montreal Canadiens seemed to ensure a player's election into the Hockey Hall of Fame: Jack Laviolette (1909–10, 1911–12), Newsy Lalonde (1910–11, 1912–13, 1916–22), Jimmy Gardner (1913–15), Sprague Cleghorn (1922–25), Sylvio Mantha (1926–32, 1933–36), George Hainsworth (1932–33), Babe Seibert (1936–39), Toe Blake (1940–48), Bill Durnan (1947–48), Butch Bouchard (1948–56), Maurice Richard (1956–60), Doug Harvey (1960–61), Jean Beliveau (1961–71), Henri Richard (1971–75), Yvan Cournoyer (1975–79), Serge Savard (1979–81), and Bob Gainey (1981–89). Only three retired Montreal captains — Howard McNamara in 1915–16, Bill Couture in 1925–26, and Walter Buswell in 1939–40 — have *not* been inducted into the Hockey Hall of Fame.

Although Habs have won the Art Ross Trophy 16 times in its history only one captain has ever won the scoring race (Newsy Lalonde, twice, in 1919 and 1921). Montreal has historically made its captain a man who leads the team by example, on and off the ice. Point totals are nice, but not a prerequisite. In the case of the Richards, they are arguably the most successful brothers to have played in the NHL. Third brother Claude starred with the Ottawa Junior Canadiens in the late fifties but never quite made it to the NHL. Nicknamed the Vest Pocket Rocket, Claude was to the Richards and the Canadiens what Zeppo was to the Marx Brothers and the movies.

Maurice and Henri are one of nine brother pairs to be inducted into the Hockey Hall of Fame along with the Bentleys (Doug and Max), Bouchers (Frank and Buck), Conachers (Charlie and Lionel), Smiths (Alf and Tommy), Cooks (Bill and Bun), Espositos (Phil and Tony), Patricks (Lester and Lynn), and Stuarts (Bruce and Hod). The Richards are also the only brothers to score 900 points each: 1046 for Henri and 965 for the Rocket. The next closest pair is Frank (1103) and Pete (773) Mahovlich, Peter (1239) and Anton (636) Stastny, and, in another class, the six Sutters who together have scored some 3000 points (see Plate 65). The Richards are also one of only three brother duos to both be captains in their careers. The others were Derian and Kevin Hatcher and, of course, the Sutter clan which has produced *FOUR* captains — Brent, Brian, Darryl, and Ron. The Richards have also won more Stanley Cups (19) than any other brother combination in the history of the game.

Both also have had their numbers retired, something only the Espositos (Phil and Tony) can claim (although both Bobby Hull and Gordie Howe have had their No. 9 retired by *two* teams). Both Richards have had special nights in their honor. Because they were more than 14 years apart in age, however, the two played together for only five seasons (1955–60). The Habs won the Cup each year. From 1942–75 the Canadiens had a Richard — the Rocket or Pocket Rocket — in the lineup. Interestingly, though, their statistics are almost exactly reversed. Richard the Elder was a pure goal scorer (544 goals and 421 assists) and Richard the Younger a superb passer (688 assists and 358 goals). This holds true season by season as well. In Maurice's 18 years in the NHL, only three times did he have more assists than goals in a season: in 1952–53, 28 goals, 33 assists; in 1957–58, 15 goals, 19 assists; and in 1958–59, 17 goals and 21 assists. In Henri's 20 years in the league, not once did he have more goals than assists.

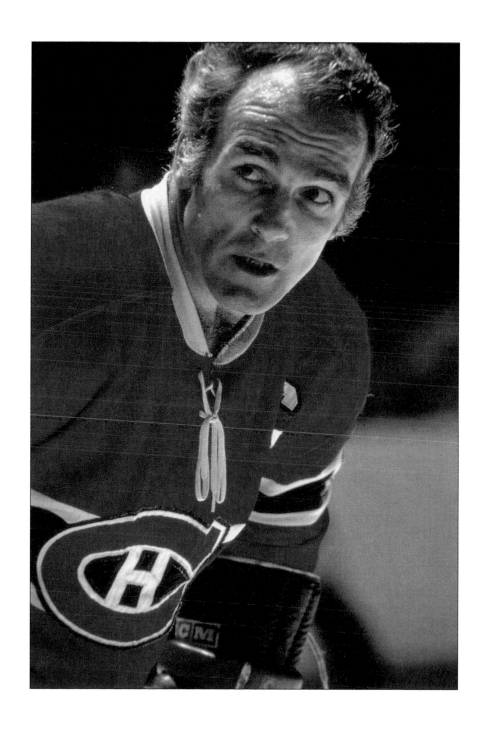

PLATE 58

BORJE SALMING, KING OF SWEDEN

--

AT FIRST, it might seem odd to invoke Salming's name in the context of the Canada-Soviet Union Summit Series of September 1972. But that series was the beginning of the modern game, and Salming was very much a part of both the changing NHL and the outcome of that series. Between the four games in Canada (September 2-8) and Moscow (September 22-28), Team Canada flew to Stockholm to play two exhibition games against the Swedish national team at Isstadion Johanneshovs to get used to European officiating and the larger ice surface. Canada's GM Harry Sinden, who had played for Canada at the 1960 Olympics in Squaw Valley, California, described the stadium as "Lake Erie with a roof over it."

On that Tre Kronor team was 21-year-old Salming (wearing No. 5), as well as Inge Hammarstrom, Lars-Erik Sjoberg, and Ulf Nilsson, all of whom went on to play in the NHL as a result of the Summit Series which opened scouts' eyes to European hockey and the possibility of making the NHL more international. Europe was the last untapped source, and one not yet bound by the entry draft. Scouting Europe took NHL teams back to the pre-1963 days when any team could sign any player if they got there first and offered enough incentive. There was no draft, few rules, and little fuss.

Additionally, Ulf Sterner, Leif Holmqvist, Arne Carlsson, and Bengt Anderson all attended the WHA Chicago Cougars training camp immediately after that two-game series. In fact, it was the WHA that had first recognized the potential of European hockey players for North America. It was a result of meetings between the top clubs and WHA officials that led Bruce Norris to usurp the WHA by establishing in the London Lions the following year (see Plate 45).

Salming began his career at age 16 with Kiruna AIF, where he played from 1967 to 1970 before joining Brynas IF in Sweden's First Division, a league that played a 30-game season. It consisted of 16 teams: Brynas IF, Leksands IF, Skelleftea AIK, Timra IK, MoDo AIK, Farjestads BK, Vastra Frolunda IF, AIK, Sodertalje SK, Djurgardens IF, IF Bjorkloven, Mora IK, Orebro IK, Tingsryds AIF, Vasteras IK, and IF Karlskoga/Bofors. The top four teams advanced to the playoffs, the first team playing the fourth, the second playing the third, in best-of-three semifinals. The winners then played a best-of-three final for the country's championship.

Salming played three years with Brynas (1970–73) where he won two league championships in '71 and '72, before signing with the Leafs on May 12, 1973. He also played in the 1972 and 1973 World Championships for Sweden, winning a silver the second time around as well as being voted MVP for Tre Kronor. He finished his career by returning whence he came, playing into his forties with AIK-Solna from 1990 to 1993 in Sweden's First Division. A hero and legend to a new generation of Swedes who worshipped his every move, he was the first Swede to be an NHL superstar and the first European NHLer to be inducted into the Hockey Hall of Fame, in 1996.

PLATE 59

DEREK SANDERSON'S LAST CALL

HE WAS CALLED Turk and lived like a sultan from the minute he joined the NHL with Boston in the late 1960s. "I got a lousy $10,000 the first season, $12,000 the next and only thirteen grand this year. This is one of the reasons I have hired an agent, Robert Woolf, to help me pick up some extra income," Sanderson noted early on in his career.

While he was making money, he was spending even more. He went through millions in a few short years, drinking and drugging his body into a state of inability. At no time could the tedium of wealth be sated by the joy of playing the game. He was the classic example of the man who had everything and threw it all away.

In his first full season with the Bruins, he won the Calder Trophy and was a key to Boston's Stanley Cup chances, an offensive threat who could win all the face-offs, play defensive forward to perfection, and frighten the other teams' enforcers — a Selke and Hart Trophy candidate rolled into one.

At the start of the 1970–71 season, just months after making one of the most famous passes in the history of hockey to Bobby Orr who leaped through the air to win the Stanley Cup, Sanderson wrote: "I've seen alcohol ruin a lot of guys I thought were cool, with-it, intelligent people. But they just ended up as obnoxious slobs. Most women I know react with revulsion to guys who abuse liquor. How can you keep any of your self-respect when you're smashed? I think a lot of people gear up on booze because they're afraid to be themselves. Pretty soon they can't face any situation without it."

Nineteen years later, he confessed: "I played hung over. I played on speed. I used Valium. I used cocaine. I was going from one ego trip to another.... I supressed my fear with alcohol, nullified it with four or five beers.... I was a full-blown alcoholic winning Stanley Cups."

Perhaps the highlight of Sanderson's biography, however, was his colossal five-year, $2.6-million contract with the Philadelphia Blazers of the new WHA in 1972. He was leaving Boston at the height of his powers, his reputation held intact because despite the off-ice stuff, he was still one of the marquee players in the NHL. However, he was injured early in his first season with the Blazers, and played only eight games before being bought out for a cool million. He returned to Boston for '72–'73, a far lesser player but a far humbler man.

He became injury prone, his body no longer able to keep pace with the neurological abuse to which he was submitting it. He came to camp in the fall of 1973 out of shape, complained about ice time, and wound up playing with Boston's AHL affiliate to lose some poundage and gain some quickness. He fought with one of the team's leaders, Terry O'Reilly, in the dressing room in March 1974 and was suspended for the rest of the year by the team for "conduct detrimental to the proper operation of a hockey team." His days with the Bruins were over, his market value much diminished, the moment of his greatness flickering.

On June 12, 1974, the Broadway Blueshirts gambled that there was hockey life left in the Turk and acquired him from the Bs for Walt McKechnie. He signed a one year, $100,000 contract and vowed to perform: "...the way I look at it is this: I've got something to prove and I'm going to prove it." Less than 16 months later, he was traded to St. Louis for a 1st-round draft choice. Sanderson moaned, "I went to New York with illusions of grandeur and ran into clouds of despair." In between the grandeur and clouds, he played just 83 games. A career that began triumphantly ended too quickly, in failure.

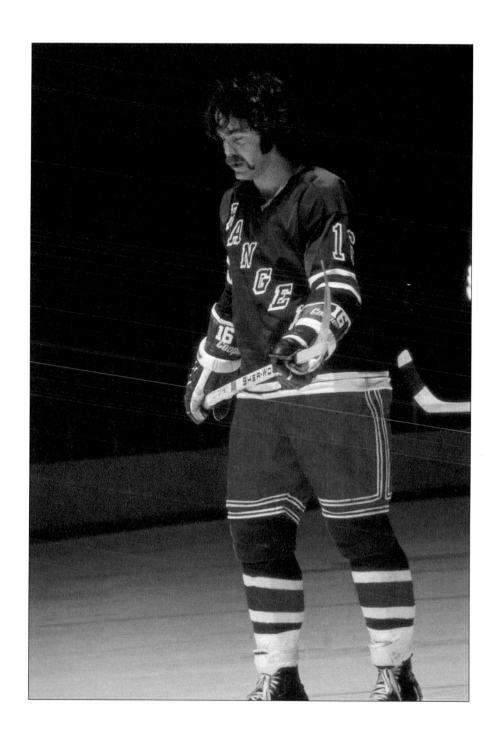

PLATE 60

GLEN SATHER, HALL OF FAMER

SATHER PLAYED 10 years in the NHL with six teams — Boston, Pittsburgh, the Rangers, St. Louis, Montreal, and Minnesota. His first year was the last of the Original Six (1966–67), and when he retired a decade later, there were 18 teams in the league. He was everything you might commonly call a player except all-star, scorer, or hero. He was a hard worker, a plugger, on a good day a penalty killer, a scrapper, and a man so happy just not to be in the minors, doing whatever he could to stay with the big team rather than be demoted.

Sather got the nickname Slats when he was playing in Oklahoma with Derek Sanderson. Sanderson swears the telephone operators were never able to pronounce "Sather" properly, so his teammates nicknamed him Slats. But Slats was not his first diminuitive. He had played for the Wainwright Midget Elks before moving up to the Wainwright Commando seniors of the Battle River Hockey League. This was not exactly the surest route to the NHL, but as a 15-year old he was one of the younger players on the team and was called "Chick." Later, he established a hockey school at Banff and always made sure that he sponsored at least a couple of kids from the Wainwright Minor Hockey Association to allow them to attend his school.

When he started out, Sather was property of the Detroit Red Wings. As part of his contract, he got the team to guarantee to pay for his entire university education. "The only condition was that to collect," Sather explained, "I had to be playing in the NHL. I'm entitled to room and board, tuition, plus $50 a week spending money." This was 1964.

When Memphis (Detroit's CPHL affiliate) traded him to Oklahoma City (Boston's CPHL affiliate) and Sather was subsequently called up to play for the Bruins in the NHL, Detroit reasonably assumed they were off the hook for footing his education bill. Not in Slats's eyes. In 1972, Sather's summers were free of the hockey school and he wanted to take summer courses — at the Red Wings' expense. Detroit refused to pay. Sather appealed to league president Clarence Campbell, and Campbell, a lawyer, sided with him. Sather continued to get a Detroit-sponsored education while now a member of the New York Rangers!

He studied child psychology, with a minor in physical education, figuring these would help him to understand and play the game better. After his NHL days were done, he returned home like many a player. He finished his career with the Alberta Oilers of the WHA as player/coach and then became head coach of the team that was knocking not only at the front door of the NHL, but also the Stanley Cup vault and the Hockey Hall of Fame. After winning five Cups with Gretzky, Messier, Fuhr, Lowe, Kurri, et al in Edmonton, he was inducted into the Hall in 1997 as a Builder.

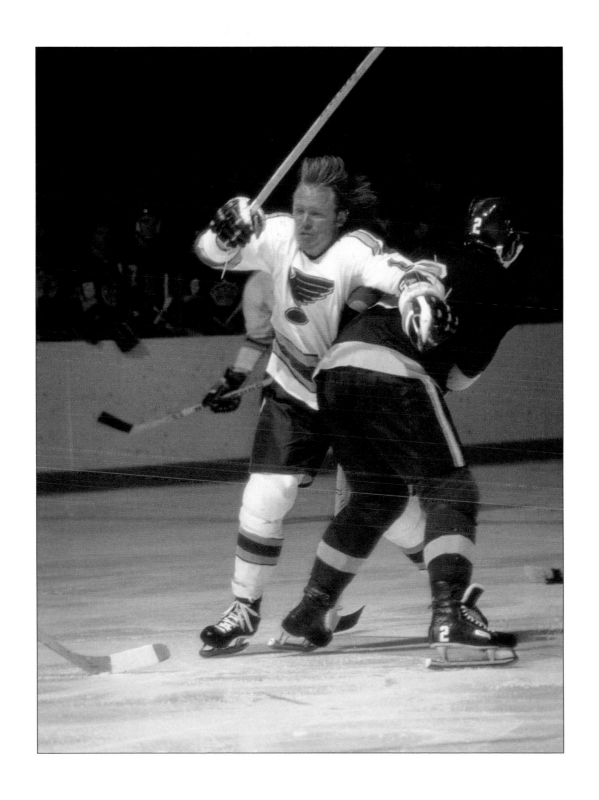

PLATE 61

FRED SHERO — THE FOG ROLLS IN

THE BROAD STREET BULLIES led the NHL in team penalty minutes from 1971 until 1982, and their two Stanley Cups in 1974 and 1975 were achieved in part by "gooning," fighting, and intimidating their opponents. They got their nickname because the Spectrum is encircled by Broad Street, Pattison Place, Eleventh Street, and Kennedy Stadium in Philadelphia and the Pattison Place Bullies or Eleventh Street Animals just didn't have the same ring. It was, in recent times, hockey's ugliest hour. In 1973–74, the Flyers had 1750 penalty minutes; the next most penalized team, the St. Louis Blues, had just 1147. That same season, only four teams had more than 1000 minutes but by '74–'75, 15 teams exceeded that number. (When in Rome...)

The Flyers were coached by Fred Shero who earned the nickname "The Fog" one night when he locked himself out of an arena after an exhibition game. He lived up to the name by committing visual and verbal non sequiturs that kept everyone near him guessing. One day after practice, he gave his players a questionnaire that read:

> There are six kinds of athletes:
> A) the con man athlete
> B) the hyper-anxious athlete
> C) the athlete who resists coaching
> D) the success-phobic athlete
> E) the injury-prone athlete
> F) the depression-prone athlete
>
> Dear fellow workers, please circle the appropriate letter so that I may be better able to serve you. Sincerely, FRED SHERO."

Shero was ahead of his time in that he was the man who introduced the NHL to the concept of the assistant coach when he hired Mike Nykoluk in 1972 to help him run the team. Today, of course, every team has at least two assistants to help the head man with the club.

Shero was a god in Philadelphia, the man whose goon tactics chased the Soviets back to their dressing room in 1976, the man who won two Cups, and whose desire to win was personified in the team captain Bobby Clarke. The coach's attitude was that the refs couldn't call everything, and for two years it worked in the Flyers' favor. However, Shero pulled a Mike Keenan in 1978 when he quit the Flyers, citing exhaustion and an inability to take the team to the Stanley Cup again. He then signed a quisling contract with the New York Rangers just two weeks later. His first trip back to the Spectrum in the City of Brotherly Love, Shero was greeted by a chorus of loud boos and chants of "traitor."

Through the brawl years, Shero took virtually no repsonsibility for a team built clearly around just three skilled players — goalie Bernie Parent, winger Reg Leach, and captain Clarke — and a group of fighters: "I've said this before, and I mean it honestly. If you can find one player I've ever coached who can claim I ever asked him to fight, I'll give you a million dollars," he boasted in a 1984 interview about his time with the Flyers. "Why did we fight? We had to because that's all we had." Besides, they couldn't call everything.

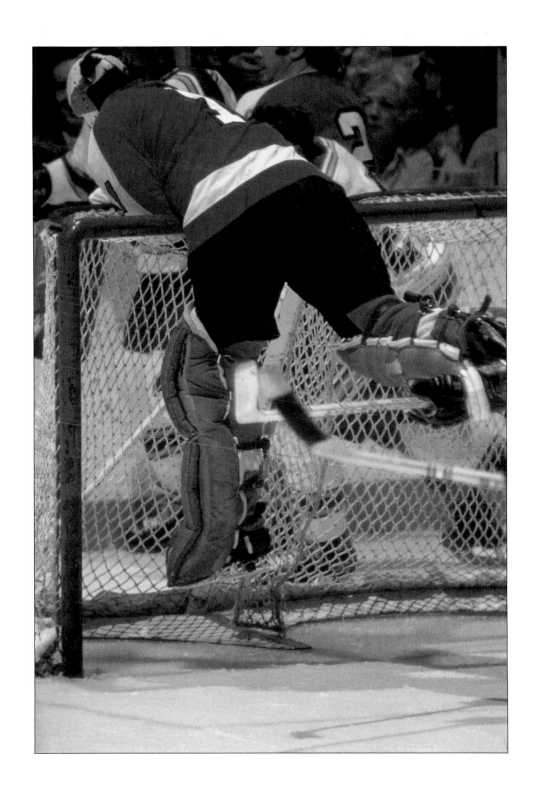

PLATE 62

GARY SIMMONS IS TRUE TO HIMSELF

GARY BYRNE SIMMONS went by the nickname Cobra owing to his quick reflexes. In appreciation, he had a cobra painted on his mask and a tattoo of a cobra stabbed into his flesh to accompany the many other body marks he had acquired over the years. The first was needled into him as initiation into the marines, a career path he scuppered almost immediately in favor of continuing his education. In succeeding years, his body accrued a total of 10 tattoos, four of which were politely visible, the others more privately located and among which include a bird, a panther, the sign of Cancer, and his wife's name inside a heart.

Simmons's attitude is vintage seventies. His approach to life and the game was individual and of the kind no coach, general manager, or owner would have tolerated in Original Six days. And yet, even within his unique way of doing things, he was different. He wore cowboy hats and snakeskin boots, but never drank. He loved rodeos but was allergic to horses. He loved guns but shot only at tin cans and trees.

Born on July 19, 1944, Simmons is a Cancer and a devoted believer in astrology, claiming he plays his best when under that sign. This was an unfortunate bit of luck for him because Cancer's dates run from June 21 to July 22 when not much NHL hockey takes place. One of the few Prince Edward Islanders to join the NHL, he established himself as a combative presence in the nets, not afraid in the least of hacking at the lower extremities of encroaching players. He was signed as a free agent by California in 1974 and shared duties with roommate Gilles Meloche with the Seals and then the Barons after the team moved to Cleveland two years later. Midway through the 1976–77 season, he was traded to Los Angeles with penalty killer Jim Moxey for goaler Gary Edwards and Juha "Whitey" Widing. Moxey wound up playing just one game with the Kings before retiring, and the Barons wound up playing just one more season before merging with the Minnesota North Stars.

Widing was another player cut from a different cloth. He was born in Finland but raised in Sweden where he was scouted by Ranger talent seeker Jake Milford. Milford was actually in Sweden to recruit Tre Kronor star Ulf Sterner (see Plate 59) but decided to bring 17-year-old Widing to Canada as well. Sterner became the first truly European-trained player to skate in the NHL (four games in 1964–65), although Swedish-born Gus Forsland was technically the first Swede to make it to the NHL, in 1932–33. Widing apprenticed in junior with the Brandon Wheat Kings of the Western Hockey League (WHL) before starting with the Rangers in '69–'70. After his career, Widing retired to a farm in the Okanagan Valley in British Columbia and died of a heart attack at the age of 38 in 1985.

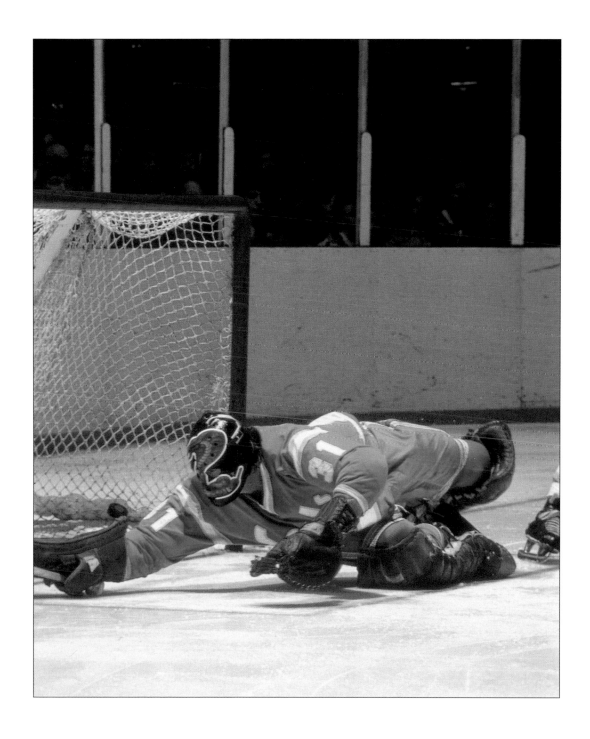

PLATE 63

STICK WORKS

S RON LOW reaches desperately and unsuccessfully behind him to try to stop the puck from whispering across the goal line, a torn Koho rips through the air well above the extended goaler, the wood shaft just moments away from landing gently on his disappointed self. The stick was, like most sticks of the seventies throughout the world, likely shaped from a combination of elm, ash, maple, and hickory cut from the forests of southern Ontario and Quebec's Eastern Townships. Most blades were made of solid ash, taken from the sapwood (the outer part of the trunk) which produced the most durable wood in the tree. The shaft, however, was often made from a blend of birch, yellow poplar, aspen, and hickory because resilience there was not as important as in the blade. The best sticks were always the ones in which the grain ran straight from top to bottom in a smooth wash.

Much changed in the stick-making business in the seventies when Japanese companies began buying huge quantities of ash and shipping them to San Diego. From there, they would transfer the wood to processing boats offshore and resell the plywood at great profit (or, at great expense to Canadian stick manufacturers). As a result, laminants and glass fibers were developed to replace ash, and soon the quality of a stick lay not in the wood but in the man-made substances and techniques used to enhance and protect that ever-diminishing amount of wood. However, while Bobby Hull and Stan Mikita had been the innovators of the sixties by curving the stick blade (wet it and put it under a door), Brad Park became the innovator of the next two decades, abandoning the traditional wood stick and experimenting with the first aluminum shaft stick.

Park was using sticks that were being developed by the famous Sherwood company in Sherbrooke, Quebec. The new sticks consisted of a much stronger man-made shaft with a wood blade hollowed out at the top that slid into a thinned end of the shaft. Park had been practicing with the aluminum stick since 1979 but had to await league approval before using it in games. By early 1982, he was playing regularly with one, and at the time, only teammates Stan Johnathan and the Winnipeg Jets' Dave Christian (whose family made a brand of the stick) used them game in, game out. Park showed the NHL the way of the future: "You're going to see a lot of them around the league, and it's going to be great for the kids," he prophesied.

Unfortunately, the durability of the stick, particularly of the shaft, now poses a hazard to the modern game. While the aluminum has been refined to the point where the shafts are virtually indestructible, players use the sticks more and more to check, hook, slash, and obstruct. The result is more stick-related injuries (i.e., the slash to the top of the hands or, accidentally on purpose, to the forearm) and a dependence on aluminum rather than skating and passing. A proposal a few years ago to ban aluminum sticks from the NHL led Wayne Gretzky to announce he'd be willing to take the league to court to keep his right to use the shiny-shafted shooters, so the motion died quietly. Safety and skill were given short shrift by legal rights. Yet baseball has managed to keep aluminum bats out of its pro game, and manufacturers are none the worse off as sales to minor-league teams and amateurs continue.

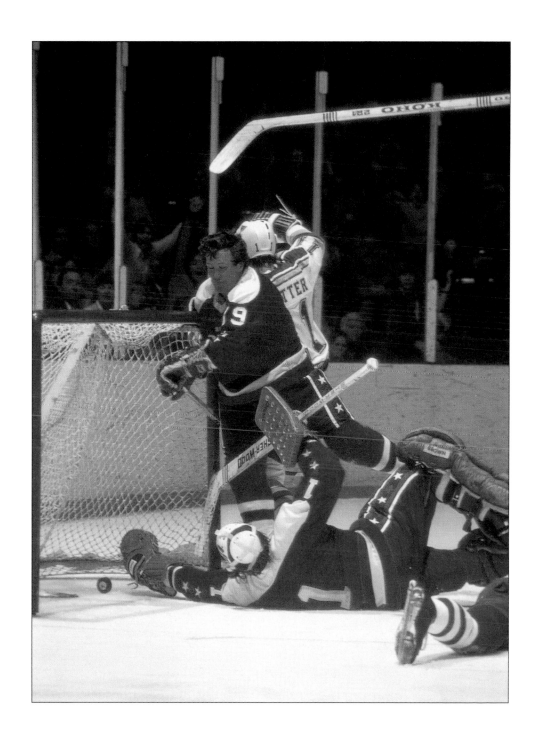

PLATE 64

THE SIX SUTTERS — A FAMILY'S STATISTICS

YEAR	SUTTER	TEAM	GP	G	A	P	Pim	PO
1976–77	Brian	St. Louis	35	4	10	14	82	PO
1977–78	Brian	St. Louis	78	9	13	22	123	DNQ
1978–79	Brian	St. Louis	77	41	39	80	165	DNQ
1979–80	Brian(C)	St. Louis	71	23	35	58	156	PO
	Duane	Islanders	56	15	9	24	55	SC
	Darryl	Chicago	8	2	0	2	2	PO
1980–81	Brian(C)	St. Louis	78	35	34	69	232	PO
	Duane	Islanders	23	7	11	18	26	SC
	Brent	Islanders	3	2	2	4	0	PO
	Darryl	Chicago	76	40	22	62	86	PO
1981–82	Brian(C)	St. Louis	74	39	36	75	239	PO
	Duane	Islanders	77	18	35	53	100	SC
	Brent	Islanders	43	21	22	43	114	SC
	Darryl	Chicago	40	23	12	35	31	PO
1982–83	Brian(C)	St. Louis	79	46	30	76	254	PO
	Duane	Islanders	75	13	19	32	118	SC
	Brent	Islanders	80	21	19	40	128	SC
	Ron	Flyers	10	1	1	2	9	PO
	Rich	Penguins	4	0	0	0	0	DNQ
	Darryl(C)	Chicago	80	31	30	61	53	PO
1983–84	Brian(C)	St. Louis	76	32	51	83	162	PO
	Duane	Islanders	78	17	23	40	94	PO
	Brent	Islanders	69	34	15	49	69	PO
	Ron	Flyers	79	19	32	51	101	PO
	Rich	Penguins	5	0	0	0	0	—
		Flyers	70	16	12	28	93	PO
	Darryl(C)	Chicago	59	20	20	40	44	PO
1984–85	Brian(C)	St. Louis	77	37	37	74	121	PO
	Duane	Islanders	78	17	24	41	174	PO
	Brent	Islanders	72	42	60	102	51	PO
	Ron	Flyers	73	16	29	45	94	PO
	Rich	Flyers	56	6	10	16	89	PO
	Darryl(C)	Chicago	49	20	18	38	12	PO
1985–86	Brian(C)	St. Louis	44	19	23	42	87	PO
	Duane	Islanders	80	20	33	53	157	PO
	Brent	Islanders	61	24	31	55	74	PO
	Ron	Flyers	75	18	42	60	159	PO
	Rich	Flyers	78	14	25	39	199	PO
	Darryl(C)	Chicago	50	17	10	27	44	PO
1986–87	Brian(C)	St. Louis	14	3	3	6	18	PO
	Duane	Islanders	80	14	17	31	169	PO
	Brent	Islanders	69	27	36	63	73	PO
	Ron	Flyers	39	10	17	27	69	PO
	Rich	Vancouver	74	20	22	42	113	PO
	Darryl(C)	Chicago	44	8	6	14	16	PO
1987–88	Brian(C)	St. Louis	76	15	22	37	147	PO
	Duane	Chicago	37	7	9	16	70	PO
	Brent(C)	Islanders	70	29	31	60	55	PO
	Ron	Flyers	69	8	25	33	146	PO
	Rich	Vancouver	80	15	15	30	165	DNQ
1988–89	Duane	Chicago	75	7	9	16	214	PO
	Brent(C)	Islanders	77	29	34	63	77	PO
	Ron	Flyers	55	26	22	48	80	PO
	Rich	Vancouver	75	17	15	32	122	PO
1989–90	Duan	Islanders	72	4	14	18	156	PO
	Brent(C)	Islanders	67	33	35	68	65	PO
	Ron(C)	Flyers	75	22	26	48	104	DNQ
	Rich	Vancouver	62	9	9	18	133	—
		St. Louis	12	2	0	2	2	PO
1990–91	Brent(C)	Islanders	75	21	32	53	49	DNQ
	Ron(C)	Flyers	80	17	28	45	92	DNQ
	Rich	St. Louis	77	16	11	27	122	PO
1991–92	Brent(C)	Islanders	8	4	6	10	6	—
		Chicago	61	18	32	50	30	PO
	Ron	St. Louis	68	19	27	46	91	PO
	Rich	St. Louis	77	9	16	25	107	PO
1992–93	Brent	Chicago	65	20	34	54	67	PO
	Ron	St. Louis	59	12	15	27	99	PO
	Rich	St. Louis	84	13	14	27	100	PO
1993–94	Brent	Chicago	73	9	29	38	43	PO
	Ron	St. Louis	36	6	12	18	46	—
		Quebec	37	9	13	22	44	DNQ
	Rich	Chicago	83	12	14	26	108	PO
1994–95	Brent	Chicago	47	7	8	15	51	PO
	Ron	Islanders	27	1	4	5	21	DNQ
	Rich	Chicago	15	0	0	0	28	—
		Tampa Bay	4	0	0	0	0	—
		Toronto	18	0	3	3	10	PO
1995–96	Brent	Chicago	80	13	27	40	56	PO
	Ron	Boston	18	5	7	12	24	PO
1996–97	Brent	Chicago	39	7	7	14	18	PO
	Ron	San Jose	78	5	7	12	65	DNQ
1997–98	Brent	Chicago	52	2	6	8	28	DNQ
	Ron	San Jose	57	2	7	9	22	DNQ
Totals	78 seasons		4836	1311	1600	2911	7138	

(C)=Team Captain; PO=Qualified for playoffs; DNQ=Did not qualify; SC=Stanley Cup

Playoff Totals		GP	G	A	P	Pim	SC
	Brent	144	30	44	74	164	2
	Ron	80	7	30	37	165	0
	Brian	65	21	21	42	249	0
	Darryl	51	24	19	43	26	0
	Rich	78	13	5	18	133	0
	Duane	161	26	32	58	405	4
Totals	66 seasons	579	121	151	272	1142	6

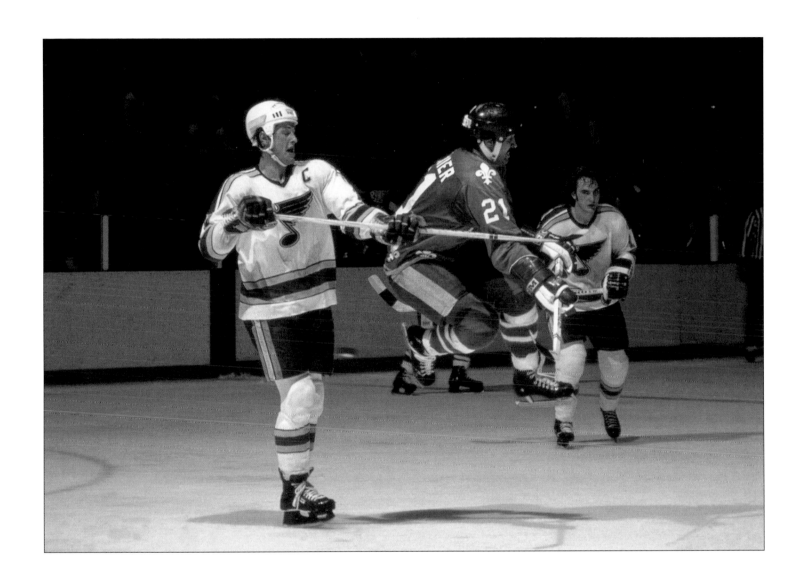

PLATE 65

DEAN TALAFOUS AND THE 1976 CANADA CUP

WHEN THE Quebec Nordiques drafted Eric Lindros first overall at the 1991 Entry Draft, they were well aware he was not going to play for the team. The Lindros family was not impressed by club president Marcel Aubut, and Eric's holdout lasted one full season. He preferred to play with his junior team, the Oshawa Generals, and join the World Juniors and Olympians as well, to playing for the Nordiques.

Lindros, however, was not the first player to shun Quebec. While the Big E had merely put his NHL career on hold waiting for a trade, Dean Talafous actually retired after being traded to the Nordiques and never played again in the NHL. On December 31, 1981, the Rangers traded Talafous and Jere Gillis to Quebec for Robbie Ftorek. In the last year of his current contract, Talafous refused to report to La Belle Province without a contract extension. Quebec refused to oblige, Talafous retired, and 10 weeks later, the Nordiques were awarded Pat Hickey as fair market compensation from the Rangers in place of Talafous.

While by no means a household name, Talafous represented the United States in the first two Canada Cups, a clear indication of just how far the US hockey program has developed in the last two decades. In 1976, the team's roster was a veritable compendium of second, third and fourth line players, some pluggers, workmen, and "who's that?" types, but not a superstar among their number. The aforementioned Ftorek led the team in scoring and Talafous was tied for second. The roster included: Craig Patrick, Mike Milbury, Butch Williams, Curt Bennett, Fred Ahern, Alan Hangsleben, Bill Nyrop, Mike Polich, Harvey Bennett, Lou Nanne, Steve Jensen, Joe Noris, Gerry O'Flaherty, Lee Fogolin, Dan Bolduc, Doug Palazzari, Mike Christie, Rick Chartraw, Gary Sargent, and in goal, Mike Curran and Pete LoPresti. In total, these players had won just 10 Stanley Cups, but four of these nonsuperstars have gone on to coach in the NHL — Ftorek (Los Angeles and New Jersey), Patrick (Pittsburgh and the Rangers), Milbury (Boston and the Islanders), and Nanne (Minnesota). Not one member from that team has been inducted into the Hockey Hall of Fame.

In 1976, Team Canada was a mirror image of the US team in terms of talent and success. The roster was an over-flowing cornucopia of Stanley Cup winners: Bobby Hull, Bobby Orr, Phil Esposito, Denis Potvin, Guy Lafleur, Serge Savard, Bob Gainey, Darryl Sittler, Richard Martin, Gilbert Perreault, Pete Mahovlich, Marcel Dionne, Steve Shutt, Guy Lapointe, Reg Leach, Bill Barber, Lanny McDonald, Bobby Clarke, Danny Gare, Jim Watson, Larry Robinson, and Rogie Vachon. Together, their names appear on the Stanley Cup 58 times, yet only Gainey, Robinson, and Vachon (eight games on an interim basis three times) have gone on to coach in the NHL.

Of the 22 Canada Cuppers, an incredible 16 have been inducted into the Hall of Fame (the only exceptions being Martin, Pete Mahovlich, Leach, Gare, Watson, and Vachon). In fact, Robinson and Gainey are a part of a very select group of men who have been inducted into the Hockey Hall of Fame as players and who went on to coach as well. But neither are part of an even more successful group who not only have been inducted as players, but also won a Stanley Cup as coach. That list is only 12 names long: Jack Adams, Toe Blake, Frank Boucher, Happy Day, Cy Dennenay, Jacques Lemaire, Joe Primeau, Art Ross, Cooney Weiland, Dick Irvin Sr., Tom Johnson, and Lester Patrick.

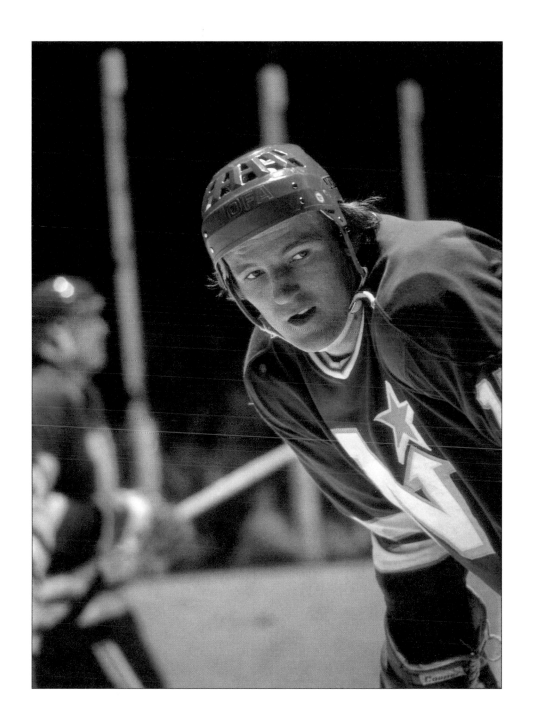

PLATE 66

FLOYD THOMSON IN THE EVER-EXPANDING NHL

FLOYD THOMSON played his entire career (eight years and 411 games) wearing the St. Louis blue note. In this game of December 17, 1974, he scored the Blues' final goal at 10:04 of the third in an 8-4 win over the New York Islanders.

In the team's first 12 years of existence, the Blues finished above .500 only four times, but because of the favorable setup for the big expansion of 1967, the team had a great deal of playoff success early on. When the Original Six expanded to 12 teams in 1967, the NHL set the old six in one division (East) and all the new teams in a second (West). This meant that the Stanley Cup finals would guarantee an old team facing an expansion number in the hope that the established teams would beat each other up in the regular season and playoffs and might be a bit soft for the finals. It never worked out that way. The Blues made the finals in three successive years — 1968, 1969, and 1970 — yet were swept in each series, never winning even one game against 12 successive Stanley Cup finals losses.

In 1970, when two more teams were added, the standings were altered but slightly. Chicago moved to the West while Buffalo and Vancouver were added to the East (two divisions of seven teams). In 1972, the Islanders were added to the East and the Atlanta Flames to the West, thus creating two, eight-team divisions, the top four from each qualifying for the playoffs. In 1974, Washington and Kansas City were added, and with them the NHL developed the first of many versions of the four-division league it currently employs.

The four divisions, in fitting NHL style, were named in honor of some of the greatest contributors to the game — Norris, Adams, Patrick, and Smythe. These were divided into two conferences — the Prince of Wales and the Clarence Campbell. The Norris and Smythe each had five teams: the Adams and Patrick, four each.

For the 1974–75 season, the NHL adopted an 80-game schedule, and there were no more than two Original Six teams in any one division. Traditional rivalries were ignored and an unbalanced schedule adopted so that teams within their division played each other more frequently than those outside the division. For instance, between 1949 and 1967, Toronto and Montreal played each other 14 times a season! By 1981, that number had been reduced to just three.

By 1993, the divisions were renamed (or, rather *de*-named) to mere geographic regions: Northeast, Atlantic, Central, and Pacific — within the Eastern and Western Conference — the Eastern Conference having seven teams in each division, the Western, six in each. In 25 years, the NHL had more than quadrupled in size, the schedule increased to 84, then down to 82 games. A new generation of fans recalls not the Original Six of the forties, fifties, and sixties but the Original 12 or 14 of the seventies, a time when expansion first thrived, then failed, then revived with the inclusion of four WHA teams and deeply serious expansion in the southern US (Tampa Bay, Florida, Dallas, Phoenix, San Jose, Anaheim). Now, a new generation of expansion to both familiar places (Atlanta and Minnesota) and new territory (Columbus and Nashville) will surely render a nostalgic look back at the "Original 21" of the early eighties.

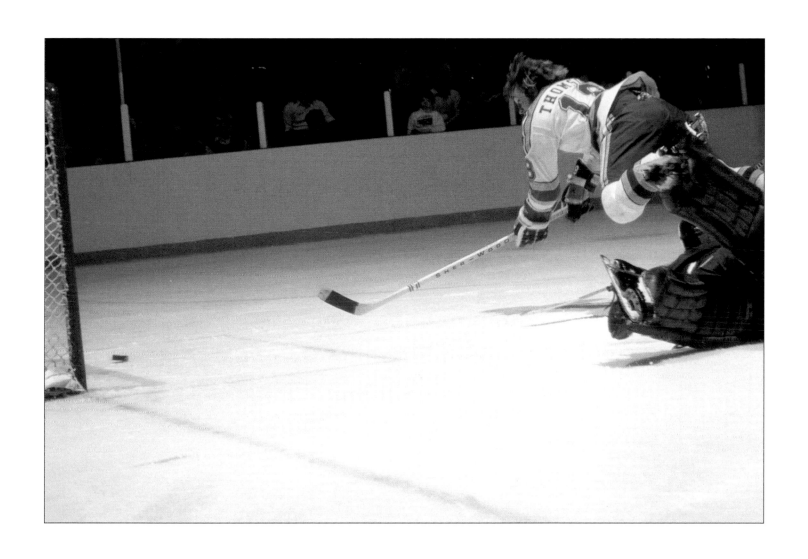

PLATE 67

GARRY UNGER'S IRON MAN STREAK FROM
START TO FINISH

"UNGIE" PLAYED 10 games with Toronto at the start of the '67–'68 season before being demoted to the Tulsa Oilers of the CPHL. In his first week in the minors, he separated his shoulder and sprained his wrist after falling awkwardly into the boards. Almost immediately after returning to the Oilers' lineup, he sprained his knee. When he was called up by the Leafs in February 1968, he played just five games before being traded to the Red Wings. That is how Garry Unger began his NHL career; that is how the incredible 914-game Iron Man streak began.

The record started with Toronto on February 24, 1968. On March 3, Unger was involved in one of the biggest trades in NHL history. Leaf GM Punch Imlach sent Unger, Pete Stemkowski, the rights to Carl Brewer (who had retired prematurely after one fight too many with Punch), and the man he had long both admired and tormented, the great Frank Mahovlich, to Detroit for Norm Ullman, Paul Henderson, and Floyd Smith.

Unger played the last 13 games of Detroit's season and then played an incredible 11 consecutive complete seasons. In fact, he has the distinction of being one of a very few men to play more games than were in the NHL schedule. In 1970–71, he was traded by the Wings to St. Louis in midseason, but at the time of the trade, the Blues had played one fewer game than Detroit. Thus, in a 78-game season, Unger actually played 79 games!

It was on March 10, 1976 that Unger became the new Iron Man, playing in his 631st straight game against, appropriately, Toronto at Maple Leaf Gardens where he broke the former record set by Andy Hebenton with the Rangers and Bruins. Of the record, Hebenton gave Unger full credit: "When I had my streak," he said, "the farthest we had to travel was to Chicago and we didn't have the concentration of games which now exists in the schedule There are more pile-ups around the goal now and, therefore, it is more dangerous for a high goalscorer such as Unger who is often involved in the pushing and shoving in front of the net."

True enough, Unger was no shrinking violet and did not skate timorously through the schedule. He had eight consecutive 30-goal seasons, had more than 100 penalty minutes three times, and played a hard-nosed, physical game. At the time he scored his 300th career goal, only four others had reached that plateau before their thirtieth birthday — Bobby Hull, Gordie Howe, Phil Esposito, and Stan Mikita — pretty fair Hall of Fame company for someone who has himself never been nominated.

Ironically, just as his streak began and became a record with a Toronto connection, it grew and ended with a St. Louis connection. He was acquired by the Blues with Wayne Connelly and Red Berenson for Tim Ecclestone on February 6, 1971. It was during his 8½ years with the Blues that the Iron Man streak became a topic of conversation. He was traded to Atlanta at the start of the '79–'80 season, and on December 22, 1979, the Flames were in St. Louis to play the Blues. The 32-year-old Unger was dressed for the Flames in the game, but coach Al MacNeil did not give him so much as a shift as Atlanta cruised to a 7-3 win.

By the third period, when the St. Louis fans realized their Iron Man had been sitting idly all game on the Flames' bench, they began chanting, "Unger! Unger!" Even his teammates petitioned MacNeil to put him on, but the coach merely growled, "I'm running this team, not you fellows." Afterward, he explained his decision: "If we had been behind, he might have played. But I didn't think we needed him." It was the only game of the season Unger missed, and the streak ended at 914.

PLATE 68

ROGATIEN VACHON THE FREE AGENT

T HE 1970s was a time of further expansion and maturity for the NHL. Paramount to these successes was a new breed of player as yet unknown — the free agent. Thanks to the WHA, players who signed a contract with one team were no longer obligated to spend their whole careers with that same organization. In other words, a three-year contract, with certain rules and stipulations, entitled a team to a player's services for three years and no longer. The implications were important for both player movement and salaries because free agency encouraged bidding wars.

On August 8, 1978, Detroit signed restricted free agent Rogie Vachon to a then-huge five-year $1.5-million contract. As a result, the Red Wings and Kings (his previous club) had to work out a compensation package that could include players, draft choices, and cash (see Plate 10). This system of compensation for free agents, however, was not mutually agreed to by the players and owners through collective bargaining by the latter with the NHL Players' Association (NHLPA). It was a system imposed on the players by the owners unilaterally and as such, open to legal challenge. The Vachon signing proved this soon enough.

Indeed, the Wings and Kings could not agree on a fair transfer of players and went to arbitration under Toronto county court judge Ed Houston. Detroit offered goalie Jim Rutherford and winger Bill Lochead; Los Angeles asked for and won Dale McCourt. McCourt, though, refused to fly quietly into the western night. He took the Kings, Wings, the NHLPA, and NHL to court, arguing that he was in the middle of fulfilling a three-year contract with the Wings and could not simply move to LA LA Land. He argued further that to leave Detroit would mean forcing him to violate his contract, and that Vachon was, in fact, a "pure" free agent not requiring compensation.

On September 18, 1978, US District Court judge Robert DeMascio issued a temporary restraining order against McCourt having to report to Los Angeles, in effect overturning the NHL's system of free agency. DeMascio argued that the rule imposed a "perpetual restriction on a player's inherent right to freely contract for his services" and "unreasonably restrains trade and commerce" and is "not necessary to maintain competitive balance in the National Hockey League." Because compensation was a gamble that factored into the signing of free agents, clubs were leery about entering into the process. This, in turn, impinged upon the player's very "freeness," as it were.

As a result, McCourt was allowed to play for Detroit while the matter was legally worked through. Thus, for the entire 1978–79 season, the Wings had both Vachon in goal and McCourt as a forward! However, topsy turned turvy on May 22, 1979 when the Sixth US Circuit Court of Appeals in Cincinnati awarded playing rights of McCourt to Los Angeles by a decision of 2-1, thus overturning the earlier historic verdict of the previous summer, on the grounds that although it was not legislation struck under the CBA, the players continued to play rather than negotiate a new CBA based on the new free agent system and its implementation. Three weeks later, the court declared a stay of its decision, leaving McCourt 30 days to decide whether to appeal to the Supreme Court. On August 23, 1979, a final showdown was averted when a trade was agreed to: Los Angeles received André St. Laurent, a 1st-round draft choice in 1980 (Larry Smith), and a 1st-round draft choice in 1981 (Doug Smith). In other words, McCourt was sent to LA on paper and traded back to Detroit.

Ironically, Vachon was put on, and cleared, waivers on March 8, 1979 while the whole legal fiasco was being played out. McCourt was quietly traded three years later to Buffalo. All part of the game.

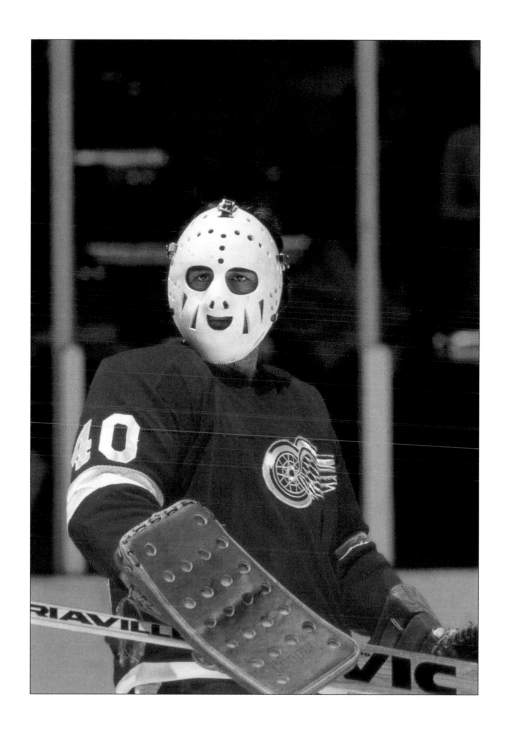

PLATE 69

ROGIE VACHON — OF GOALIES AND COACHES

VACHON BECAME general manager of the LA Kings shortly after he retired, and during his tenure (1984–92) coached the team on three different occasions for a total of just eight games. Only five men in the history of the NHL have coached fewer games. Dick Duff coached the 1979–80 Leafs for two games as a substitute for Floyd Smith who had been injured in a car crash. Duff was quickly replaced by Joe Crozier who coached the remainder of the season and into the following year. Jacques Laperrière was also a fill-in, a temporary, last-minute replacement for Jacques Demers after the 1995–96 Habs got off to a disastrous start. Laperriere was replaced after one game by Mario Tremblay who led the team for the rest of the season.

Charlie Querrie was the GM of the Toronto St. Pats in 1922–23. He began the season as coach but was replaced by Jack Adams after only six games. He never coached again in the NHL, and although he became a fixture in Toronto as a writer and theater owner, he sold his interests in the team shortly thereafter as well. Roger Crozier coached one game for Washington in 1981–82, and Maurice Filion coached the Nordiques in Quebec for six games in 1980–81.

Only Vachon was a substitute on three different occasions. An interesting note is that he is part of another rare group of men — the goalie who goes on to boss the bench. Incredibly, of the 259 men to coach in the NHL between 1917 and 1998, only eight have played goal in the NHL: Vachon, Gerry Cheevers, Ron Low, Emile Francis, Eddie Johnston, Bob Johnson, Hugh Lehman, and Lester Patrick. Goalies are like superstars. What they do is unique and not good training or apprentice for NHL head coaching. Their skills are often used to coach goalies, but rarely to lead an entire corps.

Goaler Lehman coached the Blackhawks briefly in 1927–28, but it wasn't until Cheevers was hired by his alma mater Bruins in 1980 that a *bona fide* NHL goalie became a *bona fide* NHL coach. Cheevers was behind the bench in Boston for 376 games in five years. Currently, the only former goalie-cum-coach is Edmonton's Ron Low whose four-year tenure promises to continue and give him the record for most games coached in this prestigious category.

Remarkably, no goalie has ever coached two teams, perhaps because the initial hiring is deemed almost as an experiment, and once he has failed, no other general manager would be willing to risk giving him a second chance. Furthermore, the only NHL goalie to go on to coach in the Stanley Cup finals was Emile Francis who took his Rangers to the ultimate round of the playoffs in 1972 (losing to Boston). Technically, Lester Patrick is the only goalie to coach a Cup-winning team, but he minded the nets only for one game when, in 1942 as a 45-year-old, he filled in in an emergency. He was really a coach and a goalie only for a night.

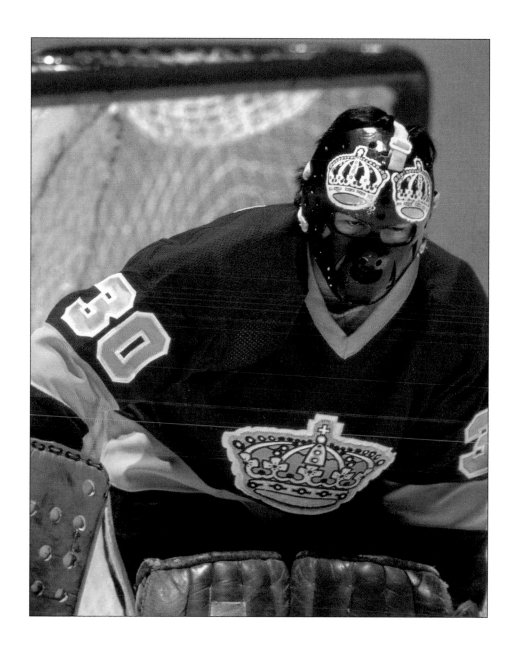

PLATE 70

THE WASHINGTON CAPITALS ARE BORN

ON JUNE 8, 1972, Washington and Kansas City were awarded franchises to begin play in the 18-team NHL for 1974–75. The two cities had presented more favorable bids than the other applicants — Dallas, Phoenix, San Diego, Cleveland, Cincinnati, and Indianapolis. The admittance fee was $6-million, and the Washington club would play out of the Capital Center, contruction of which began on August 24, 1972.

The team selected the nickname Capitals from more than 12,000 entries submitted by the public, and the decision was made by the team's owners, Abe Pollin and his wife Irene, at a special ceremony at the Cap Center on January 21, 1974. Other names that were submitted ranged from the inventive to the ludicrous and sarcastic: Cutthroats, Killers, Stompers, Punishers, Atomics, Growlers, Werewolves, Domes, Cyclones, Streaks, Comets, Ice Caps, Blades, Cheetahs, Turtles, Koo-Koos, Ice Skins, Pink Violins, Snowflakes, Mosquitoes, Dum Dums, Chimney Sweeps, Watergate Bugs, Buggers, Wet Backs, Wing Pings, Cold Cuts, Catfish, Isms, Apes, Otters, Pollinites, Capital Abes, DC Delegates, Whips, Largo Lizards, DC Toppers, Troopers, Slapsticks, Whippers, and Colonials. Some 88 people had submitted the moniker Capitals, but only one, whose name was drawn at random, won the prize of season's tickets.

The team's first player-related move was to hire as general manager Milt Schmidt, former Boston Bruins superstar. He did what he could with what little he had, and in 1974, that wasn't much. The WHA was in full swing, and the Expansion Draft did not provide the talent it later did. As well, few available players were chomping at the bit to join Washington. The Caps' first draft choice was Greg Joly, and Schmidt also signed Tom Williams from the WHA, acquired goalie John Adams, André Peloffy, and Bill Lesuk for cash, and traded for Yvon Bilodeau and Doug Mohns. Their first year lineup included such anonymities as Michel Belhumeur, Bill Mikkelson, Jack Egers, Steve Atkinson, Jim Hrycuik, and Bruce Cowick. Hardly a tour through the Hall of Fame, this list.

Washington's inaugural season was the worst ever for a franchise. The team was an embarrassment, winning only eight games in 80, and only once (in 40) on the road. They scored 181 goals while surrendering 446. The team's only shutout during the year was against expansion partner, Kansas City Scouts (3-0) who were shut-out themselves 12 times during the year. Seven times the Caps gave up ten goals or more.

Although they selected an incredible 24 players in the 1974 Amateur Draft, only six ever played with the team: Greg Joly (98 games), Mike Marson (193), John Paddock (8), Paul Nicholson (62), Brian Kinsella (10), and Tony White (158). Joly was the first player selected overall after the Caps won the honor by a coin toss with Kansas City. To hear Schmidt describe the proceedings at a Toronto hotel on March 28, 1974, it was a little more complex than it sounded: "There were four drafts for which we had to decide who would have first choice — the Amateur Draft, the Expansion Draft of players, the Expansion Draft of goalies, and the Inter-League Draft. Washington won the first toss and had its choice of first pick in any of the four. We elected to take first pick in the Amateur Draft. Kansas City had its choice of any of the remaining three and they took first choice in the Expansion Draft. Then we tossed the coin again and this time, Kansas City won, and they elected to take first choice in the goalie draft, which left us with first pick in the Inter-League Draft."

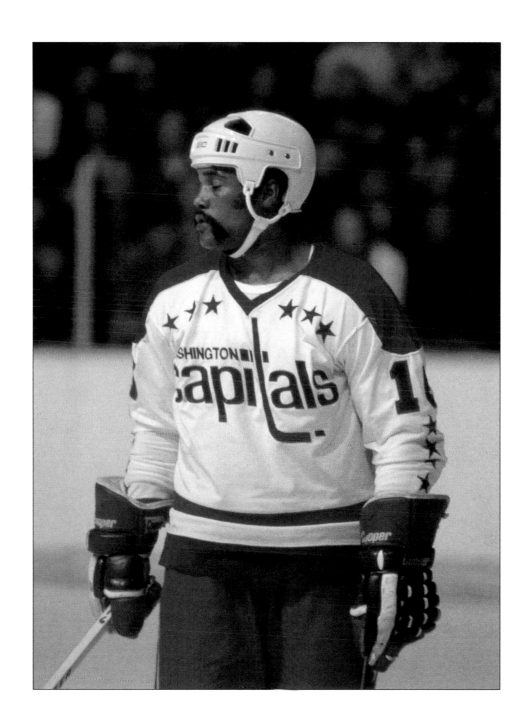

PLATE 71

DAVE WILLIAMS GETS INTO (WHAT ELSE?) TROUBLE

"TIGER" WILLIAMS was the Eddie Shack of his generation, a character, a quick-quipped gangster, a fighter who could score, a skater who could hit, a man who played without fear save the fear of not playing. The meat and marrow of his career came in the seventies, an era that was both suited to fighting but also wary of it, especially while expanding into the US market that had forever been perceived as unwilling to accept this inherent component of the sport. Thus, Williams was at once a hero and a villian, a guy who spoke to one segment of society and was vilified by another.

He also had the task of playing during the prime of Philadelphia's Broad Street Bullies, a feat that was exacerbated by the fact that Toronto and the Flyers met in three violent playoff series in consecutive springs. Those were brawl-filled games, evenings when the bad blood bled into the penalty box, the corridors of the Gardens and the Spectrum, and all but eliminated that fourth wall in the theater of sport between audience and spectacle. Fans and police were hurt, and Ontario Attorney General Roy McMurtry was called in to take civil action for on-ice action the laws of the land had never before enforced (see Plate 56).

Williams was himself involved in another ice-to-courtroom incident. In a game on October 20, 1976 against Pittsburgh at the Gardens, the Pens' Dennis Owchar sustained a cut to his head that needed 22 stitches. The incision was opened by Williams's stick and was delivered with a force that made the blade snap. Tiger claimed the blow was an accident and noted that referee Bryan Lewis did not even mete out a penalty on the play. But police who watched the video the next day felt otherwise. Williams was charged with assault causing bodily harm and possession of a dangerous weapon — a hockey stick.

At the preliminary hearing on March 11, 1977, Judge H. Ward Allen allowed the video from the game to be used as evidence in the trial, but not at slow motion speed, saying it, "is not a true and accurate reproduction of the incident..... The dimension of time is distorted." A year after the brawl, the case went to trial, and the prosecution began by showing two video clips of previous fights involving Williams. In one, he was cross-checked by the Flyers' Tom Bladon and got up swinging; in the other, he swung his stick and just missed the head of Colorado Rockies forward Steve Durbano.

In court, a pile of broken sticks was placed at the desk of Crown attorney Robert McGee, courtesy of Canadian Hockey Industries Limited of Drummondville, Quebec. A representative for the company, however, said Williams's blades were typically lighter than those sold in stores and thus had a shorter game life. The CHI tested five sticks and discovered it took a force of 1825 pounds of pressure swinging the stick at a solid steel cylinder to break a blade as Williams had done. In rebuttal, it was brought to the court's attention that these tests had been conducted using only new sticks, and that wear and tear would certainly mean an older stick would be more fragile and require less force to break. The CHI also admitted that many NHLers had complained that very fall that their sticks were breaking at the heel. Later, an engineer testified that only 272 to 428 pounds of pressure would be needed to break the stick. Referee Lewis took the witness stand and confirmed his initial assessment that, in his opinion, the incident was accidental.

On November 3, 1977, Judge Hugh Locke gave Williams "the benefit of the doubt" and absolved him of any criminal wrongdoing. The Tiger was free. Hockey, too, was free to police its own game. That was, to everyone in the NHL, what the trial was all about.

PLATE 72

BEHN WILSON — A DIFFERENT MAN
ON ICE THAN OFF

THE HOCKEY PLAYER who walks into the rink is often a remarkably different person after he puts on his equipment and goes out to play the game before thousands of fans. Behn Wilson's curriculum vitae is as interesting culturally as his on-ice behavior is vicious. Born in Toronto, Wilson studied music, acting, and speech, taking courses that were moving him toward a teaching certificate in those disciplines. He even performed in a few operettas, and that went a long way to making him a mature, emotionally developed 19-year old when the Flyers drafted him in 1978. GM Keith Allen made sure he knew what kind of a person Wilson was before considering him for the Philadelphia organization: "We took Behn out to dinner twice and discovered two things. He was a very mature, intelligent young man, and he had a terrific appetite."

Because the draft often represents a team's future, the players any GM selects have to be cut from the finest cloth. Increasingly, scouts and teams rely less on what they see on the ice and more on what they know about the player's character. Skill is the most easily discernible attribute a player possesses, but it can often be the least important. The psychological makeup of 18- and 19-year-olds is a huge consideration in these days of superstardom and million-dollar contracts.

The Flyers felt they had a keeper in Wilson and traded three veterans — Orest Kindrachuk, Ross Lonsberry, and Tom Bladon — to the Penguins to obtain a high selection in the first round of the 1978 Amateur Draft, which turned out to be sixth overall. The Flyers selected Wilson, and he made the team at his first camp that fall.

Yet this same articulate, cultured man is the same Behn Wilson who was suspended midway through his second season, on February 13, 1980, for three games and fined $700 for a fight he refused to end which resulted in his fourth game misconduct of the year (meaning automatic suspension). It is the same Behn Wilson who was suspended for three games after injuring Buffalo's Derek Smith and then engaging in a stick-swinging parry-and-thrust with Danny Gare on January 28, 1981. It is the same Behn Wilson who was suspended for four games on November 19, 1981 after slashing the Rangers' Reijo Ruotsalainen under the eye with the blade of his stick. And the same Wilson who was suspended another six games on March 4, 1983 after he hit Rangers' goalie Glen Hanlon on the back of the helmet with his stick. According to teammate and captain Bobby Clarke, "The kid is a tiger. Tough as nails, but no goon."

And so one of the great anomalies of hockey is reconfirmed. The tough guys may look like thugs on the ice, but they are often the most intelligent, least intimidating people away from the rink. They know their job, and when their equipment comes off so does their physical tenacity. It's something that's inconceivable to most fans, and is probably most evident in old pictures one might see of the penalty box which both teams used to *share!* Players would fight violently on the ice, then go to the box and sit beside each other calmly and peacefully to serve their penalties. Most of the time.

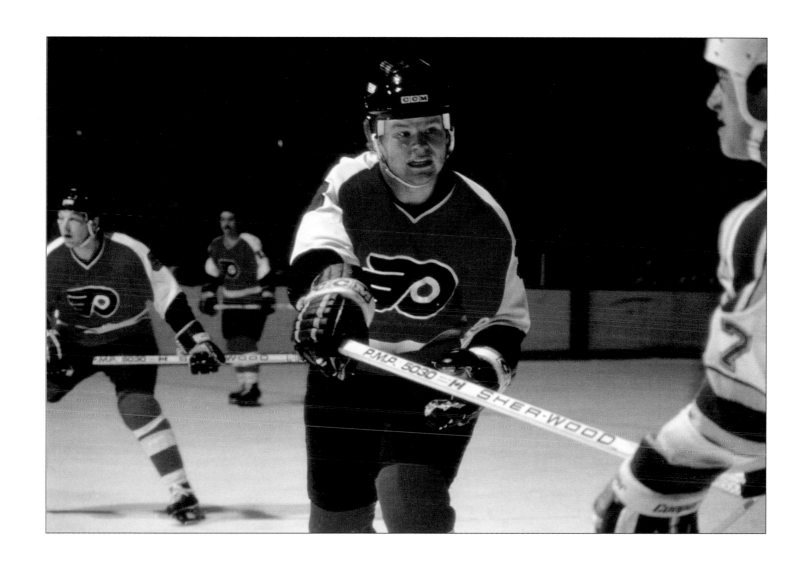

PLATE 73

DUNC WILSON — A FREE SPIRIT

WHEN A SMALL GROUP of players got together with Alan Eagleson to form the NHL Players' Association, the intent was to improve, among other things, players' rights. Previously, coaches and general managers ruled with an iron hand. The six-team NHL ensured that players who misbehaved, in the opinion of the front office, could easily be demoted to the minors and replaced by players of equal skill, quite arbitrarily if necessary. But when 12 teams spread the talent more thinly and plundered the minor leagues of, essentially, their top six teams' worth of skill, players were put in a stronger position and could live life a little less rigidly.

Goalie Dunc Wilson would not have survived a minute in the pre-NHLPA Original Six era, but in the 1970s, he was part of a new breed of openly rebellious players. He would show up to practice with his long shaggy hair, wearing a windbreaker with a shirt but no tie, and looking drawn and not excited about the prospects of working up a sweat during happy hour (a time when ice was put in cocktails, not under skates). Late in his first season with the Canucks, he stopped showing up for practice altogether after Vancouver had been eliminated from the playoff race. Of course, this was also an expansion team, and not much was expected from the Canucks, but Wilson's carefree attitude was interpreted as sloth and ennui, a completely unprofessional way to prepare for hockey games.

The laid-back Vancouver scene also complemented Wilson's lifestyle. He spent as much time as possible fishing sockeye with his friend Al Brown and hung out in bars listening to rock 'n' roll with his musician friend Terry Jacks. Wilson admitted, "I like a pop music life and the people. In a way, that life is a little like playing hockey. Both careers are fickle, and you need a string of consistent hits. In both music and hockey, you're only as good as your last performance."

While maintaining his unique way of living, Wilson was constantly having to defend himself. "A lot of people I came up against were a couple of generations behind the times. People tried to control my lifestyle. I'd get into personality conflicts that grew worse and worse. They'd get after me because of my long hair or because of the way I dressed. I prided myself on being my own man."

"Of course, my so-called wild lifestyle has been exaggerated because if I did all the things I'm supposed to have done, I'd be dead. It makes me laugh sometimes," he said. Coach Hal Laycoe once tried to prohibit a local reporter from entering the dressing room because he sported a modern haircut and sideburns, so by extension, Wilson knew exactly how the coach felt about *him*. "The hair was what I considered to be another dumb thing," Wilson said. "Just about every guy in town had his hair at a length that was over his collar, but the team seemed to want the players to have it a half-inch long. There again, they didn't rate me on how well I stopped the puck but seemed to be judging me on a lot of silly garbage."

During his first season with Vancouver in 1970–71, his wild style was also reflected in his behavior on ice. He left his crease to join in the fighting no fewer than *seven* times, making Ron Hextall look like a peacenik by comparison. This prompted Vancouver management to swear Wilson to an oath of good crease conduct for the following year before offering him a new contract.

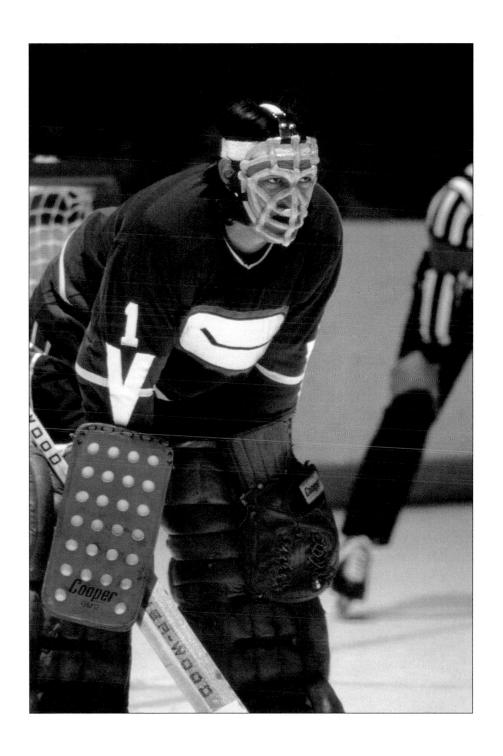

PLATE 74

LORNE WORSLEY AND HIS FAN CLUB

"GUMP" WORSLEY played an incredible 21 years in the NHL, won two Stanley Cups, and was one of the last goalies to play without a face mask. And there are not too many players who can claim to have had a fan club established in their honor. His club's newsletter was called the *Gumper-Gram* and was issued by club president and Gump-aholic Stu Hackel. First year membership would set a Gumper-gaper back $1.20, but this included a one-time initiation fee of 45 cents. New members received an 8" x 10" glossy photo of Worsley and a membership card entitling them to seven issues during the annual publication period.

The first release alerted fans to a minor injury the Gumper received in Toronto on February 16, 1966 and provided game reports from the *New York Times* and a photo during Gump's 4-0 shutout win over the Rangers while a member of the Montreal Canadiens. A scathing editorial on the following page condemned Rangers coach Emile Francis for obvious anti-Gump strategy: as the game wound down and the Rangers trailed 3-0, Francis pulled his own goalie Ed Giacomin in an effort to score just once. Said Francis: "I just didn't want Worsley to go out of here with a shutout if I could help it." One empty net goal later, that's exactly what happened. Gumper the Great gained the goaltending glory with the goose egg.

The second issue of the *Gumper-Gram* featured an outline of the Vezina Trophy with the following declaration: "This is the Vezina Trophy. Great goalies win it. Glenn Hall would like it. So would Johnny Bower. And Terry Sawchuk. And Roger Crozier. And Ed Giacomin. And Cesare Maniago. And Ed Johnston. And Bernie Parent. But they are good goalies, not great ones. Some of them are not even good. Gump Worsley is a great goalie — the greatest. This is the Vezina Trophy. Color it Gump."

Issue number four appeared near the start of the 1966–67 season, and Gumper-gloating president Hackel, back for a second term, noted that Bobby Orr scored his first NHL goal against the Gumper on October 23, 1966 (and then had the Gumption to add, parenthetically, that the Habs won the game 3-2!).

The appearance of the fifth issue was delayed (a controversial publishing decision that was never explained), but its belated release brought startling news: "December 7, 1966 — exactly 25 years after the bombing of Pearl Harbor, another tragedy took place. And even though it is definitely not on the same scale as the Hawaii incident, Gump Worsley's knee injury that night in Toronto, to say the least, hasn't helped Les Canadiens' fight to prove they're a better team than the standings show." The Gump de grâce, however, came on page two of this historic issue and featured a picture of Worsley in action with information regarding the most serious injuries suffered in his Gump-time in the NHL.

In a head-to-toe drawing of the goaler, members are informed that in 1963, the man no one called Lorne received a 14-stitch cut to his head; in 1961, a 10-stitch cut around his eye; in 1962, a dislocated shoulder (out two weeks); in 1965, a shoulder bruise from a Bobby Hull slapper (out one week); in 1959, two severed tendons in his hand (out three weeks); in 1963, a serious hamstring pull (missed eight weeks); in 1954, a pinched nerve in his spine; in 1966, a knee injury that required an operation. No extant issues of the *Gumper-Gram* are known after this late December 1966 printing even though Worsley continued to flourish in the NHL for another number of years.

President Hackel, meanwhile, remains involved in hockey and has gone on to bigger, less Gumper, pursuits.

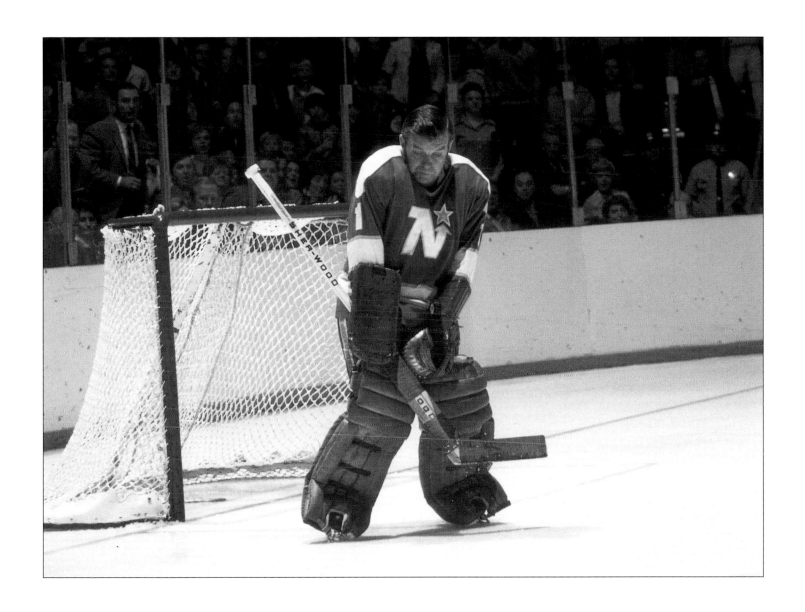

PLATE 75

ACKNOWLEDGMENTS

THE AUTHOR would like to thank those who have helped directly or indirectly, tangibly or in-, in getting this book done. First, as always, to Dr. Jon Redfern and Geri Dasgupta for so very much. To John Neale, John Pearce, and Don Sedgwick at Doubleday for support so rich it cannot be so richly deserved. To everyone else at Doubleday, primarily the anchor in the imprint, the superb Christine Innes. To Tania Craan, for magnificent design on a second hockey tome in as many years. To my ever-faithful and forbearing agent Dean Cooke. To the extended family at the Hockey Hall of Fame: Jefferson ("Gos") Davis; Passport Phil Pritchard, king of the sneaky drop pass; Craig "five hole" Campbell; Darren Boyko (aka the Finnish Flash); Peter Jagla, hockey's answer to Bill Gates; Bill Hay, Jeff Denomme and Bryan Black; No. 6, Ron Ellis; Miss Kelly Massé (oo la la); the invaluable Jane ("Sip") Rodney; Izak Westgate, a deeply Blue and White bleeder; Craig Beckim, Tim McWilliams, Anthony Fusco, Craig Baines, Dave Sandford, Barry Eversley, Ray Paquet, Jan Barrina, Jason Fowler, Jeff Graham, Sandra Buffone, Anita Goel, the splendid Sophie Harding, Sylvia Lau, Marilyn Robbins, and the main Pearl Rajwanth. A very special apology must go out to everyone *a mare usque ad mari* for the colourless spelling used in the text. Thanks also to a few precious others who have helped with information here and there: Bob Clarke for letting the letter in; the Austrian Ice Hockey Federation; Stu Hackel (Gumps a million); Glenn Hall and Johnny Bower for facial recollections; Terrible Ted Lindsay, who really isn't at all; Scott Morrison for PHWA info; Tom Johnson in Boston for namesakes; Benny Ercolani and David Keon Jr. at the NHL; Martin Harris in London re his beloved Lions; and Dick Irvin in Montreal for trivial knowledge about numbers. To Rey Sandre and Bob Vitt for their valuable help in sorting the collection, and to Julia McArthur for assisting. To Lewis Portnoy (and Lois, of course!), who gave of his time to talk about his work and gave of his life to create a body of eternal hockey memories. And, of course, to my mom, for giving me my one hot meal a week with lots of veggies and a great planned dessert.

INDEX